HUMANS OF LONDON

CATHY TEESDALE

LOM
ART

First published in Great Britain in 2016 by LOM Art, an imprint of
Michael O'Mara Books Limited
9 Lion Yard
Tremadoc Road
London SW4 7NQ

A CIP catalogue record for this book is available from the British Library.

Papers used by Michael O'Mara Books Limited are natural, recyclable products made
from wood grown in sustainable forests. The manufacturing processes conform to the
environmental regulations of the country of origin.

ISBN: 978-1-910552-42-1 in hardback print format
ISBN: 978-1-910552-59-9 in e-book format

1 2 3 4 5 6 7 8 9 10

www.mombooks.com

Cover design by Dan Mogford
Designed by ROCKJAW Creative

Printed and bound in China

I've lived in this great big beautiful metropolis for nearly thirty years now, pretty much ever since leaving university. Yet, in all that time and with all the extraordinary culture, diversity, history and creativity it offers, I never truly fell in love with the place – until I began the Humans of London project and started really seeing and listening to so many of its people.

London's sheer size and density often left me feeling overwhelmed and adrift as I scrambled to make my living as a freelance photographer, writer and editor. But then, in late 2013, I discovered Humans of New York (HONY) and thought, 'What a brilliant idea!' Brandon Stanton, HONY's creator, was shooting portraits of people he met in the street, recording and editing their answers to his searching questions, and then sharing their stories online. This seemed a perfect way for me to marry my skills, and my willingness to talk to strangers, with my deep love for, and faith in, humanity. Perhaps, through this project, I too could work to expand empathies, inspire others to connect more with those around them, and so finally do some real good.

There was only one problem. Brandon had started his HONY project in 2010 and, by 2013, over 500 other 'Humans of...' pages had already started up all over the world, including three 'Humans of London' ones. I was late to the party, but I was still sure I had something to give. So, because it's the area of London where I live, I initially started up a Facebook page called 'Humans of West London' – with the

slightly unfortunate acronym 'HOWL'. Luckily, circumstances quickly conspired to make me ditch that and look for another. Then a wise and dear friend suggested 'Humans of Greater London' and 'HOGL' was born.

Having solo adventures abroad had already given me lots of practice in talking to strangers – if you can't, you'll have a pretty lonely and far less interesting time – but it always seemed so much harder at home. This is partly because of our famous British reserve and disapproval of 'nosiness', and partly because you can find yourself worrying you'll be seen as a nutter or a Norma-no-mates, desperate for friends.

But I took a deep breath, plunged in and quickly started having uplifting and preconception-challenging encounters with humans I might otherwise have passed by. Very early HOGLs included panda-loving Pat, who'd come all the way from Latvia for a Gogol Bordello concert and some London Christmas magic; busking Ella, who'd once had her guitar smashed to pieces and thought she might be about to die; and Gavin (sadly not in the book but who can be found on the Facebook page), who was rocking a fabulous punk tweed look and hoping to get on to a fashion design course, while volunteering at the homeless support centre which had helped to get him off the street. Later inspirational HOGLs include Errol, Kiry, Grace, Sonia, Elvira, Dave, Bamboo, Joseph, Raga, Ruth, Diane, Sue, Naiomi and Jay, all of whom you can meet in this book.

Very occasionally, someone I approached would decline to be photographed or interviewed but, particularly if they were looking sad or lonely, I'd often stop for a chat and we'd end with a hug anyway. Studies keep showing that feelings of loneliness, invisibility and disconnection are on the rise, particularly for the homeless and old, yet I've discovered it's so easy to counter that, daily, by just taking a moment to stop, smile back and dare to engage. So often you'll hear you've just made someone's day.

I decided to keep the HOGL shooting style spontaneous and natural (largely photographing people as I found them, rather than moving and placing them carefully against some more photogenic background), because real life's often untidy and I want readers to feel that they could have been standing in my shoes, or sitting in my chair, looking straight into those expressive eyes, having this encounter, and sharing my brief window into another person's world. And I like to share the occasional photojournalistic, candid shot to show something of daily life in London alongside its featured people.

I've also been able, like HONY and many another Humans of... page, to let HOGL be a channel through which people's natural empathy and kindness can be turned into concrete help. First came Naiomi, who stopped me to ask for a cigarette on Camden Road in May 2015. After I'd sat down to smoke one with her, heard her horrific story and fallen in love with her megawatt smile, I shared both on my Facebook page and her post

went viral. So many people were keen to help, and several begged me to set up a crowdfunding page for her, so I did, via JustGiving, and we managed to raise £1,400, which helped her to get off the streets and into her own safe flat (see pp. 150–1).

Next came Jay, who I first saw sitting cross-legged outside my local Tube station in April 2014. Once I'd sat down and talked to him, I heard another poignant story, again served up with an amazingly undimmed smile. So I HOGLed him too, and afterwards would stop to chat every time I passed by – until suddenly he wasn't there any more and I just had to hope his luck had changed. When he reappeared in his usual spot at the end of 2015, I decided to carry on sharing his story on the page and, during a bitter cold snap in January, a wonderful bunch of HOGL fans paid for him to have over a week of warm and dry nights in a B&B (see pp. 216–19).

Because Greater London is such a huge area of around 610 square miles spread across 33 boroughs, with a population of over eight million and more than 300 languages spoken, I always felt this project needed to be bigger than just one woman with her camera. So I was delighted when, in November 2015, Richard Kaby and Trisha O'Neill came on board to help me HOGL. They've since served up many a beautiful and unexpected post, several of which are included here, and I'm looking forward to our team continuing to grow.

'London is a beacon of tolerance'; 'London does multicultural mixing better than anywhere else in the world'; 'there's nowhere else I feel as free to be authentically me': these are phrases I now hear all the time. It makes me proud to be a Londoner and hopeful that this unique city could yet help light the path to a kinder, more cohesive future, too. To that end, we now run quarterly HOGL Hubs. These are relaxed social gatherings, complete with food and drink, live music and storytelling, which allow an incredibly diverse range of people to connect, come together and spark offline, in the real world, as well as out there in cyberspace.

Above all, I love being part of a growing movement that's actively countering the demoralizing negativity of so much of our mainstream news with positive and heartful human portraits and words. All the Humans of... pages, as well as other wonderful blogs like Portraits of America, Souls of Society, The Atlas of Beauty and Advanced Style, and Yann Arthus-Betrand's epic film *Human*, are busily inspiring us to stop and look around us with clearer, kinder and more hopeful eyes. If we believe in each other and come together to exercise some serious People Power that demands an end to the madness, we could yet merge all our tiny, insignificant water drops into one unstoppable tide which really changes our view.

HOGL definition:

verb: to admire, listen to, photograph and embrace a human.
noun: a human who has been or could be HOGLed.

KALA: 'I'm buzzing with life – I don't even need to drink coffee or tea, never mind alcohol. I'm a drug myself, and a rainbow!'

SHOREDITCH

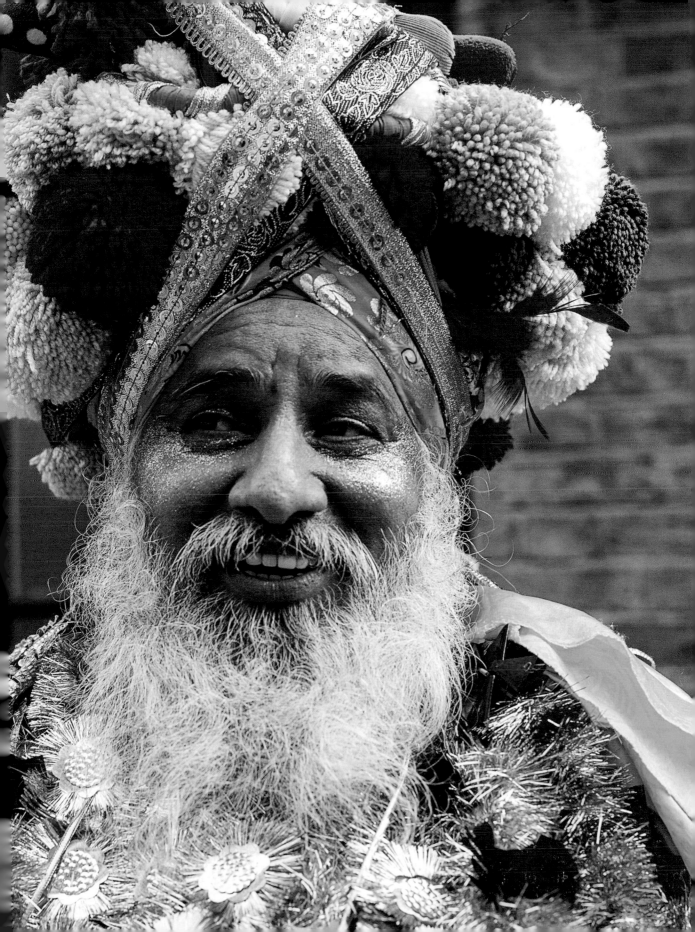

Playing findball in an autumn mist
GUNNERSBURY PARK

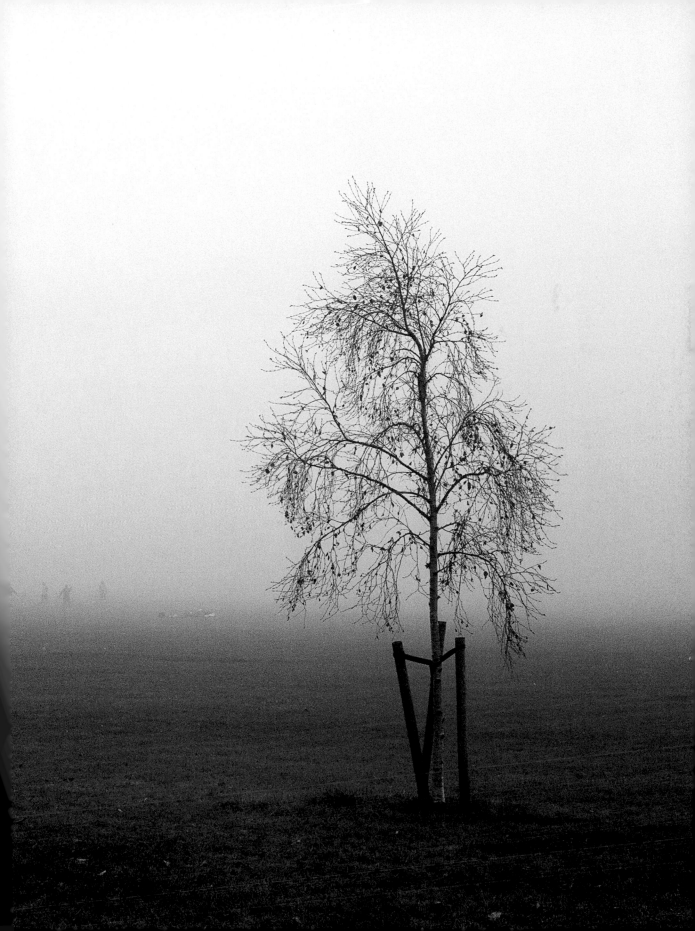

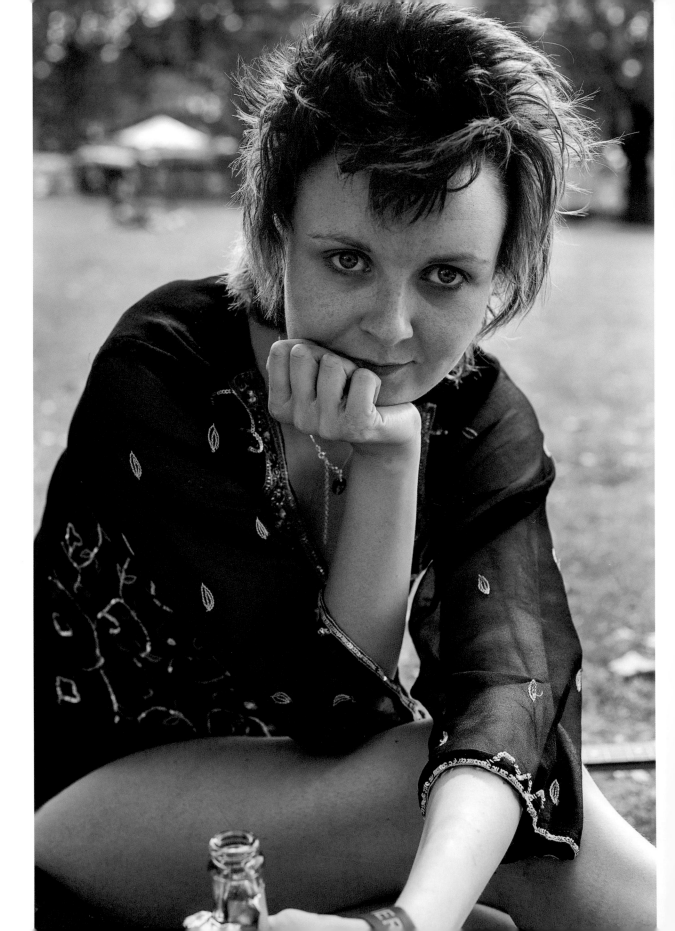

◄ **DANIE:** 'I'm very, very spiritual, and sometimes just a guitar solo can do it for me. Mick Ronson, who was David Bowie's guitarist, had this amazing ability – his playing sounds like the energy I would make if I wasn't in this human shell.'

HACKNEY

▼ **ISAAK**

'He loves anything with slapstick in it. He really likes to laugh, make fun and play jokes. He's not a difficult child at all. But he doesn't really speak. We communicate mainly through sign language, though some of his signs – we have absolutely no idea what they mean. He is who he is. We just roll with it.'

Met with his dad
ACTON TOWN

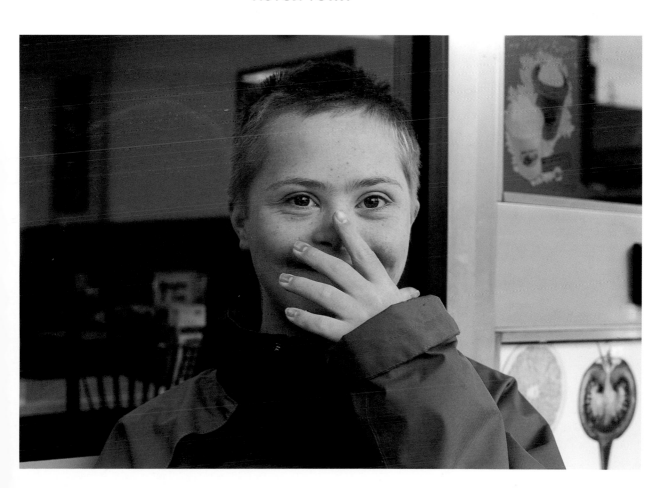

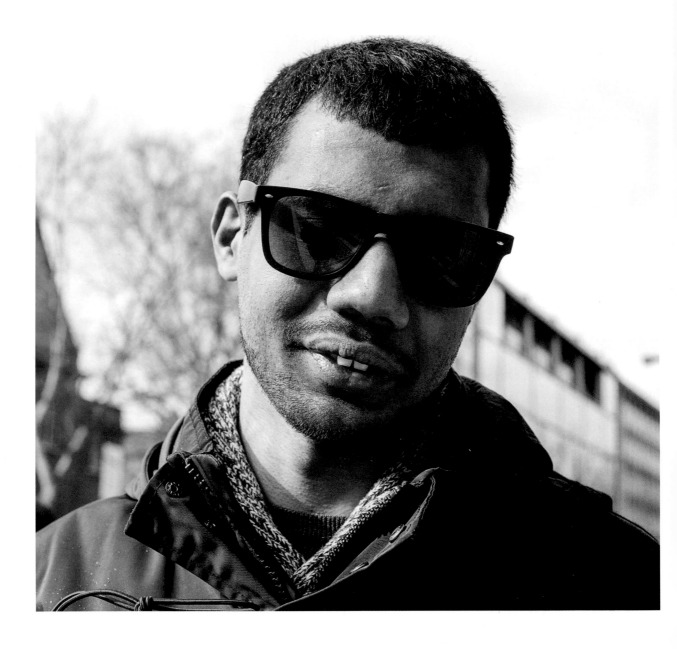

NAQI: 'I was born with this incurable disease, congenital glaucoma, and I was completely blind by the time I was seven. I also had extreme photophobia, so it would often be excruciatingly painful just to open my eyes or raise my head to the sun, and they would water all the time. Then, two years ago, I had a surgery where my eyes were removed and replaced with silicon prosthetics, and that worked. The photophobia has gone and I no longer have to suffer pain from light every day.

'I was really scared that losing my actual eyes might make me lose my "phantom vision" (where the brain makes associations from touch, you build up a mental picture of a room, filled with colours and shapes, by feeling your way around it), and I would be left in a world of claustrophobic darkness. But that didn't happen, I still have my inner vision.

'I was born in Pakistan and my mum (who's Indian) sacrificed her own business career to get me into a regular school, teach me Braille and help me cope. My dad was incredibly supportive too, but in a different way. He was much more keen on sports, so he had me doing things like karate, cricket, swimming, cycling and skating. He even made me drive a car and ride his motorbike – although very slowly and in an empty space of course!

'I'd always liked science and maths, but people kept telling me: "You can't do it, it's too tough!" Luckily I stood my ground and said, "No, I don't want to do something that will be just easy for me, that I'm not passionate about." When I finished my industrial engineering degree, even though I was the only one in my class with a physical impairment, I got the top marks, so they invited me to give the valedictorian speech. That was my chance to say to my family, "Thank you so much for all you've done for me and I'm really proud that I could make you proud!" It was one of the happiest moments of my whole life.'

TOTTENHAM COURT ROAD

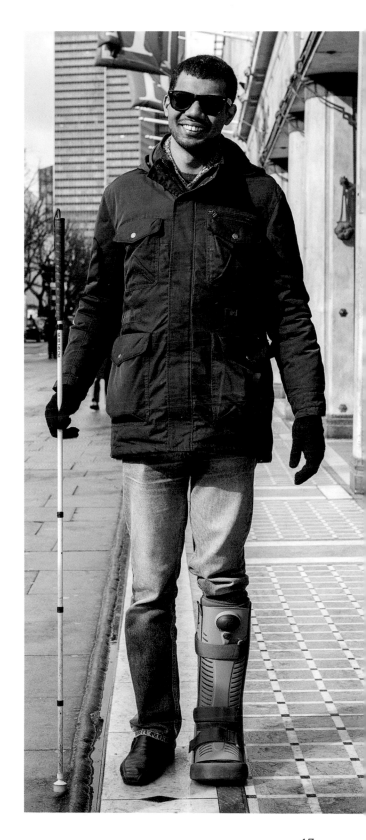

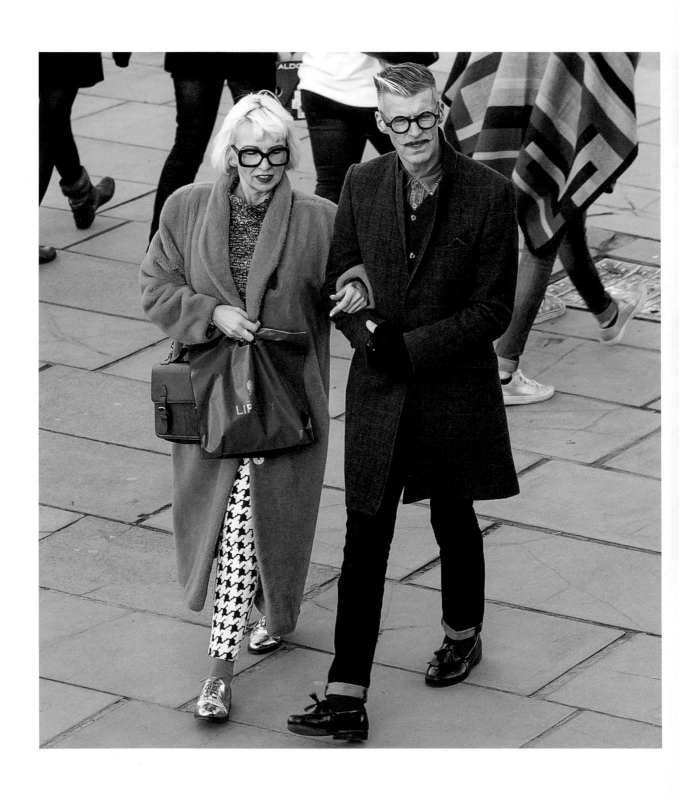

Serious style on the South Bank

▲ GIRADO: 'I've come over from Italy for a week's holiday and to see Noel Gallagher's concert. I've deliberately come by myself because it makes me so emotional to hear him. I know I'm going to cry, and I can concentrate better if I'm on my own. I've never heard any poetry as beautiful as his songwriting. For me, Noel is my only god.'

O2 ARENA, GREENWICH PENINSULA

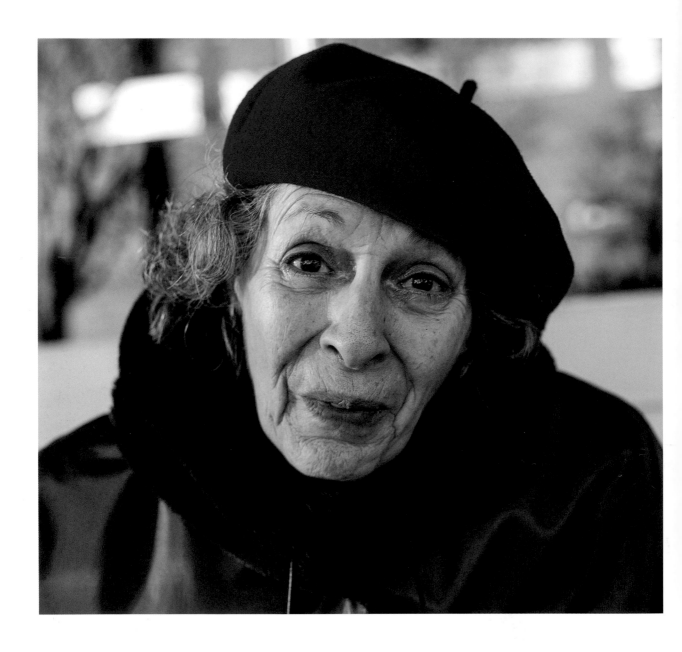

ELENA: 'I've always been too honest. My mother used to say to me, "Darling, it doesn't matter if you say a little lie." But I can't help it – I'm very straightforward, very square, and sometimes I say too much. Which makes me think it's better to be alone, because sometimes I can really put my foot in it with my truth.'

SHEPHERD'S BUSH

ZIBA: 'Oh, I look terrible today, I've been crying so much. You can take my picture, but no close-ups.'

Can I ask what's been making you cry?

'I'm a poet, so I'm a very sensitive person. I cry all the time, about all sorts of things.'

WEST HAMPSTEAD

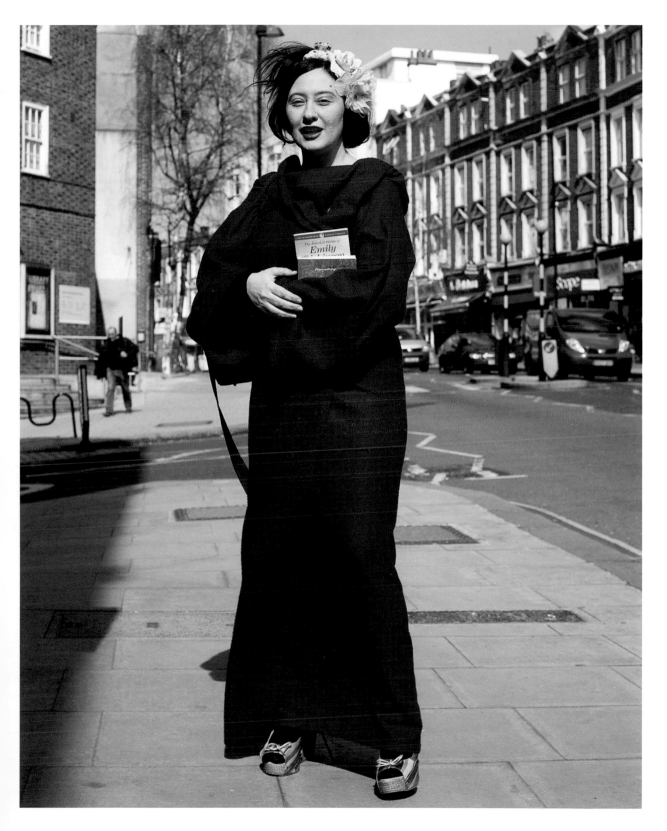

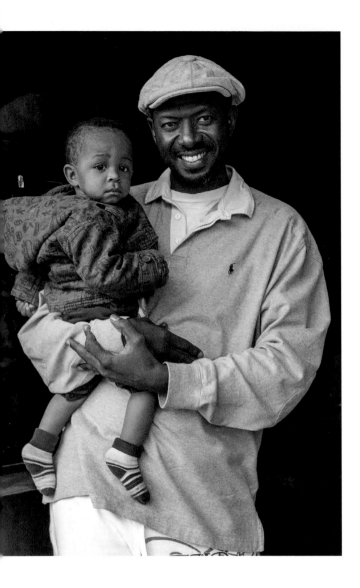
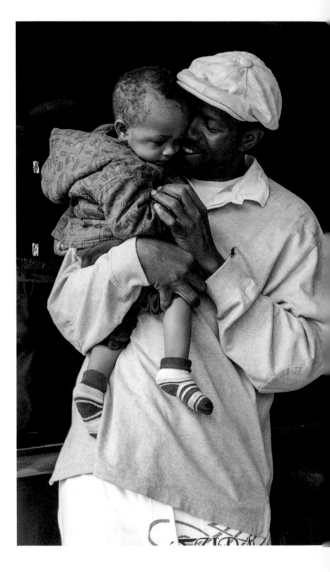

⋀ MO & SWALEH

M: 'He's a very lovely boy. I feel so lucky. He likes to laugh and he makes me smile all the time. He's my first child and I was always praying to have a son, and now I've got a lovely one and I really thank God for that. I hope he'll grow up with good manners and respect people, the way I do. He is my friend. So even though I'm broke, I'm happy inside.'

ACTON TOWN

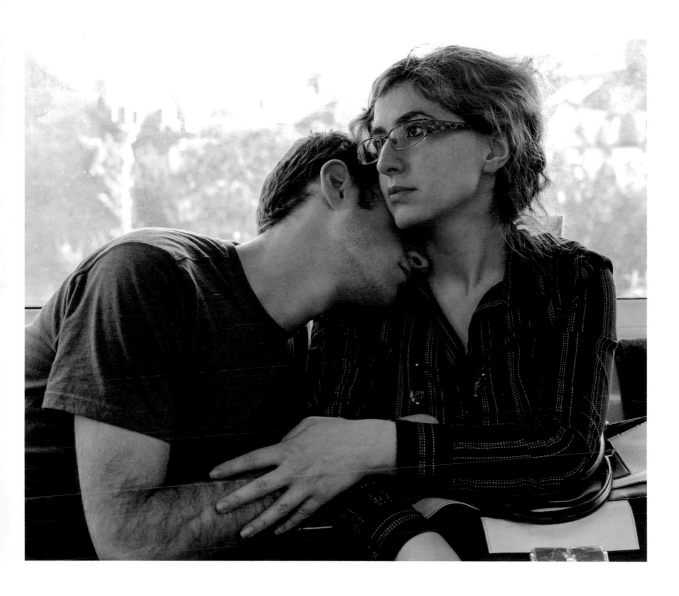

Lost in their own world
PICCADILLY LINE

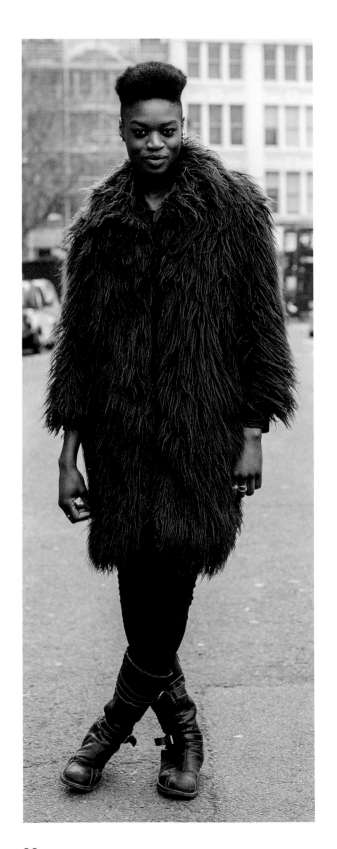

> **CAROLE:** 'My third husband was the love of my life. I married him when I was thirty-eight and he was twenty-two and we were together for twenty-four years, but then he died suddenly, fifteen years ago. For about two months I kept doing silly things like putting my keys down the loo, leaving the door open, forgetting where I lived – it was the weirdest feeling, like I was dreaming. I went to the doctor's and they said, "It's not grief, it's shock."'

CHISWICK

< **ESTELLE:** 'It makes me happy just to see people doing their own thing and having no shame in showing that they can be different.'

SHOREDITCH

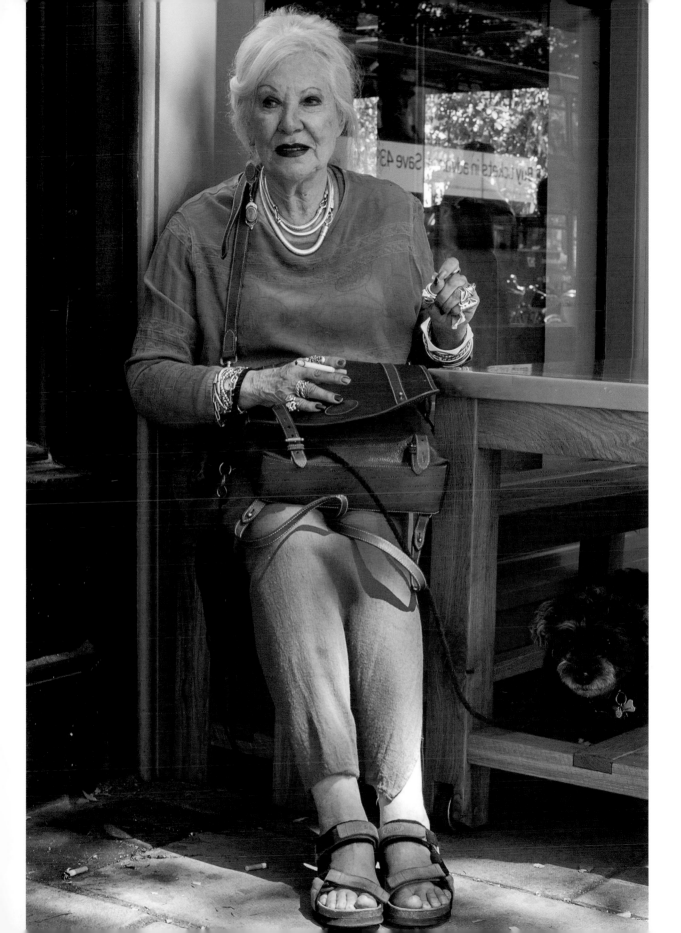

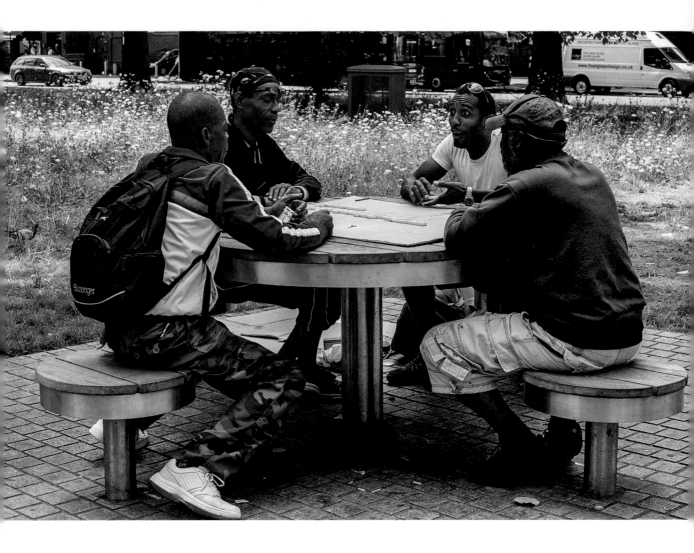

Seriously?!

DOMINOES ON SHEPHERD'S BUSH GREEN

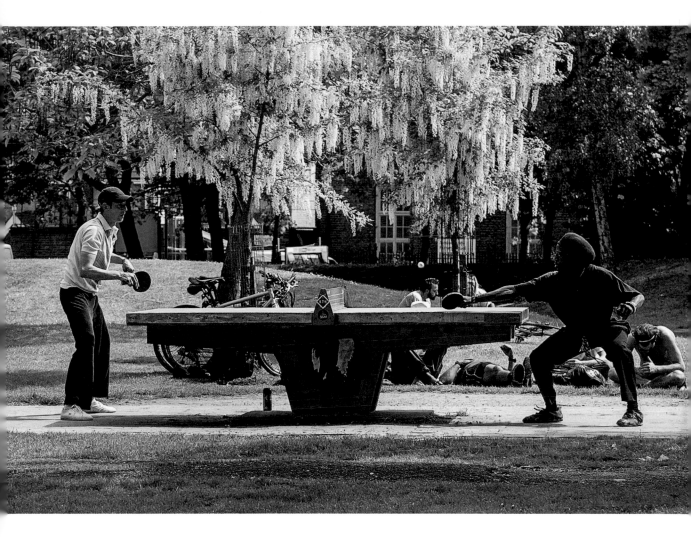

Focus...

PING-PONG IN LONDON FIELDS, HACKNEY

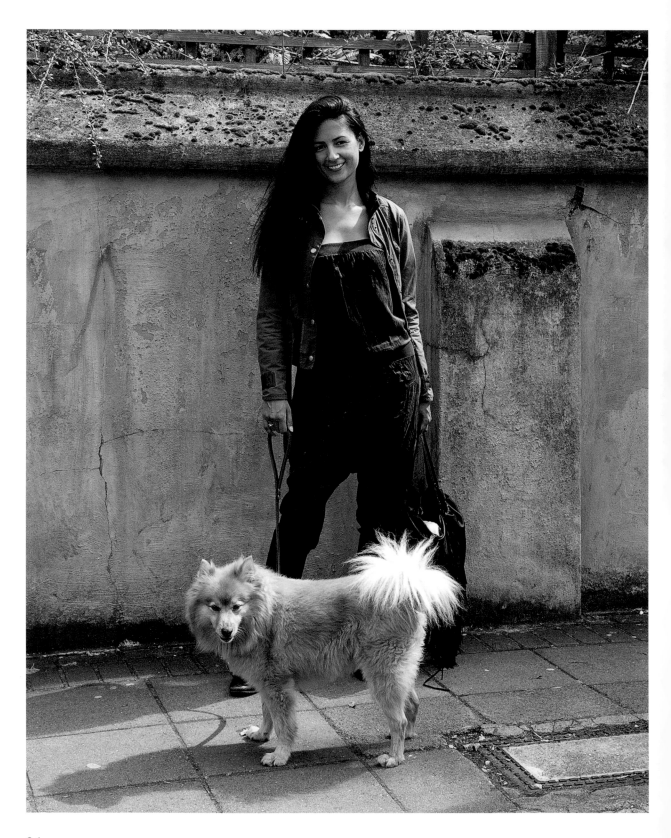

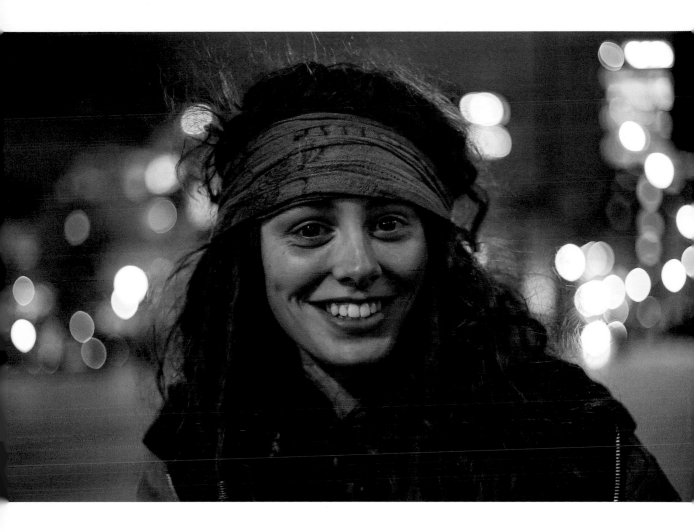

◄ ARUNA & PHILIP

A: 'I love Burning Man [festival]. It's like a playground for artists because it really allows and encourages radical self-expression – whatever you want to do, you can do there without worrying about money, or being criticized or judged. It's an alternative vision of life, which is really beautiful, based around compassion, gifting, sustainability, cooperation and trust.

'It is pretty hardcore – the sandstorms, grit everywhere, the heat, cracked lips and nosebleeds. Because it's so dry you have to use nasal sprays. But people often go through a period of sadness when they get back, because they've experienced almost a utopian way of living.'

ACTON TOWN

▲ OWL: 'The world needs less bullshit and more honesty.'

WESTMINSTER

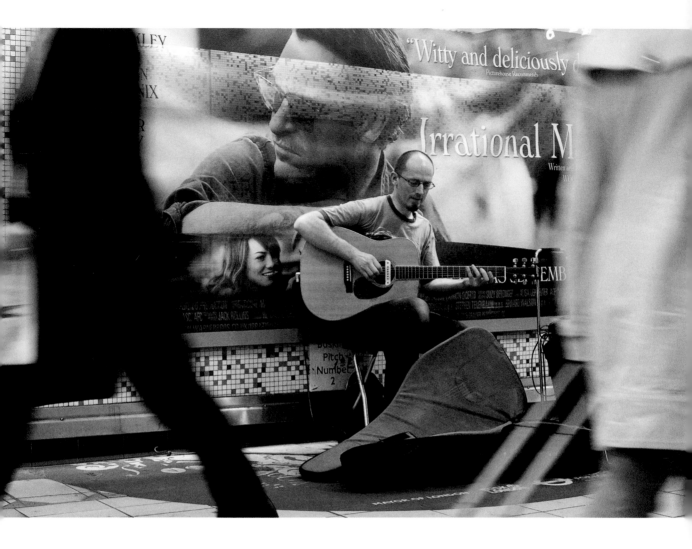

▲ **EGON:** 'In the Underground many people rush by on their way to work. But very often they'll stop and listen for a long time, and then tell me, "Oh, you made my day!", which is such a great feeling.'

GREEN PARK STATION

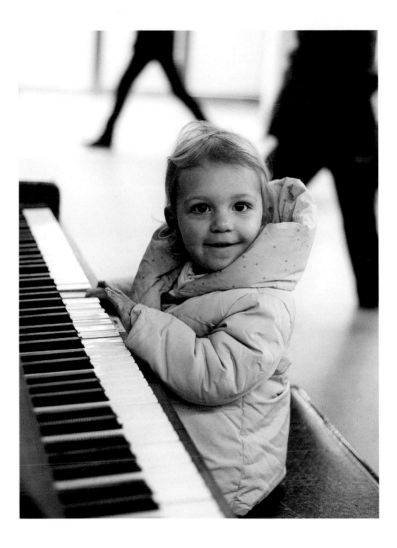

▲ HELENA

'She's a very cheeky monkey and she loves music – which is why I brought her here. She also really loves her baby sister, who's six weeks old. She can't stop kissing her.'

Met with her mum
ST PANCRAS STATION

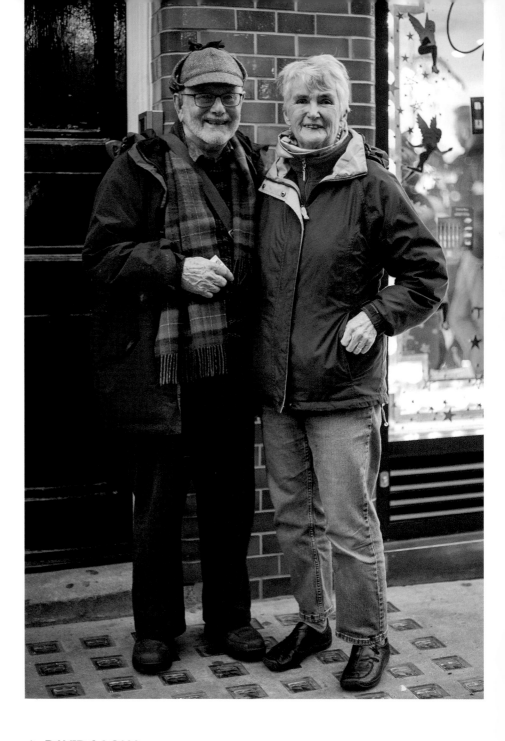

▲ DAVID & LOMA

D: 'We're both Kiwis but with Scottish ancestry, and we're both ordained priests now too. The third time we met I spent hours chatting her up. It took me until five in the morning to get her to agree to marry me!'

L: 'You've got to take a little time to think about something like that, haven't you? We just fell head over heels in love, but first he had to be ordained and I

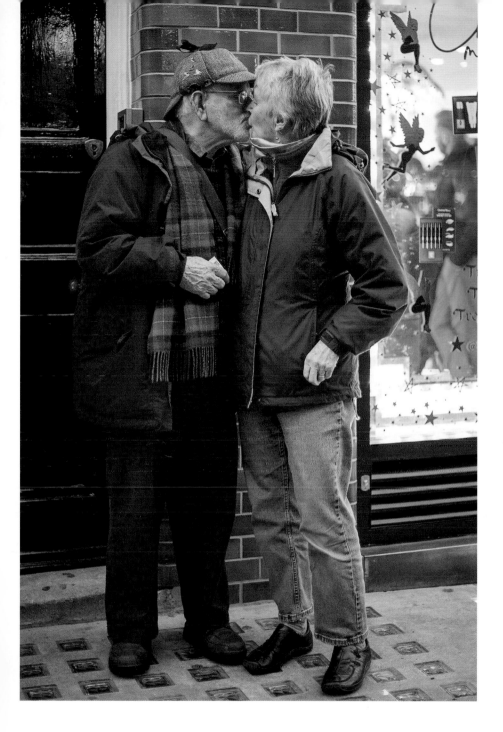

had to finish my nursing training, so we ended up being engaged for eighteen months, which was very hard because we both really wanted to have sex!'

D: 'In those days, the sixties, we Christians didn't believe in sex before marriage – and she is pretty desirable!'

COVENT GARDEN

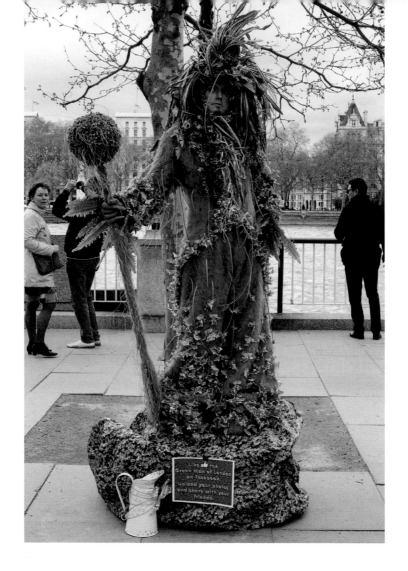

Making like a tree

SOUTH BANK

➤ **PIERRA:** 'I stopped eating meat over thirty-five years ago because I really love animals – I look at them as friends, and I can't bear that we are torturing them for their flesh and milk. Now I can empathize with and "read" my dogs so much better, and the smell of grilled flesh just makes me want to flee. I really hope the vegan movement will get strong as hell!'

RICHMOND PARK

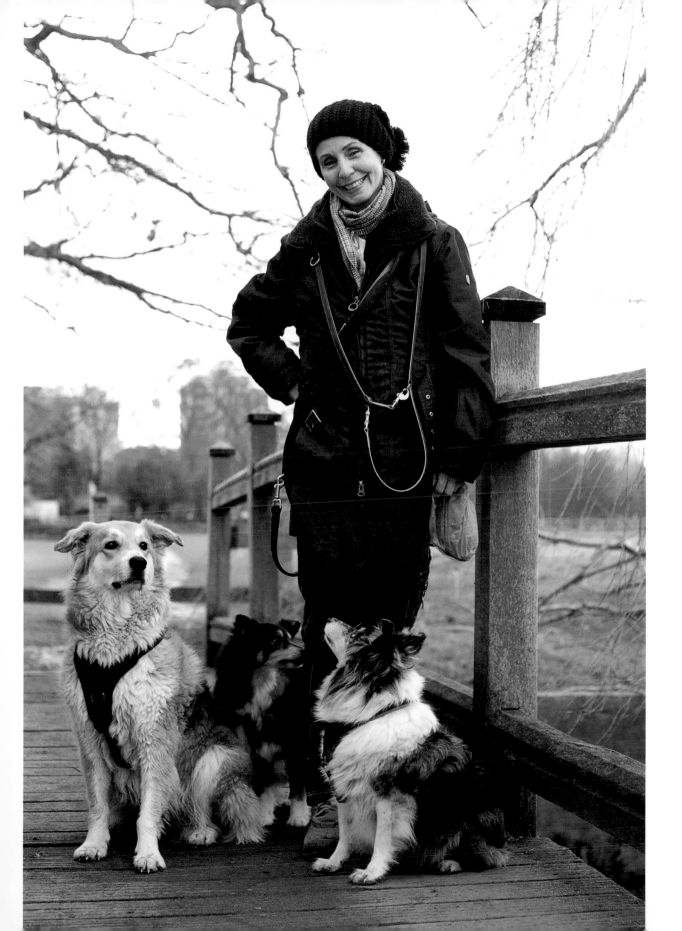

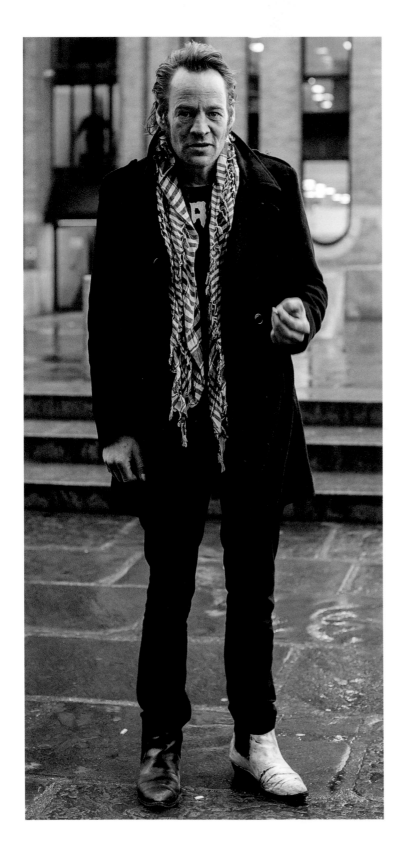

◄ **DAG:** 'I wear only black and white. I used to only wear black, and that's a bit grim, so I decided to go all crazy with colour, which would be white. That's as far with colour as I go. So it's both all the colours together, and none of them. That's the only reason I do this. It has NOTHING to do with vanity whatsover! It's a philosophical statement – I am everything and I am nothing, haha.'

SOUTHWARK CATHEDRAL

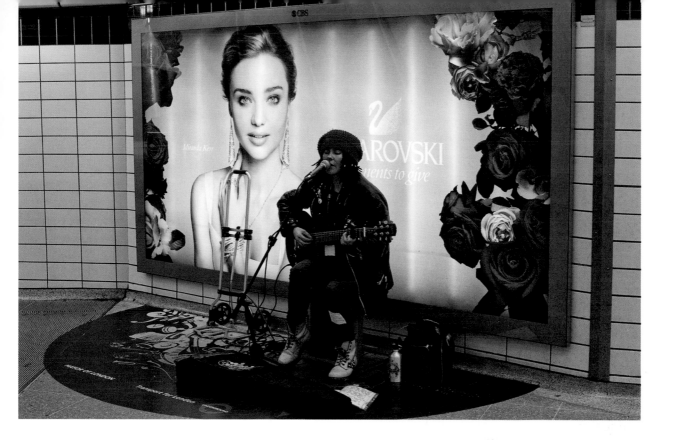

ELLA: 'You know the one thing that's very special about doing this down here? The human connection. That's what keeps me coming, because the money's not always good. I've had some really touching times; I've had some really scary times down here. I've had my guitar taken off me and smashed to pieces – I thought I was going to get killed. But I say, you see everything, every walk of life down here, assholes to angels – you see it all.'

LEICESTER SQUARE STATION

ADRIAN: 'When I'm busking I meet people, opportunities come from it, so it's a good way of networking. When I'm not doing that, or teaching music, I play in a band called the Heliocentrics, which makes me feel really good, and useful, because it brings everyone together, onto the same page, and that's what life should be like really.'

BETHNAL GREEN

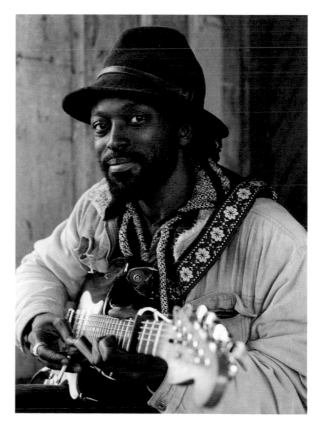

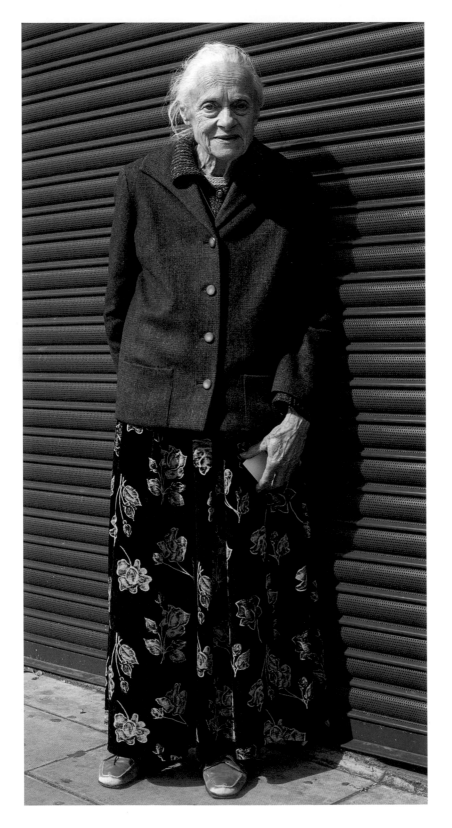

MARY: 'I'm so surprised I've made it to eighty-six! Sometimes I can't even remember my own name, though I live alone so that doesn't matter too much. I do always remember where I live though, which is a good thing. I fell over and banged my head five years ago, I think it dates from then.

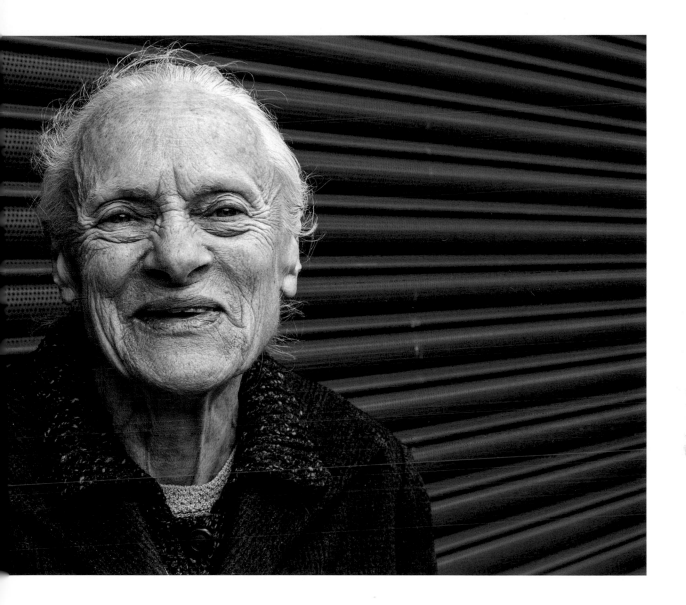

'But yes, I'm still enjoying life. I've got my two sons and three grandchildren, and I've been out for hours and hours and hours today. I live just round the corner and I walked down there and saw them blowing this building up. What an amazing sight – huge clouds of dust and smoke! Then I got lost and I had to ask at least four people which was the beautiful way home. It wasn't very beautiful at all in the end, but a beautiful woman walked a large part of the way with me.

'I can't bear all this dreadful new technology, smartphones and the Internet, all that. I won't have anything to do with it, but somehow I'm surviving, in spite of it. I've lost count of the number of people who've said to me, "I'll never have a life again now!" Sometimes I tell the angels off. I tell them they should have done a better job when they created humanity!'

ACTON

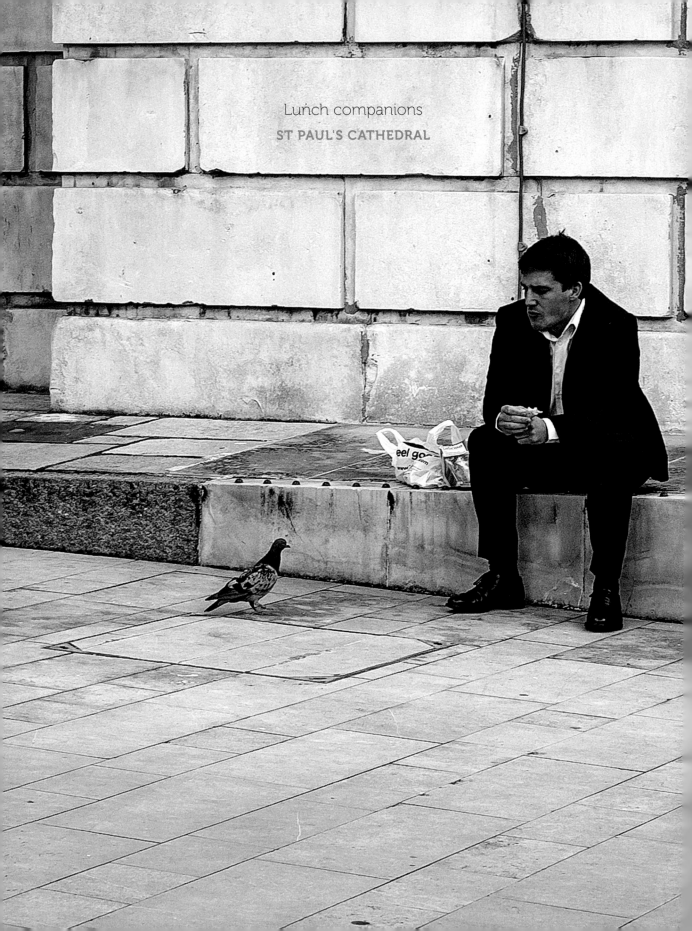

Lunch companions
ST PAUL'S CATHEDRAL

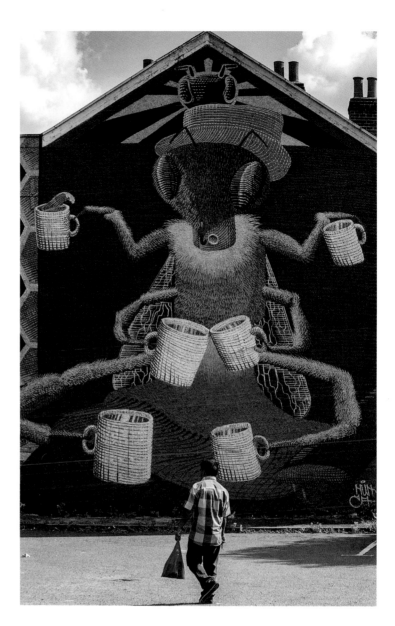

Time for tea

EAST DULWICH

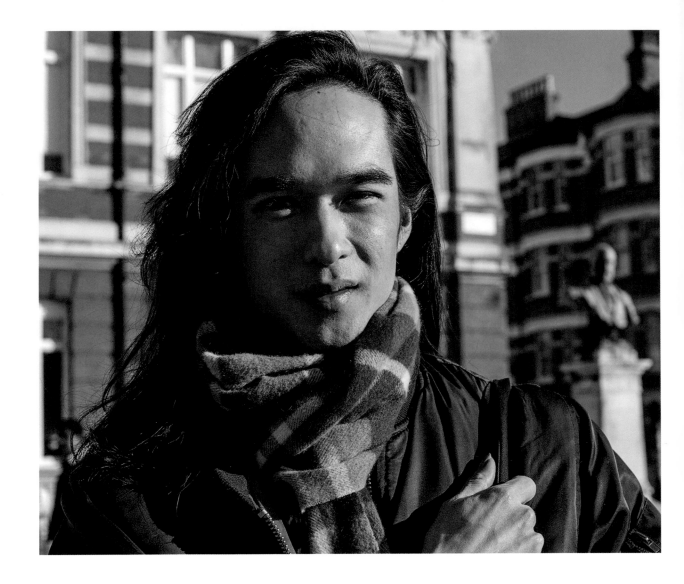

▲ **BAMBOO:** 'I came out quite young as gay, which was OK because Montreal is very open. It was when I moved here five years ago that I started to explore being transgender, which to me is a much broader and more philosophical term than "transsexual". It's a way of questioning gender stereotypes that split us apart as human beings, a way of reaffirming everyone's wholeness and unity, and basically allowing individuals the freedom to express their feminine and masculine sides, and be however they want to be. So I'm kind of going on an adventure, I'm travelling within.'

BRIXTON

➤ **RUSSELLA:** 'I'm really not a very interesting person to interview. I'm better at being photographed because I'm very beautiful!'

LIME WHARF,
BETHNAL GREEN

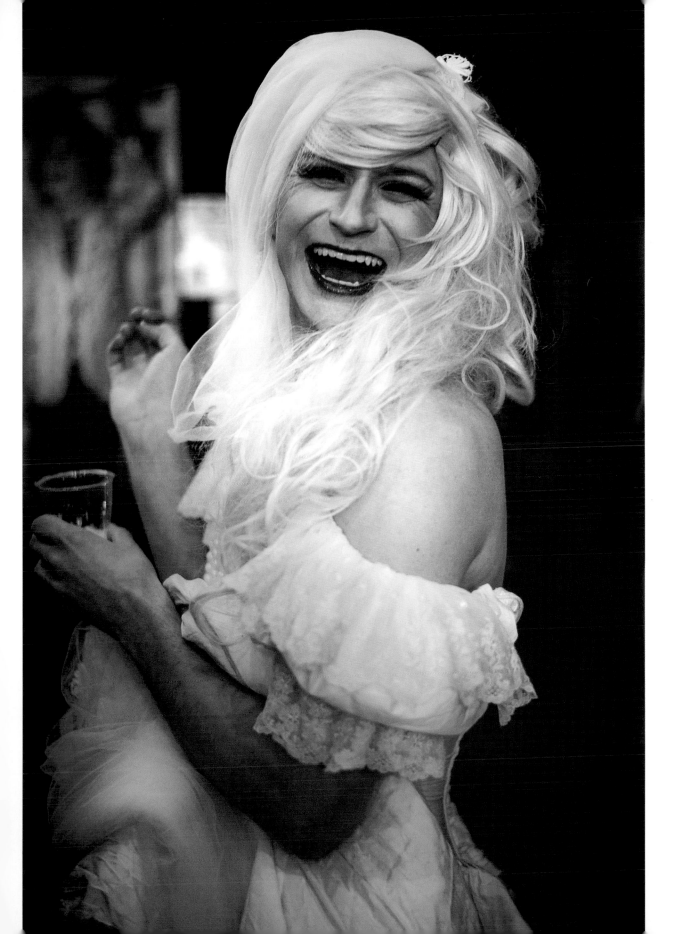

These two ladies looked so very happy
and content, feeding and playing with their
babies in this sunny little café, that I
had to approach them

HIGHBURY FIELDS

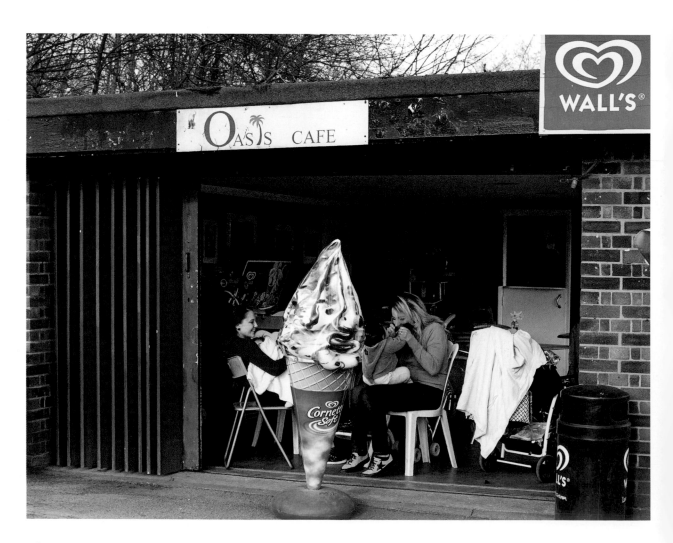

▼ GIZEM & MAYA

G: 'I normally cover her when I'm feeding in public, but because there's no one around here now and I'm with my friend... I enjoy breastfeeding. It's about feeding my baby and that's what matters.'

▼ SEREN & ELA

S: 'I'm a full-time mum, I don't have a career. I haven't done much to be honest because after my studies I had terrible gastric health problems for years, I think because I used to take everyone else's stress on, but I don't have those any more. They've gone with meeting my husband and having Ela. They've gone with happiness I think.'

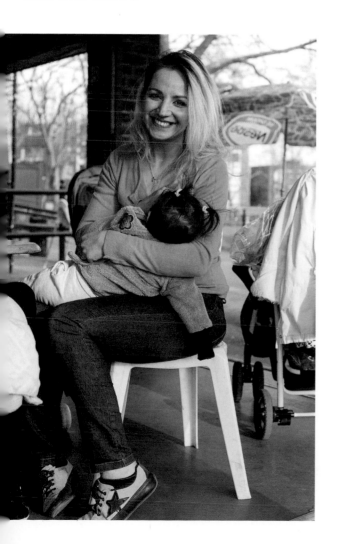

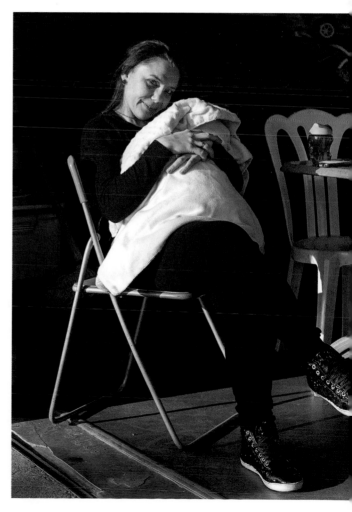

JOSEPH: 'I didn't realize until I got into my sixties how amazing being alive is. I've had a couple of very close friends who've passed away and you realize that, shit man, being alive is just fantastic! You discover the value of simple things. Simply walking is just really marvellous. The colour, the noises, everything is great. Every instance, every event, becomes an experience, something to savour.'

He was softly rehearsing his poetry lines for Derek Walcott's Omeros *at Shakespeare's Globe. I only later discovered that he's famous for playing the English butler in* The Fresh Prince of Bel-Air **GUNNERSBURY PARK**

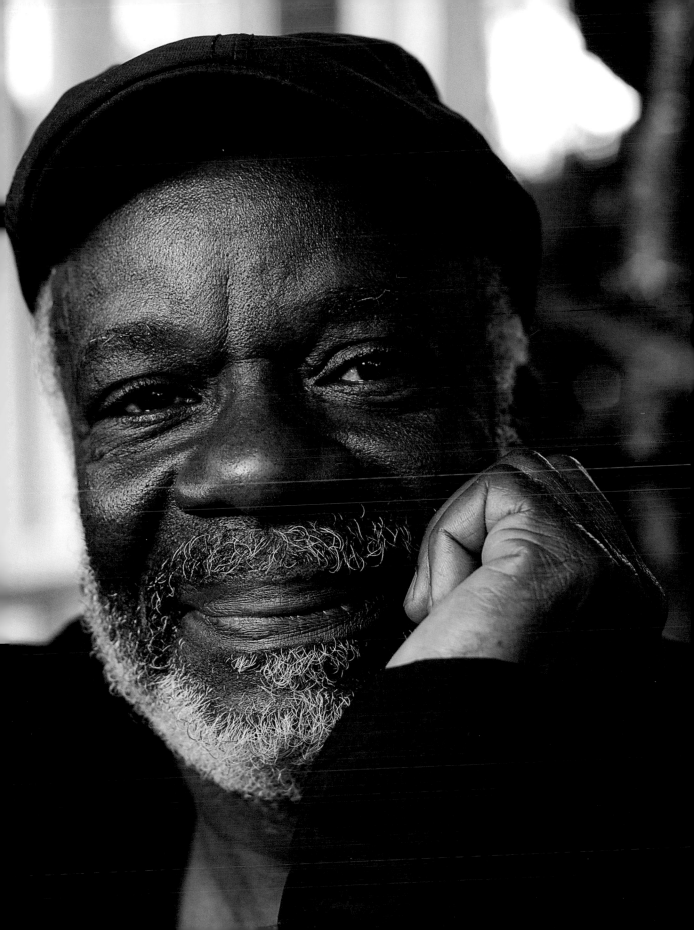

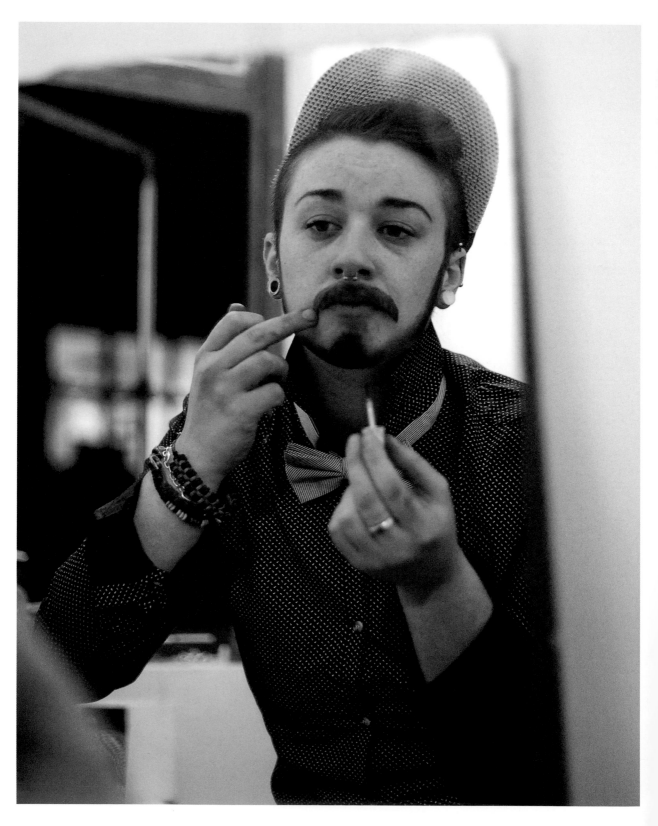

CASS: 'I was always a tomboy: short hair, trousers. When I was younger, it was really hard for me to feel beautiful because TV and magazines were full of tall, blonde, blue-eyed girls with long hair. Then I thought, "OK, I'm never going to be that kind of girl. I'm not beautiful, but I've got charm and that's so much better!"'

EALING

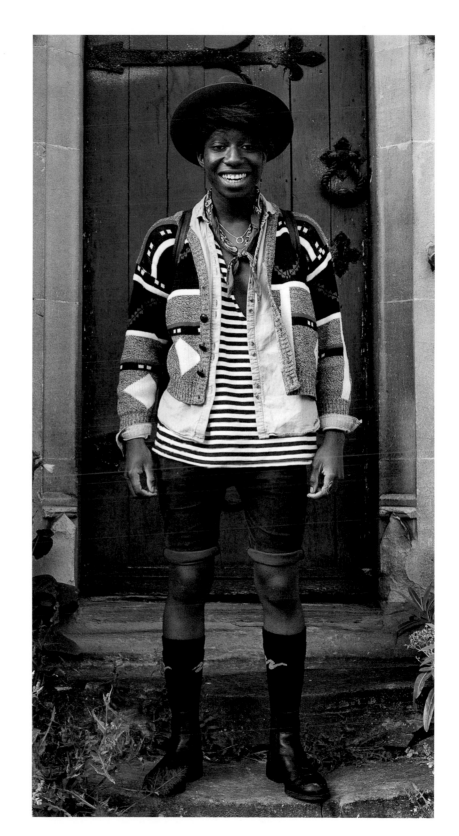

LUCY/LOUIS: 'I've always been so goosebumpy and full of fire when I was singing and it's something that's stuck with me all my life. My grandma was my rock and she taught me my first songs, and was the one person who always encouraged me because I had a really, like, shitty upbringing. There was a lot of violence and sexual abuse, so I was really fucked up in my perspective of what was a woman, what was a man, what was I, where was my place, where was I going, what's my role. But I always felt that I had something magic, and being a drag king, being Louis, is a way to be on that stage and sing and just not give a fuck what people think about the way that I look.'

SOHO

45

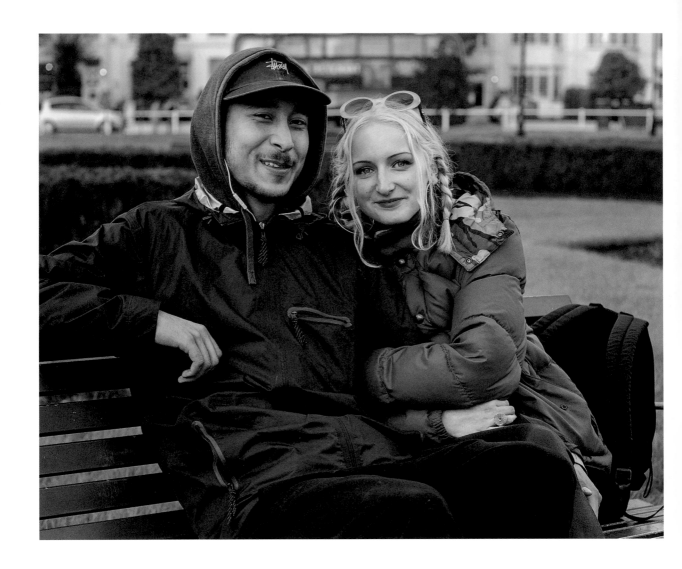

▲ MUSHTABA & NATALIE

N: 'I was hanging out with my friends at a skate park and I saw him skating with this really big grin on his face, and I just thought, "Oh my god, he's so cool!" I love that he's so passionate about his skateboarding, and he's really good at it, but it's sweet that he's so relaxed and modest about it too.'

M: 'The first time we went out for the night, we were chilling on a bench and she was sitting on the ground between my legs. I kind of nudged her, she looked up and I kissed her, upside down, in a Spiderman kind of way, and everything just stopped.'

EALING PARK

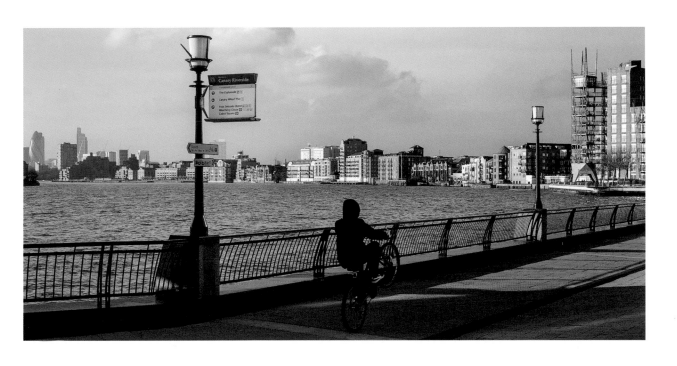

Pulling a wheelie by the water

CANARY WHARF

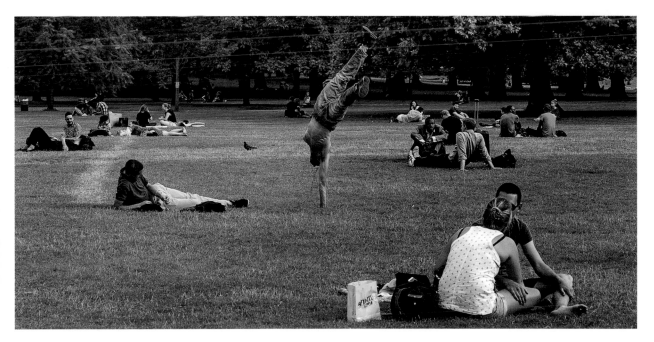

Nobody's watching...

GREEN PARK

'Badfingers' Bundy, giving his double bass a twirl while rocking 'Do the Portobello Boogie'

PORTOBELLO ROAD, NOTTING HILL

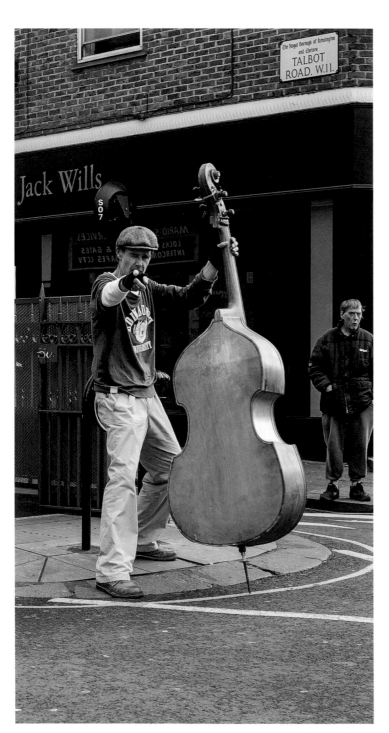

➤ EMMA & EMILY

Emma: 'We first met online when we were looking for friends and we were both quite lost. Now we've been together four years and we inspire each other.'

Emily: 'I think when we met each other our real identities came out. Before that, we had both been lost in our own minds, our own little bubbles.'

SPITALFIELDS MARKET

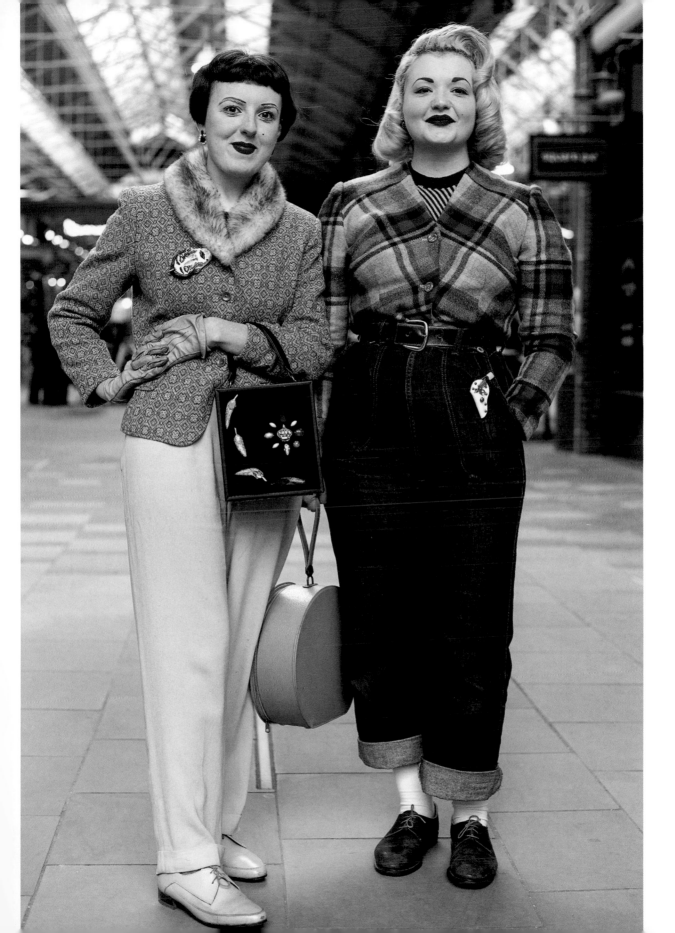

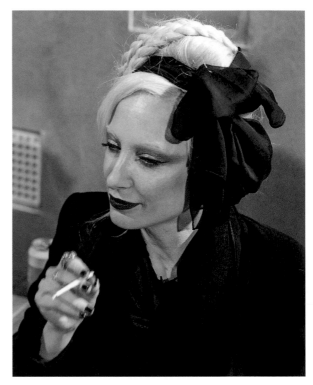

▲ **MAGDALENE:** 'I had an upbringing that was very wild, living with sheep and cows in the middle of nowhere in the Welsh mountains. My parents were old English hippies and I was always a bit weird. I had some social issues, couldn't get on at school, and was always getting into trouble with my teachers, a bit rebellious and very creative. So my parents stopped forcing me to go and just let me do whatever I wanted – which was mostly making clothes, and watching and being inspired by old movies. Now I have my own business designing bespoke clothes and costumes.'

HACKNEY

➤ **GRYFF:** 'I'm not no philosopher, I'm just a watcher.'

CAMDEN

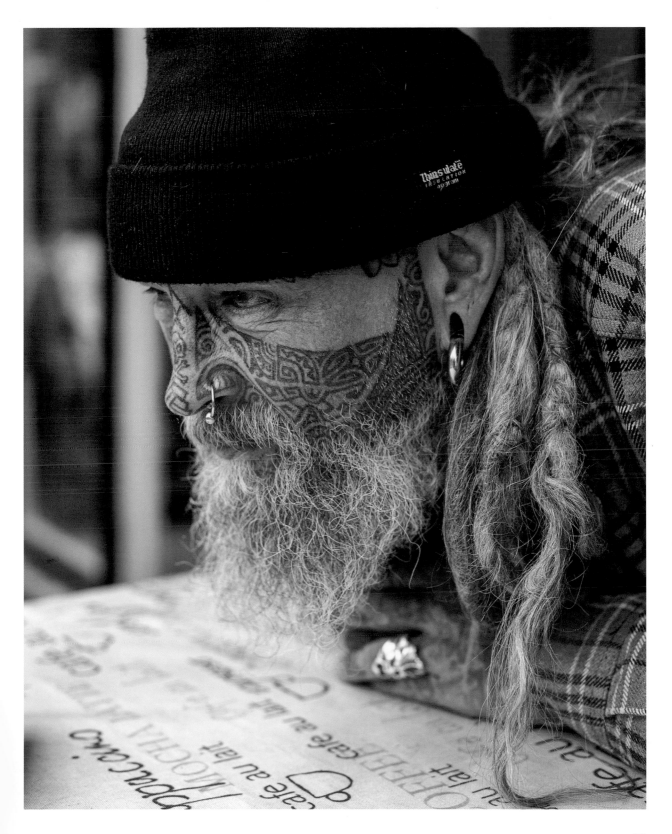

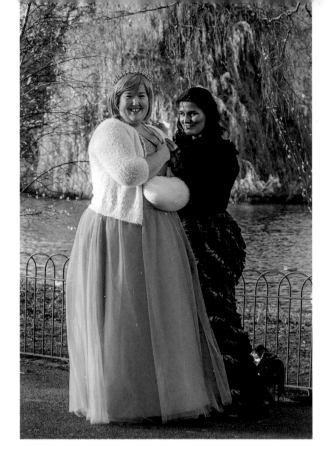

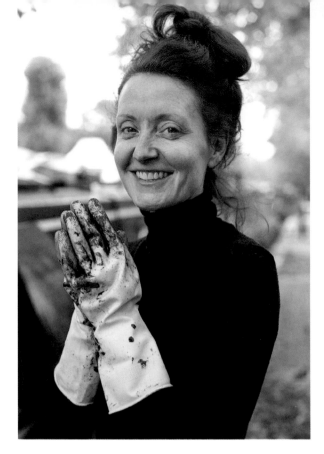

⌃ HOLLY & MANJA

H: 'We're going to see *Wicked*, the musical, again tonight and we're both really into cosplay. That's actually how we met and became friends. Basically, life's too short to worry about being judged or stared at. When you dress up, you're just putting it right out there and saying "I don't care"; you kind of feel like you've got no limitations or inhibitions. Plus, you're giving people some fun and brightening up their day.'

M: 'For me it's more personal. I grew up with a skin condition so I always stuck out anyway. I said to Holly just this morning, I actually feel most myself when I'm like this, which is weird.'

ST JAMES'S PARK

⌃ **SHELI:** 'This is the first boat, and home, I've ever owned. I've taken to it like a duck to water – excuse the pun. It's a floating palace and I wake up grateful every day. I just love the simplicity of it, and I feel completely expanded and completely free. It's magical.

'I find I haven't been wearing make-up at all on the boat, not even mascara, even though I've always worn mascara because I've got blonde eyelashes. And it's giving me a lovely balance, because my job is very hashtag glamorous – lots of false eyelashes, coiffured hair, spangles and expectations. It's showbiz, you've got to be glitzy. But here I'm literally living in nature and being natural, embracing my natural self. However I look when I get out of bed in the morning, that's my perfection, rather than anything that might be projected onto me – what or how or who I should be.'

LITTLE VENICE

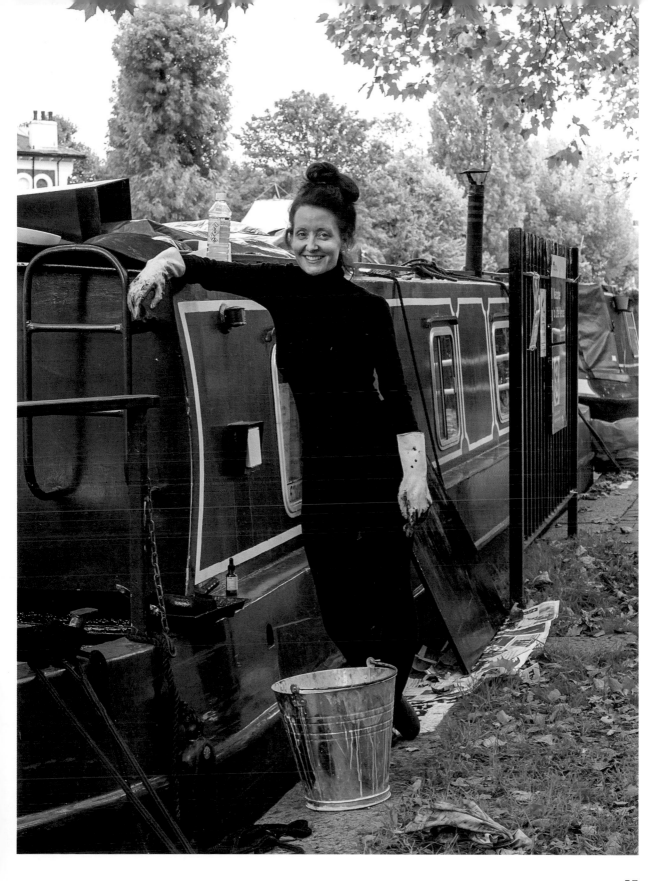

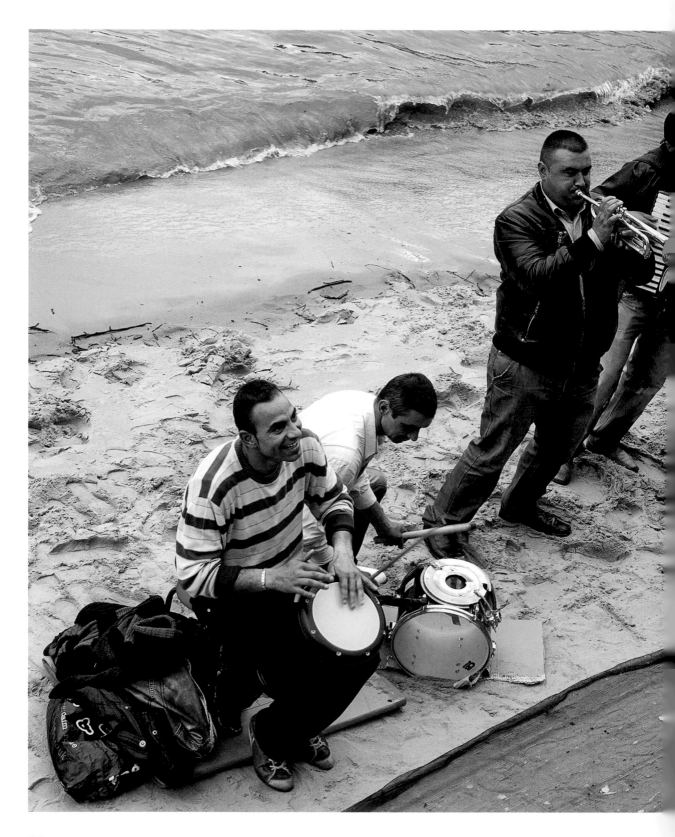

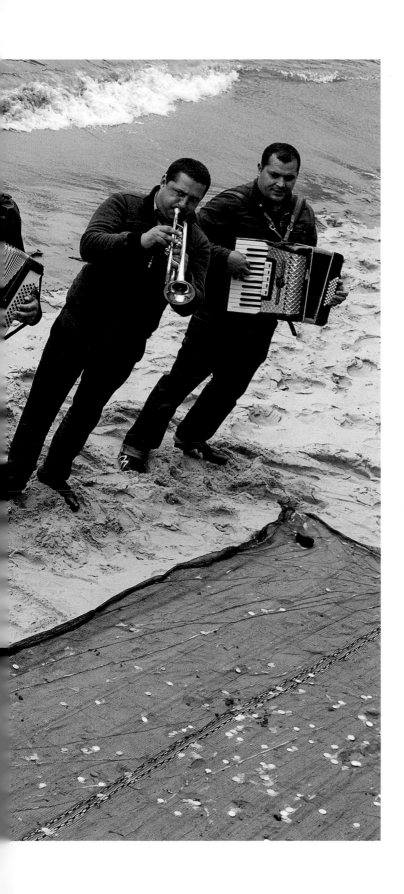

Hope they know that the
Thames is tidal

SOUTH BANK

➤ NICKI & MILO

N: 'Before I had him I worked in medical research, running clinical trials on HIV, and you think, "God – I used to host enormous meetings and run complicated studies and think about complicated things. How can this be that hard?" But it really is. It's a big adjustment to spend all your time thinking about things that are so mundane.

'I know deep down I love him, but I don't like him a lot of the time, which is hard. The way it is in films, the way they tell you it's going to be, is, "Oh, you're so beautiful!", but I spend a lot of time thinking, "What's wrong with you? Is this normal? I don't understand what you need!"

'He's started to smile in the past week, which really helps. Before that, you're just a milk slave. You are. You feed, they sleep, they cry, they poo, then the cycle goes again. People kept saying to me, "It'll get better at six weeks," and I was really clinging onto that. Luckily they were right, it really did.'

SYDENHAM

56

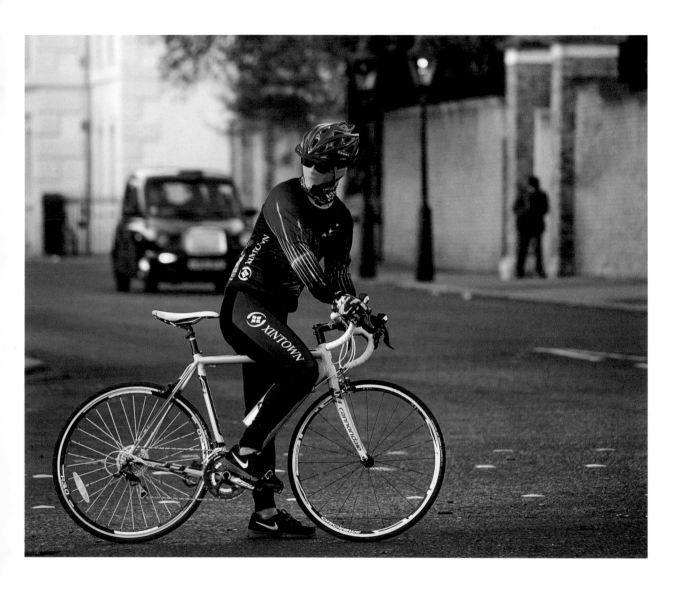

The aliens have landed

PALL MALL

JACOB & LEE

J: 'It's called humanity, isn't it? We need more of that, every day. It's the one thing that keeps you human. If you lose that, then what's left of you? You're just another corporate suit, another cog in the wheel. I'm only twenty and I've been through so much – right now I'm fighting to stop the council evicting me from my home because my mum died on New Year's Eve and the tenancy was in her name. But whatever troubles or stresses you're going through, if

there's a little old lady you don't know who needs help getting down the stairs, then you blooming help her! To keep your humanity, say hello, smile, help other people, that's what it's all about at the end of the day.

'This is my stepdad, Lee. He and my mum got together nine years ago. Before that it had just been me and her. The doctors had told her she couldn't have children after she'd been horribly abused as a child, so she always said I was a miracle baby for her – the best gift that she could ever be given. She was always a loving, caring person, with a childlike energy field. It always felt calm and happy to be around her. But because she'd been through hell and back a dozen times, she used to party a lot. When she turned to drugs I was sent up North, to Preston, to live with my auntie.

'We started having more contact again when I was seventeen and started living on my own, and then, last May, I dropped out of university so I could come down and look after her, because she was very unwell. Now I'm so glad that I found my way back to her then, because she died on 31 January of this year. She was only forty-three.'

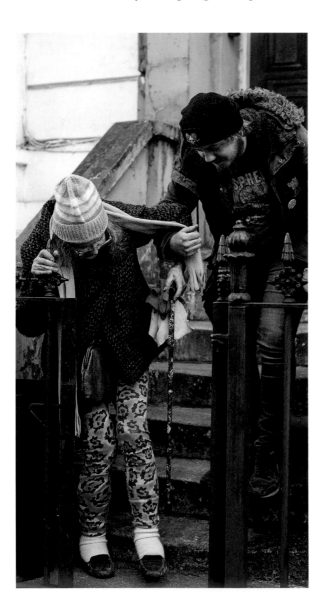

L: 'Jacob's mum showed me a different way. She literally brought more sunshine into my life. She's the only person I've ever met who could tame me, literally, and keep me straight, keep me upright. She just had this way about her. I wanted to look after her as well, so we had this great little partnership where we helped each other out. It doesn't seem real. If I didn't have Jake, if I didn't need to be strong for him, I think I would have teetered over the edge, slipped back to where I was before I met her. Now we're being strong for each other.'

ISLINGTON

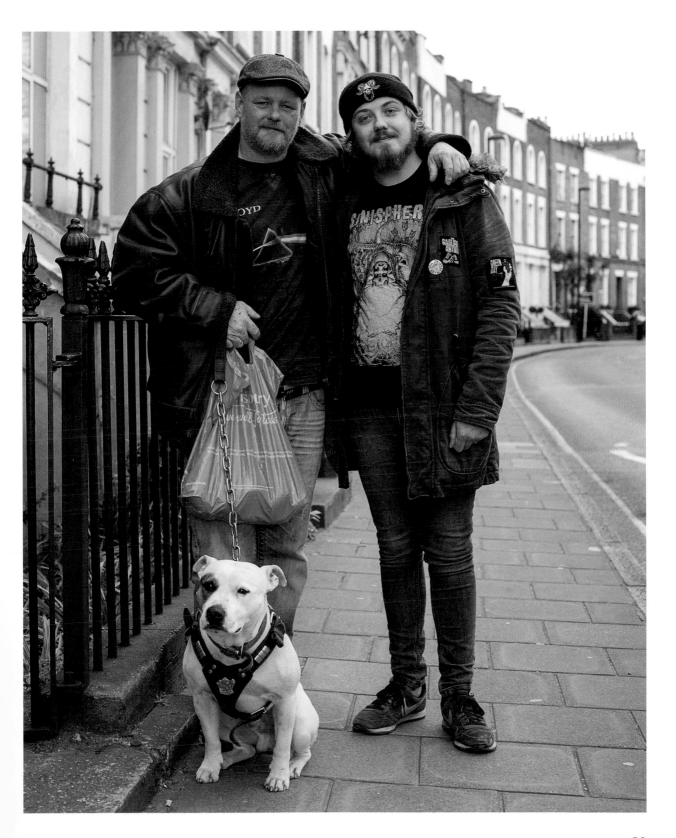

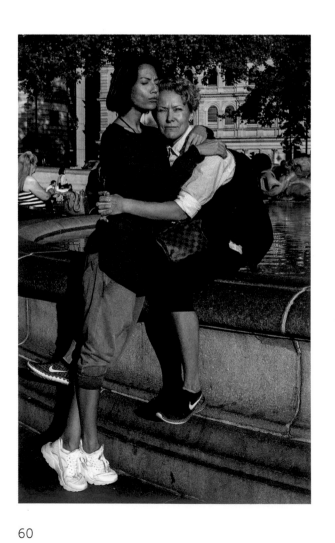
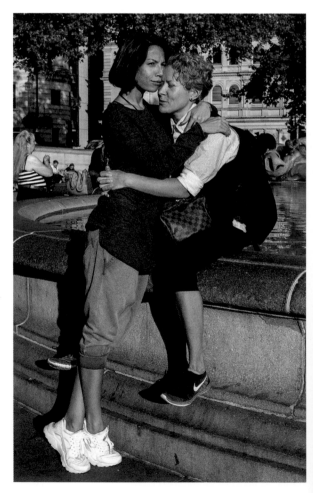

KRISTINA & ANNA

A: 'We're planning to get married next year and have kids, one each, and we'll carry on living in London because there's more freedom here for the way you feel, to express yourself. The whole world should be like that. Maybe in the future. You're the most advanced country in the world in that way, I'd say.'

TRAFALGAR SQUARE

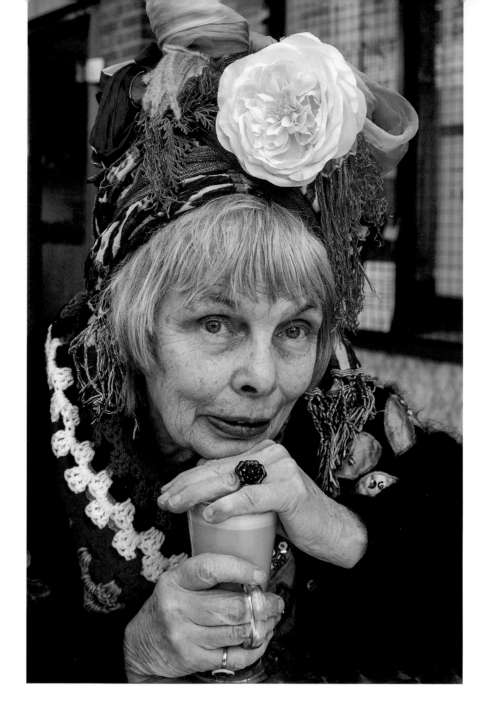

⋀ RAGA: 'I'm always dressed this way. People don't realize how much wearing colours lightens things up! I want people to feel able to approach me, to lose their inhibitions and know that they're likely to have a fun conversation, a communion, with me. And people do approach me, just like you did today, all the time. All ages, all genders. And they'll often say, "Oh, I feel so much better for having talked to you!"'

BOROUGH

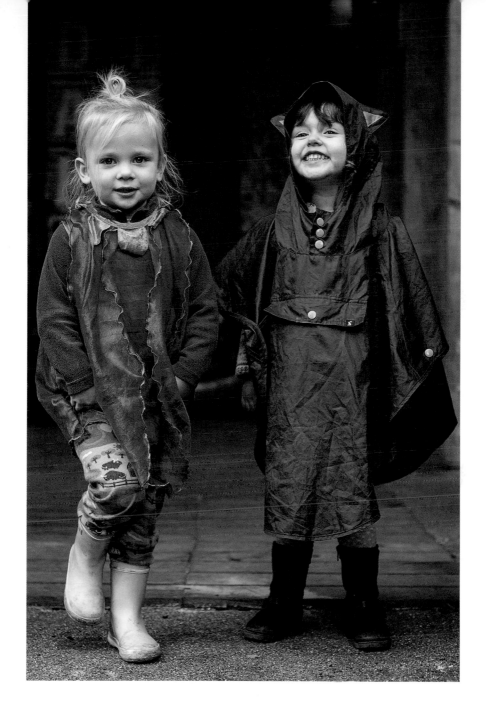

⌃ STELLA & LYRA

'They're both almost three, very funny and best friends, and they call this space the Kitty Kat Garden because they always like coming here to find the cat.'

Met with their nanny, Laura
DALSTON EASTERN CURVE GARDEN

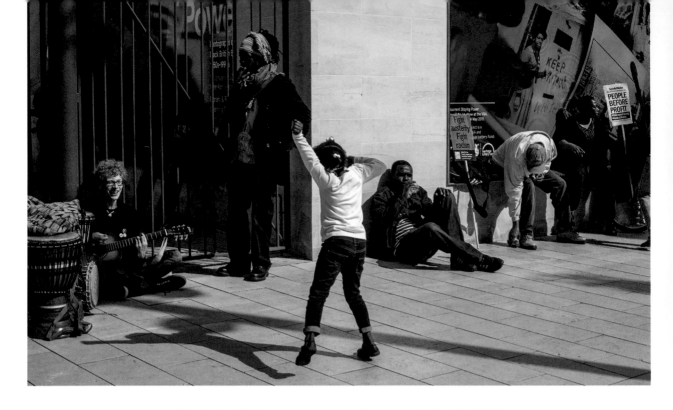

Reclaim Brixton community event, April 2015

WINDRUSH SQUARE

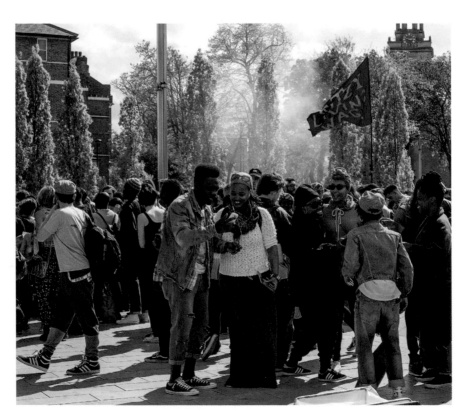

> **JOSÉ:** 'The redevelopment programme for the whole of the centre of Brixton threatens all the shops and cafés that have already been here – under these arches – for decades. Each of them is like a little community centre where different circles intersect and interact, and everyone just gets on with each other.

'It does feel as if they're killing off the whole community and the reason why Brixton is Brixton. No one here is talking about preserving the place in aspic and not allowing anything to change, but this just feels like an amputation.

'So we've got a campaign going called Brixton Community United and it's been really nice to see so many people pitching in and saying "Here's my business card, I'm a web designer, I work for the BBC." It's really encouraging that we've now got this massive pool of resources at our disposal, and we're starting to join up with other campaigning groups under the banner of "Reclaim Brixton". Together we can only be stronger.'

In his Continental Delicatessen,
which has since had to close down
BRIXTON

> **JO:** 'I think it's terrible what's going on in Brixton. Those small shops are the pillar of the local community and all of a sudden it's all about profit, and they're being closed down. The people running things don't care about the community any more. This is what I see happening all over London. Its individuality is just being eroded, stripped away, with rents going up so much that small shops are no longer able to afford them, and they're being replaced by the same chain shops. All the creativity and character are being taken away, pushed out of the inner city, which is really sad because we all came to London because of how vibrant and multicultural and varied it was.'

Save the Brixton Arches benefit gig
BRIXTON

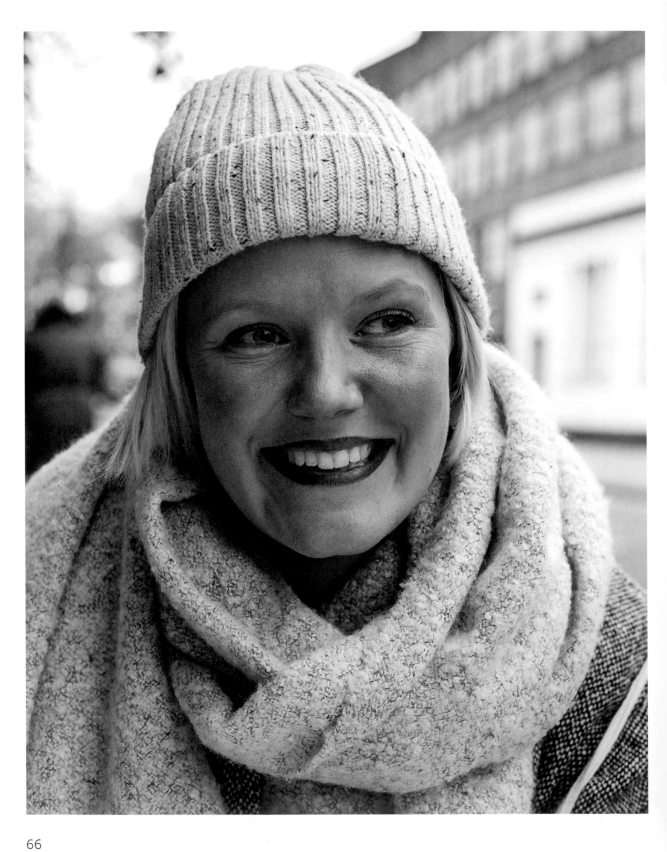

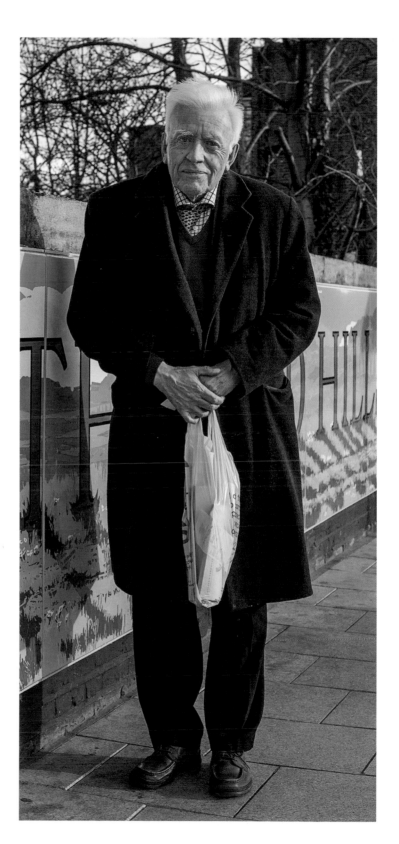

> MICHAEL: 'I'm going to a pub in Kew, which I've been going to every Tuesday for the last thirty-one years. I've only ever missed one or two when I've been ill. I've known three lots of landlords. The newest landlord, he knows how far it is from Northwood, and he tells me, "I can't believe you keep coming all this way!", and I say, "Well, I quite like coming here, it doesn't seem too bad." I don't really go out in the evenings apart from that. I don't have any family around me, I'm on my own.'

Are you lonely?

'Hahahahaha! No, I'm used to it. Now my bus is coming. All the very best to you, it's very nice of you to do that. Thank you.'

NORTHWOOD HILLS

< CHRISTINA: 'In Denmark it's much easier to be young and to feel younger for longer, because you get paid to study, so there aren't that many worries. Now I'm thirty-two and my boyfriend is eight years younger than me.'

FOREST HILL

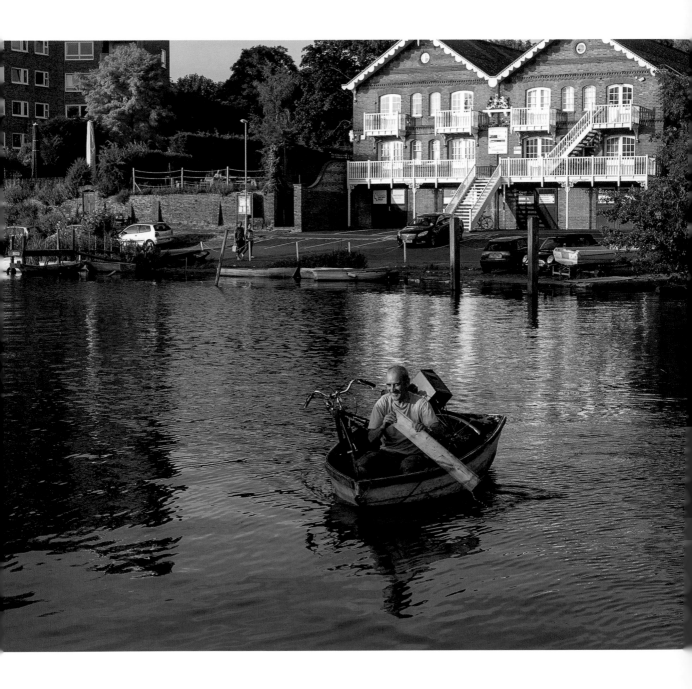

∧ HAM: 'The thing I love most about boat living is the people – they're so friendly, they're real people. You know Martin, he's one of my best buddies, and it's people like him, he's always there and he'll help you out at the drop of a hat. He's just a really decent guy. It's nice to have friends like that. My tender sank last time we had the floods here, and the very next day there were six guys helping me get it back up.'

Planking the tender out to his narrowboat
KINGSTON UPON THAMES

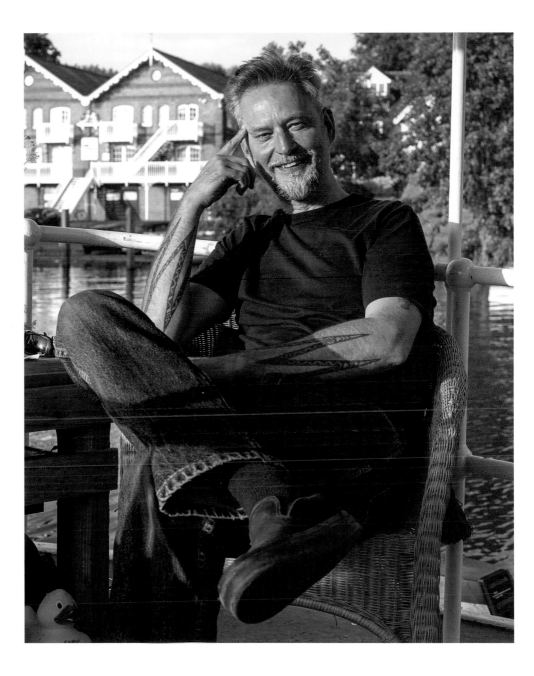

▲ **MARTIN:** 'I bought this boat with money my mother left me when she died, so I named it after her and my brother helped me fix it up. It was pretty much a shell with an engine when I got it. It feels good to be more self-sufficient – you tend to fix things that go wrong yourself, and you enjoy things more when you've made some effort and feel you deserve them. You really get to see the seasons passing here too. I can see myself doing this for a long time.'

KINGSTON UPON THAMES

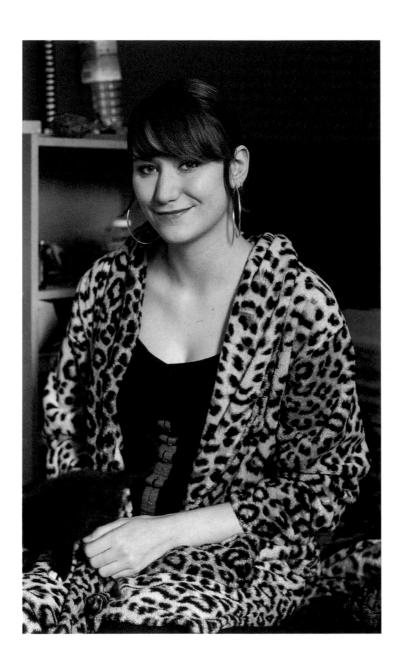

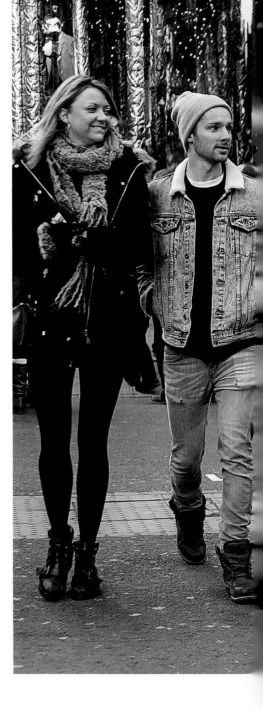

⋀ MORWENNA: 'I've had five litters so far, thirteen kittens, and I got them all good homes, most of them in the countryside. I've always loved cats. They're more aloof and independent than dogs, but they can be quite psychic too – they know when you're upset and they'll come and give you a cuddle, wrap their paws right round your neck and give you some fluffy love.'

BOROUGH

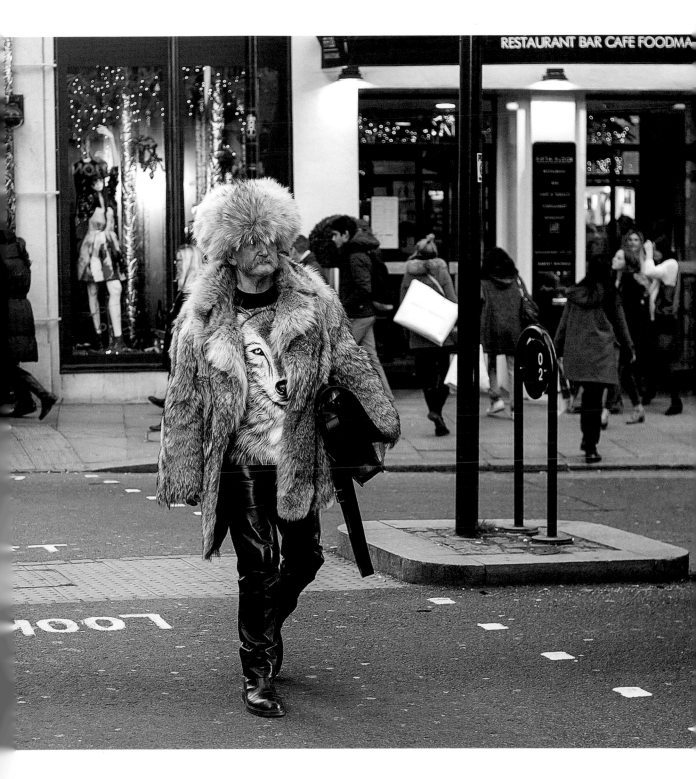

Feeling groovy
KNIGHTSBRIDGE

KAYSHA: 'I really want to write my own roles and make my own work, because then you're not sitting around waiting for someone to let you be an artist. You're creating your own opportunities.'

BRIXTON

MIM: 'When I was forty-eight, I discovered I had EDS – Ehlers-Danlos Syndrome. It was a very emotional experience, but a relief, because I'd always felt very fragile – I'd bruise easy and everything would always hurt. It's always been easier for me to swim, cycle and dance than it is to walk, so I've made dancing my life.'

SHEPHERD'S BUSH

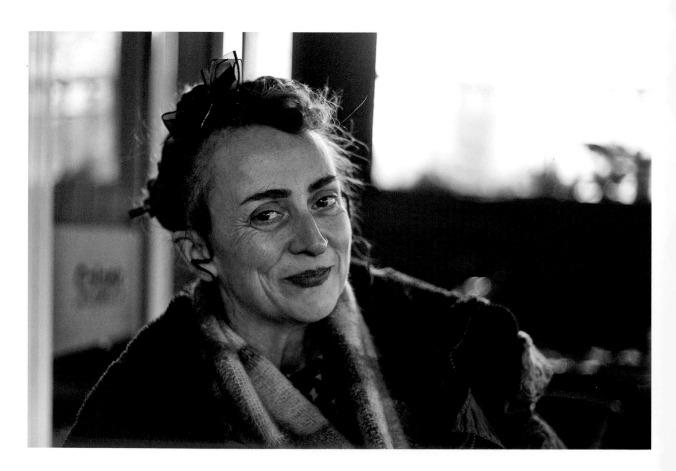

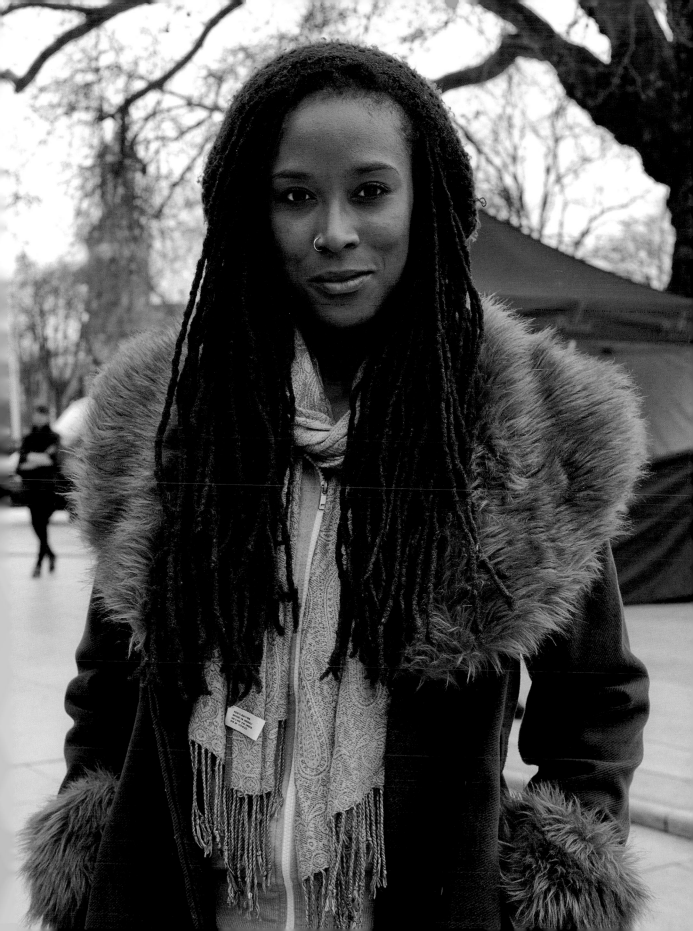

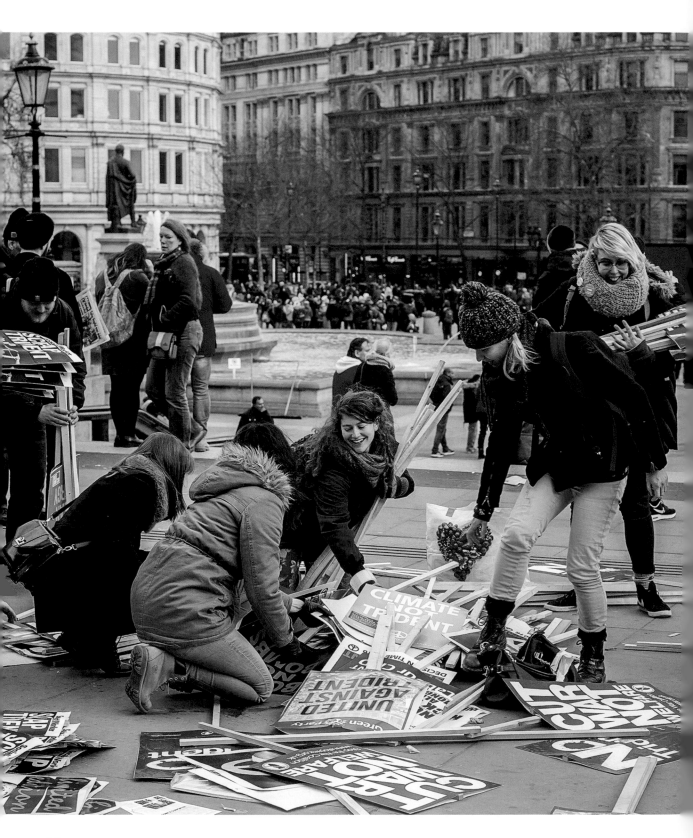

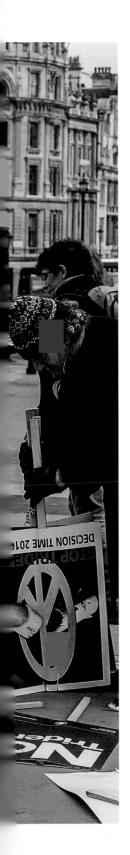

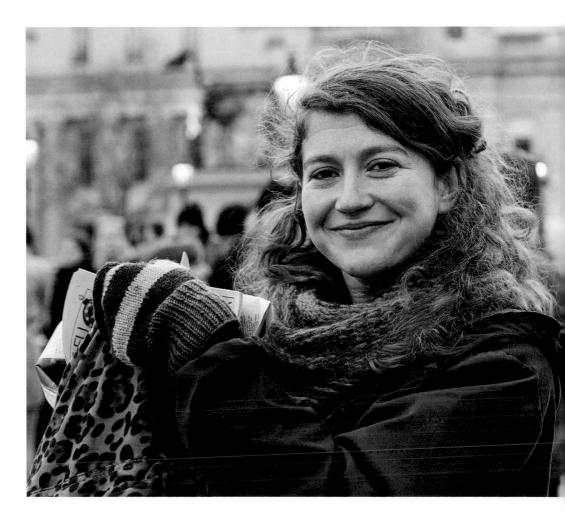

EMMA: 'It was a great demonstration, with at least 10,000 people, maybe more. It shows that people are really feeling confident about standing up and doing something about this issue.

'I've lived here for ten years. I grew up in Minnesota in the States. Now I'm a primary school teacher, and I'm also a massive fan of the NHS and free healthcare here. Take it from an American: making everything private doesn't make life any easier or better for people, it actually does the opposite!

'While the NHS, the welfare state, education, everything is being dismantled and privatized in the name of "austerity", how can our government justify spending hundreds of billions on weapons that are just designed to murder and terrify the rest of the world?'

Stop Trident demonstration, February 2016
TRAFALGAR SQUARE

Lost in thought
NOTTING HILL

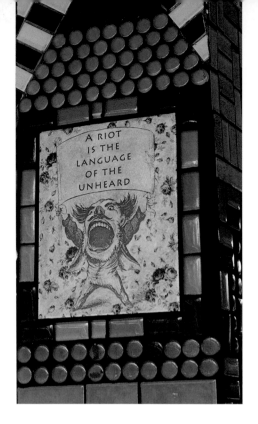

Craftivist tiles by 'renegade potter' Carrie Reichardt,
gracing the South Acton Estate

➤ **ESTELLE:** 'My sisters and I had a magical childhood. I still feel nostalgic about it. My mother was a painter and my dad was a sculptor and loved art, but he made his living doing a very difficult job as a debt collector. We had a very pretty cabin in our garden. It was our kingdom, and we were always dressing up, making fashion shows and transforming ourselves.

'In the summer of 2015, my dad committed suicide. It was so brutal, sudden and traumatizing. I had to

deal with it and move forward, but I still have such deep questions, regrets and sadness inside me. Luckily, my creativity and art give me strength. They help me let go of the tension and express myself – softly, madly, darkly, colourfully, weirdly. I feel so lucky to have this ball of creative energy inside me, and I wish so much that I'd been able to give some of this energy to my dad before he lost his taste for life. If only I'd known.'

WALTHAMSTOW

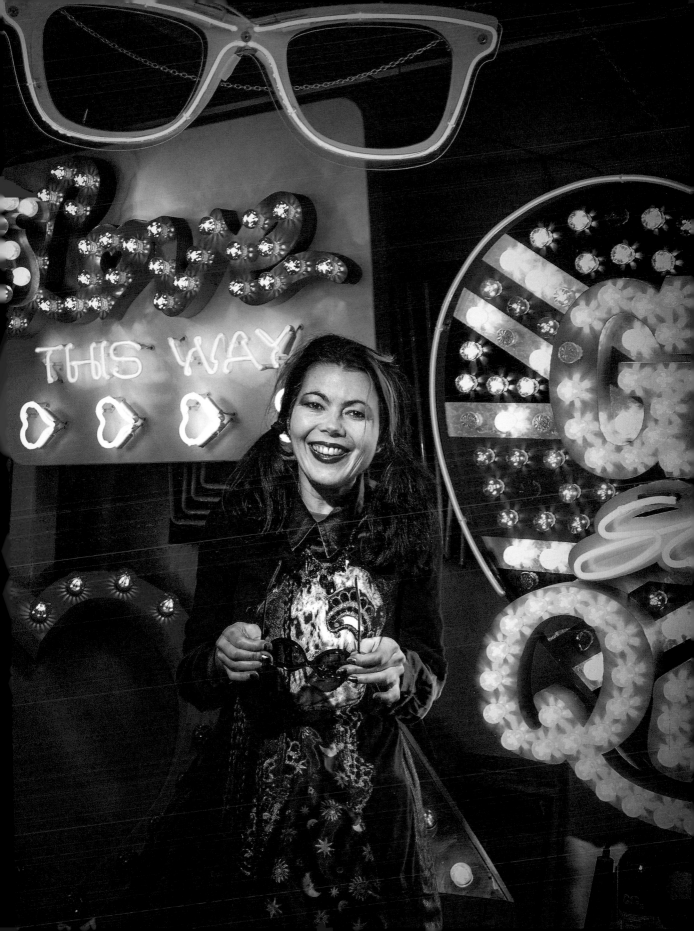

➤ **SARAH:** 'I've just finished doing a variety performance at the Hackney Empire and it was amazing, one of my best days ever! Directors are always a bit bossy – you've just got to live with that – but they shouldn't scare you because that might put you off doing it any more, and if they do you can go and tell their boss.'

HACKNEY

▼ **JOAN:** 'I'm almost ninety-two. During the war, which was awful, I worked at Bletchley Park, where the code-breakers operated. I only discovered recently that there were 4,000 of us women working there – I hadn't known that before! I'm still very acute. I'm aware of what's going on.'

BELSIZE PARK

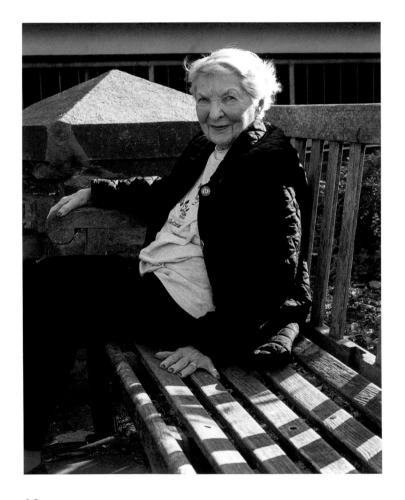

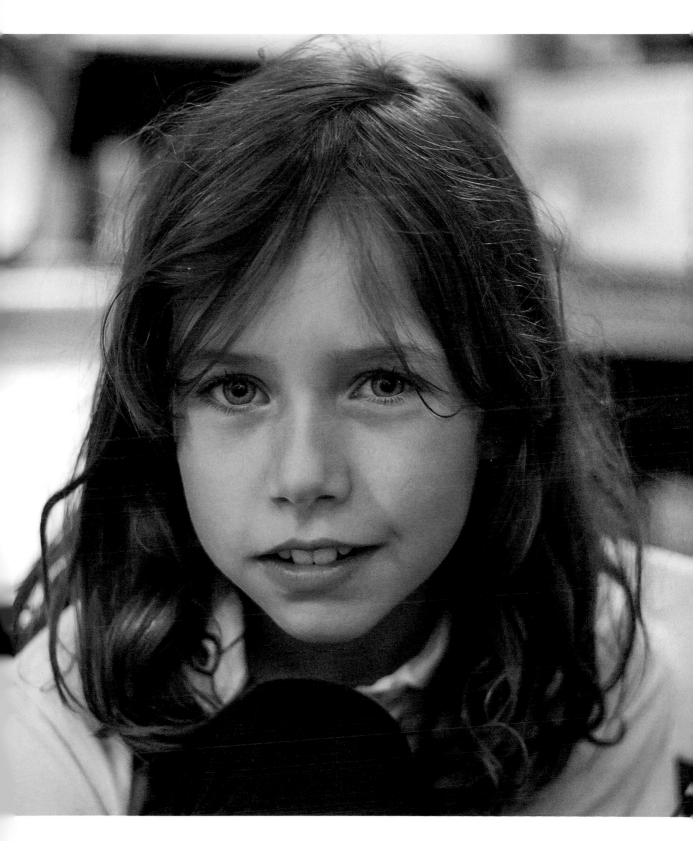

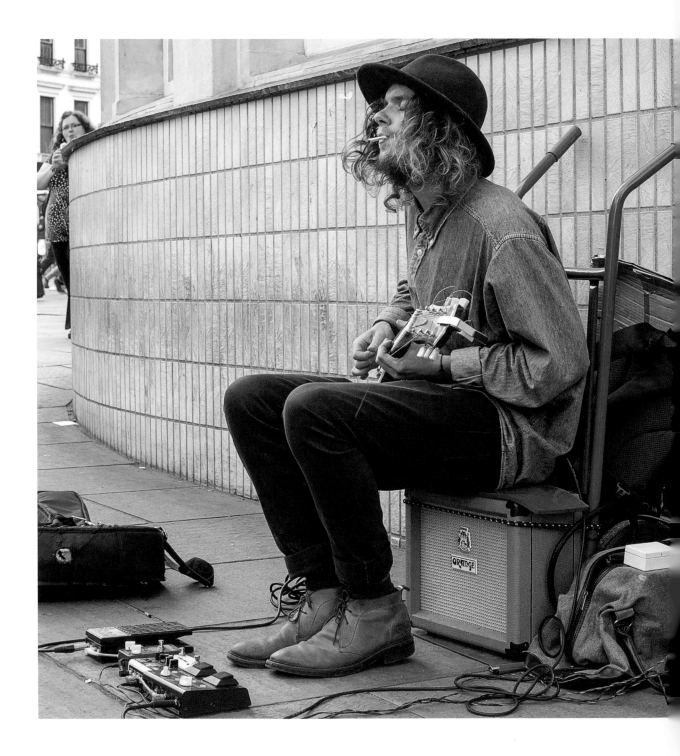

▲ **JOSEPH:** 'Making my own music makes me euphoric. I just get lost within myself.'

Creating ethereal, looped soundscapes
CAMDEN TOWN

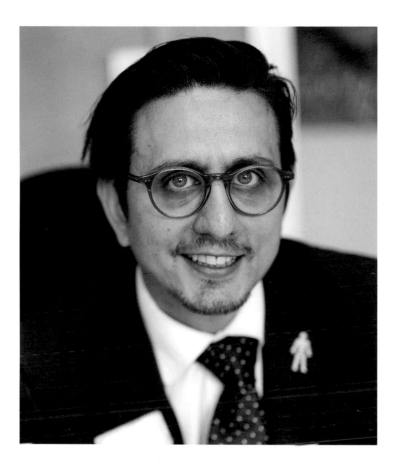

▲ **GARRY:** 'In 2000 I was diagnosed with multiple sclerosis. At first, massive denial! But then I married a woman who brought out the best in me, I surrounded myself with positive, creative people, and I studied like crazy too – self-development, how the mind works, neuro-linguistic programming, how sales work.

'In the last sixteen years, I've only had one day off sick. You have to reach down somewhere really deep inside and keep insulating yourself with a positive mental attitude. Now I'm forty-two, I have four children and two businesses that I'm really proud of; I'm an author, a public speaker, a school governor and I run networking meetings too. I'm also the chair of the MS Society for Barnet and Hertfordshire because I really want to show others that, even with multiple sclerosis, you can still lead a fulfilling life. I'm just determined not to let it beat me.'

ENFIELD TOWN

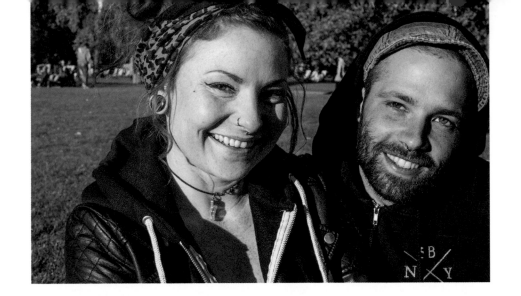

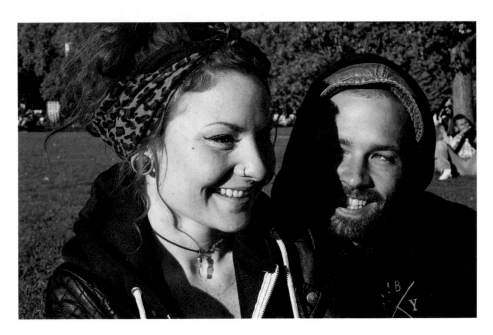

One man and his parrots

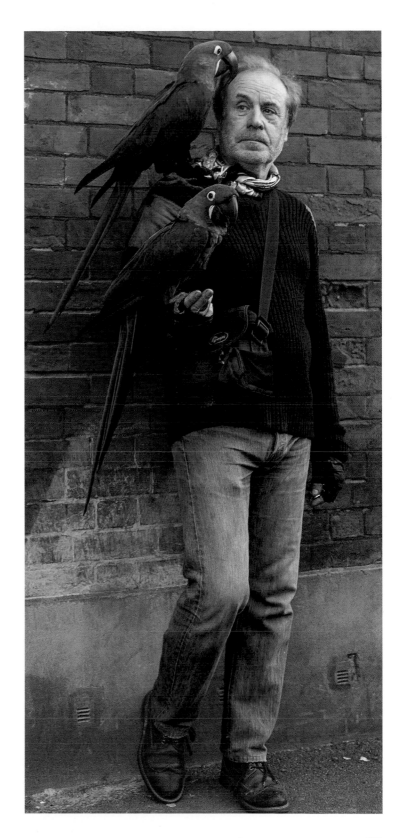

◄ **SAM & BARNI**

B: 'I just think she's amazing. I really like that she does weird stuff too – like her taxidermy. She's going to teach me some while I'm here. I will do a mouse.'

GREEN PARK

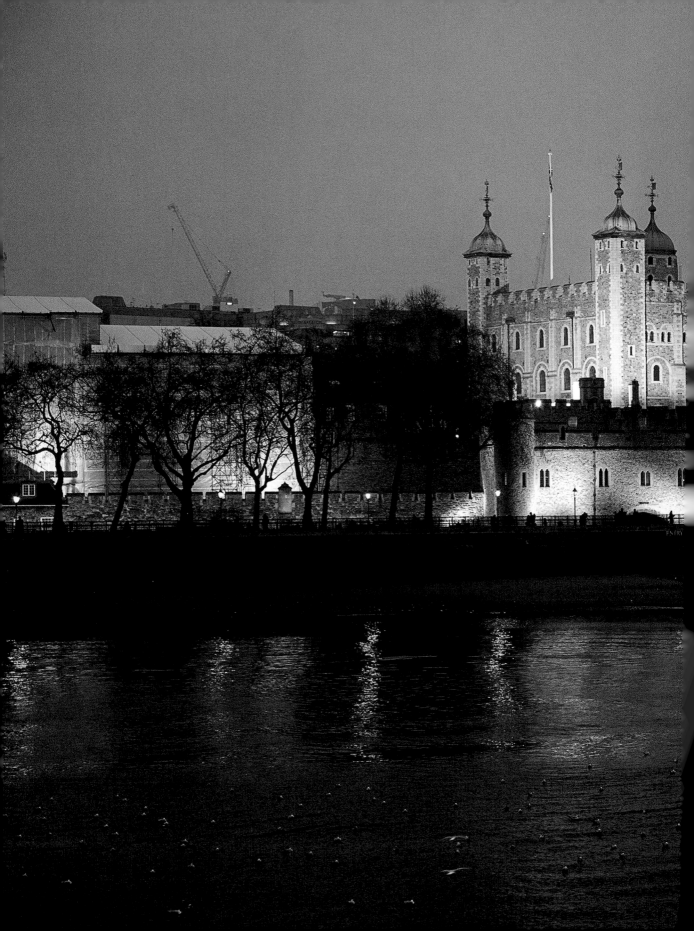

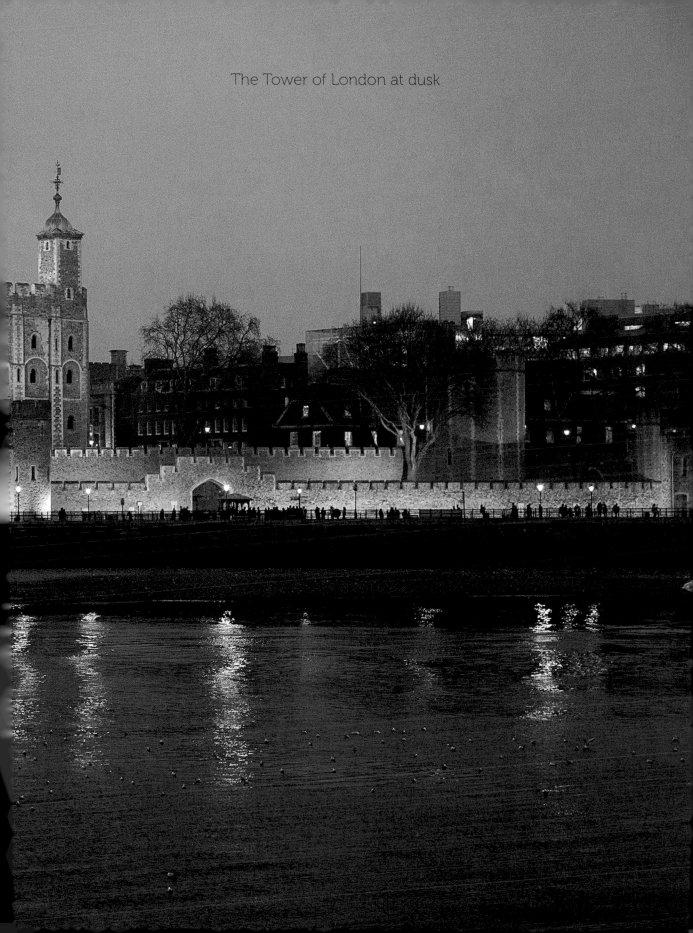
The Tower of London at dusk

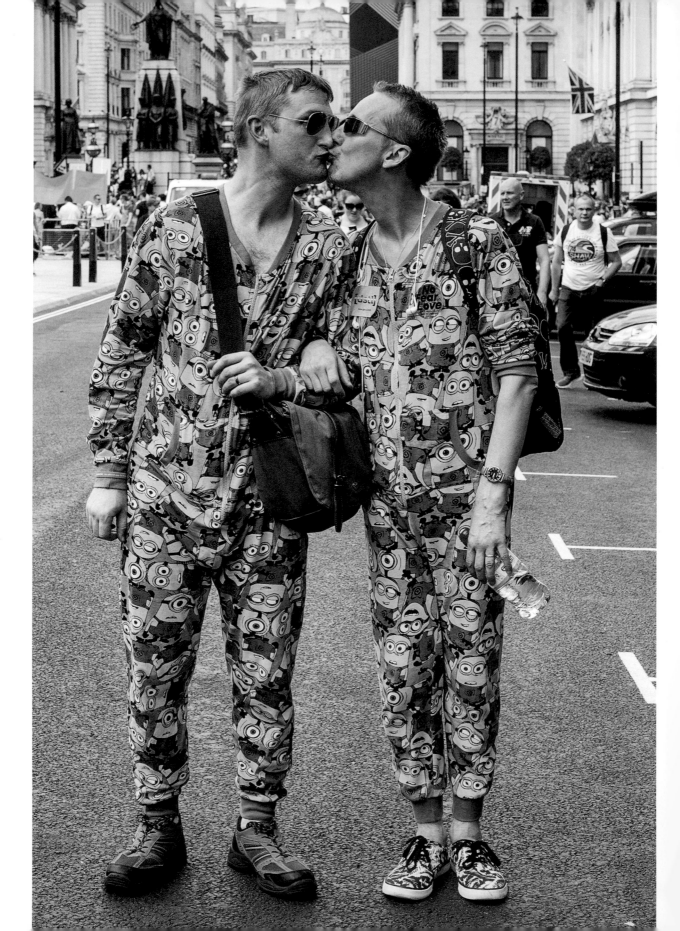

◀ IAN & JAI

J: 'We met through Grindr, we've been together nearly six months, and now we're planning our wedding. When I'm having a bad day at work, I just look at my engagement ring, think of him and I start smiling. All my cares seem to melt away.'

Pride, June 2015
WESTMINSTER

▼ LOA

'He does a very good Darth Vader impression.'

Met with his dad
LONDON FIELDS, HACKNEY

▼ GILLY & ESME

G: 'War and violence and madness is in all of us, so we need to start with ourselves. Anger just draws more anger forth, so we all really need to stand up for peace in our own little lives. Start spreading humanity in your own community.'

Don't Bomb Syria demonstration, November 2015
WHITE HALL

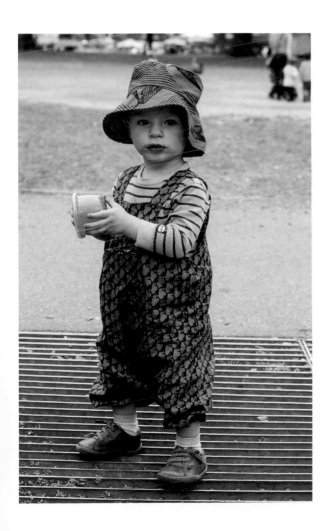

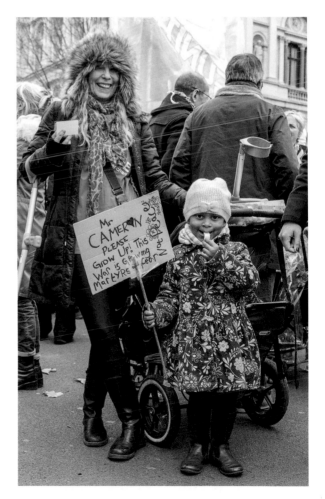

ISOBEL: 'I've got a really big bum, which is fine, I like it, but that's why I'm into retro, fifties clothes, because that was a more accommodating and supportive era for curves.

'Walking around South London, I do get my bum slapped, or groped, a lot, by complete strangers. What could possibly make men think they have that right? So when we had to pick a social issue as part of my uni course, I chose one I felt directly affected by. My idea was that women carry this card with a telephone number on, which they could hand to any guy who was harassing them. When he rang that number there'd be an automated message encouraging him to treat women he doesn't know with more respect, to think, "What if this was my mum or my sister?" I think education really is the key – without that you're just treating the symptoms and not the cause.'

WHITE CITY

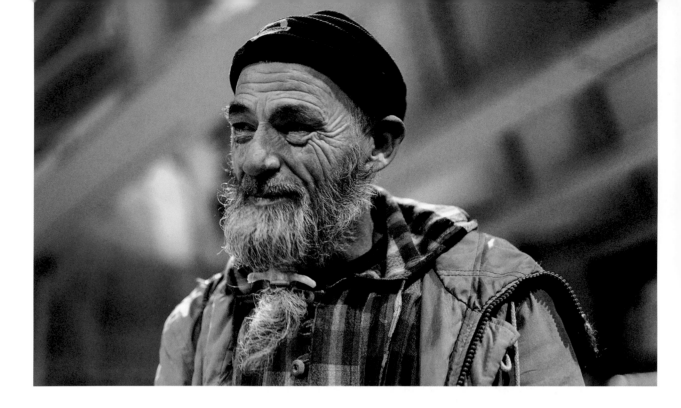

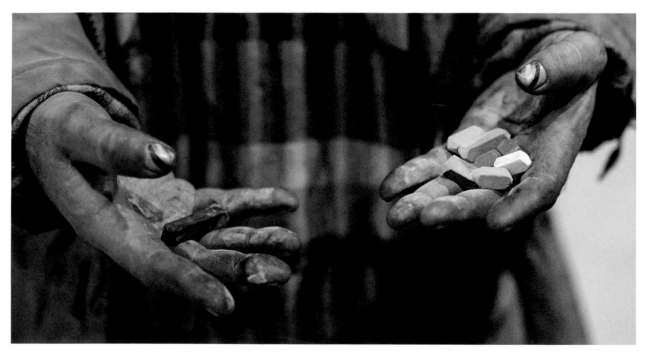

▲ **HYMN:** 'I am Hymn, The Storyteller, as I call myself today.
Let me drop a few conscious breaths into your day?'

BLACKFRIARS

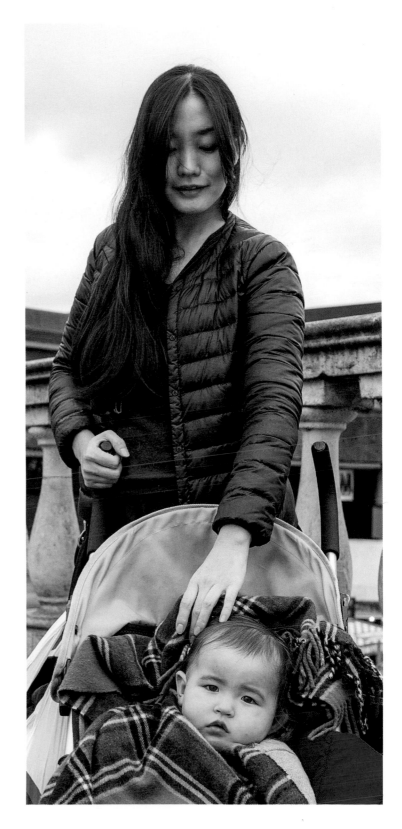

➤ SAYAKO & RIN

S: 'Once you're a mother, you will be a mother forever. Which makes me feel so much more connected to my mum because now I understand her mother's point of view, and I know I will be her child forever too.'

KINGSTON BRIDGE

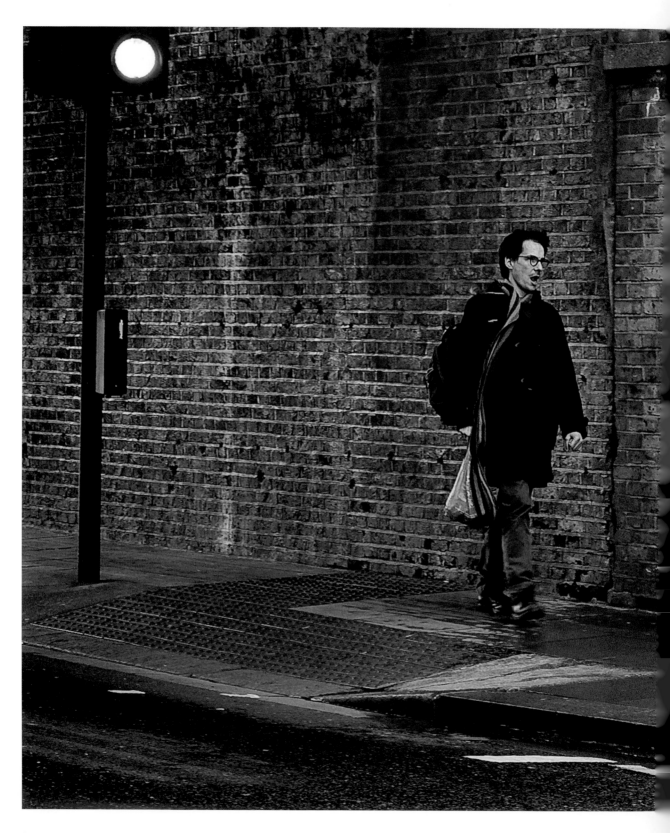

We all heard him long before we saw him, singing full-throated opera as he strolled along, making everyone smile

PARSONS GREEN

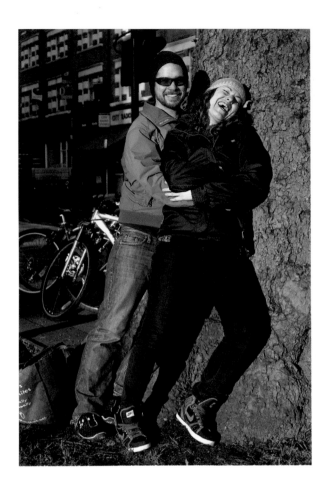

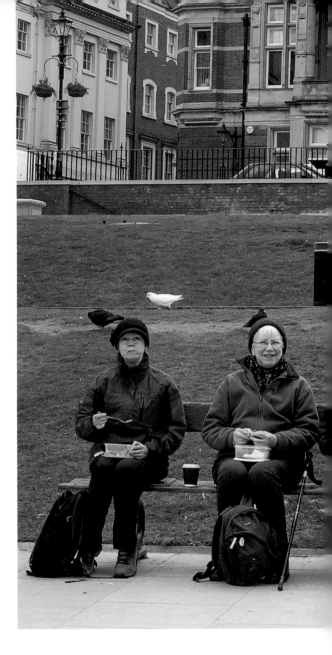

⌃ JON & JULES

Jules: 'He's vegan. I'm veggie and kind of making that next step into veganism. We're about to go off to South East Asia for six months – I'm going to study Thai massage in Chiang Mai (I can't wait, it'll be amazing), and Jon loves to surf. Other than that, we're just going to chill out, eat nice food, see some culture and enjoy the sunshine, enjoy life.'

Jon: 'When we get back, we want to buy some land and try to get off the grid. We want to grow our own fruit and vegetables, be healthy, self-sufficient, teach others, and use technology and knowledge to help the evolution towards a more sustainable future.'

EALING GREEN

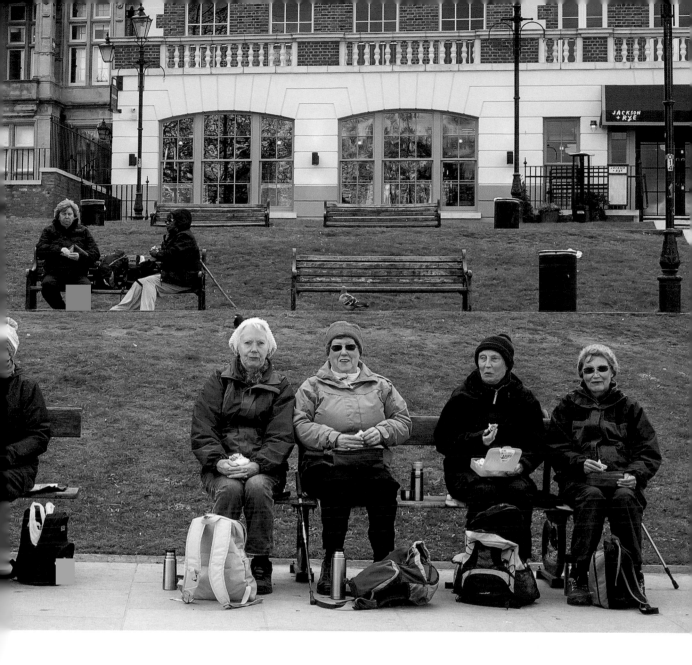

▲ THE LADIES: 'We go walking together every Thursday, usually within the Greater London area, because most of us are retired so we've got Freedom Passes. Only torrential rain will stop us – well, some of us! So we meet at an Underground station and walk for five to seven miles. We also have socials and holidays together. We haven't got a club-house. We just meet. Most of us are widows. When your husband dies, you have to get back out there, so you join this club, it just snowballs, you make lots of new friends, and the world opens up again.'

Members of the North West London Holiday Fellowship Club,
stopping for lunch beside the Thames
RICHMOND

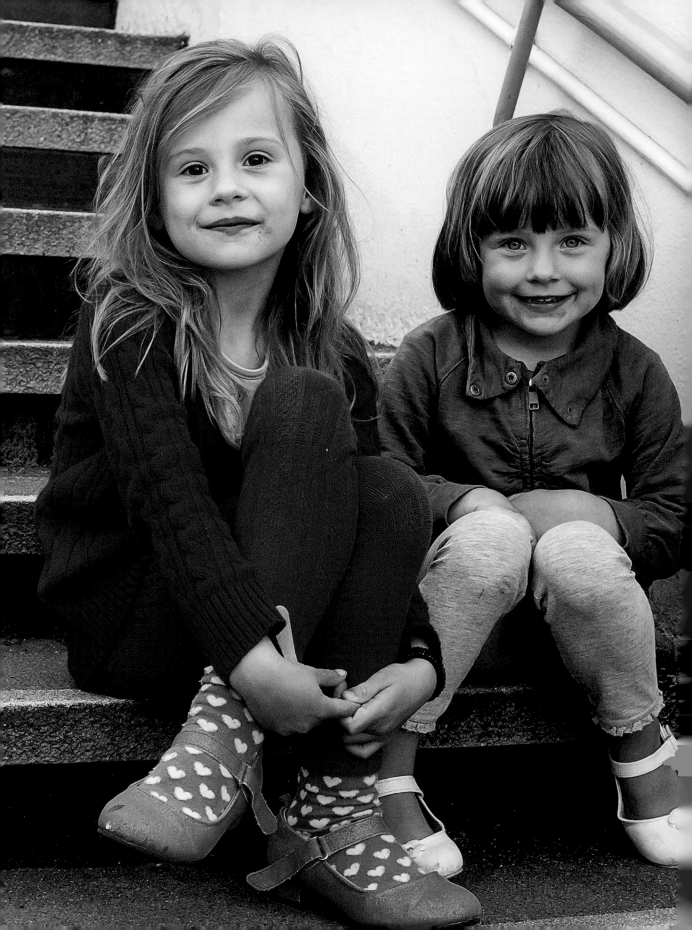

NATASHA & MIA
OK, photo with chocolate ice cream smears or without?

Both: 'With!'

Sisters Natasha and Mia, who'd been having fun sliding down the bannisters at dusk
SOUTH ACTON STATION

MUSTAFA: 'Culturally I'm a Pashtun from Waziristan, on the border between Afghanistan and Pakistan – one of the areas where the Americans are bombing all these innocent people with their drone strikes and calling it "collateral damage". Pashtuns are known for taking revenge, even if it takes a hundred years. It's part of their tradition. So the Americans are just creating more enemies and more terror. Personally, I think forgiving is good and justice should be left to God. I learnt that from reading about my religion, Islam.'

GUNNERSBURY LANE

MYLLA: 'You've caught me in a weird time. I've been spending a lot of time trying to decide what kind of woman, what kind of person I want to be. I think about the impact of everything I do – from the rubbish that I throw into the bin to the things I could do in the future to help others. I have to think about every single aspect of my life.'

VICTORIA MEMORIAL
BY BUCKINGHAM PALACE

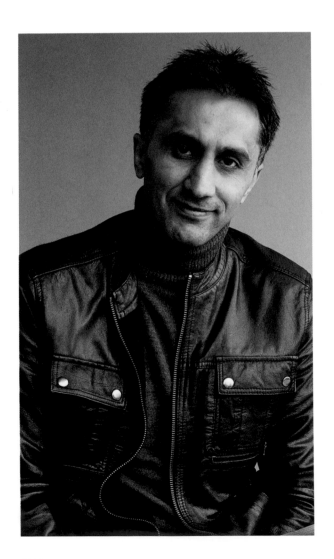

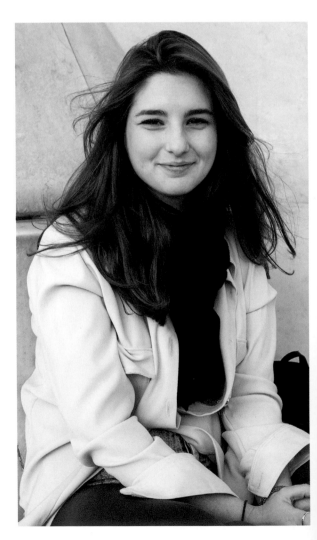

AMIN: 'I left my country, Afghanistan, in 1996, when I was around twenty-one, twenty-two, because of war. We suffer, and we have to run from Taliban to find safer place. I see so many dead bodies. I lost my cousins, my auntie, my uncle. Life, in comparison, is very easy here. I'm a happy man. I'm happy with my wife, my children, my work. I enjoy it all.'

ACTON TOWN

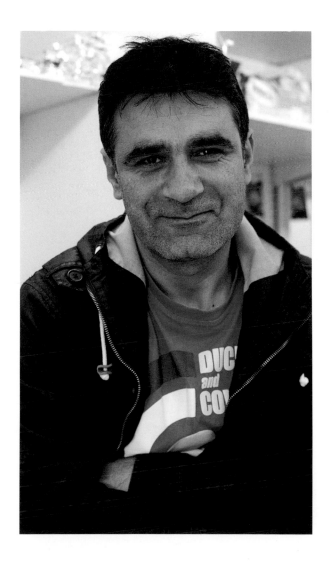

We refuse to be enemies.

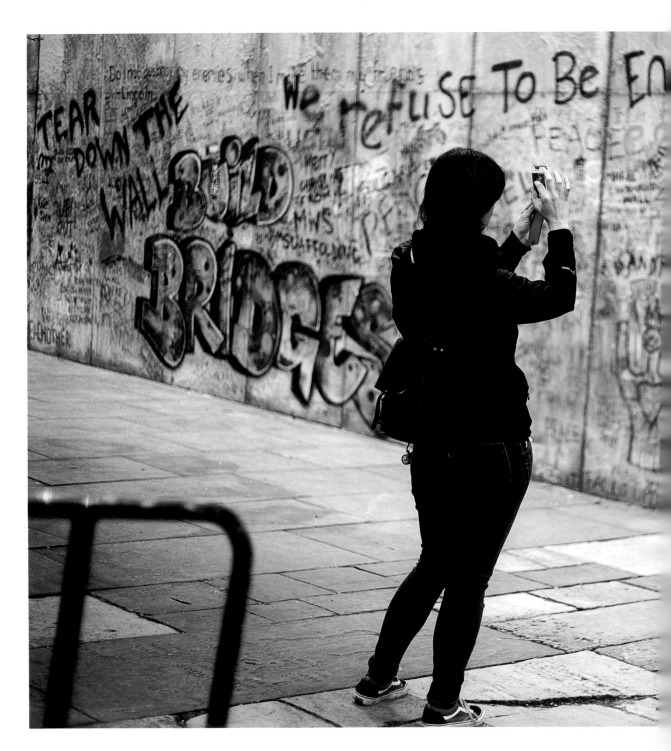

▼ ISO & JONATHAN

I: 'I'm from London, although my family's from Wales, and we're both students at the United World College in Costa Rica. UWC, as a movement, is about bringing the world together through shared education, and creating a better future with peace and understanding. Core competencies include leadership, diversity, a healthy lifestyle, sustainability and service. It lets students have a really strong impact, and every week we do CAS – Creativity Action Service – where we go out in Costa Rica and try and do things for the people there.'

J: 'I come from a little village in Denmark and at UWC I've met people from villages and cities all over the world, and I've been able to form deep, deep friendships. I often think it's as if I saw life in black and white before, and now that I see all the colours, I begin to understand.'

HAMPSTEAD HEATH STATION

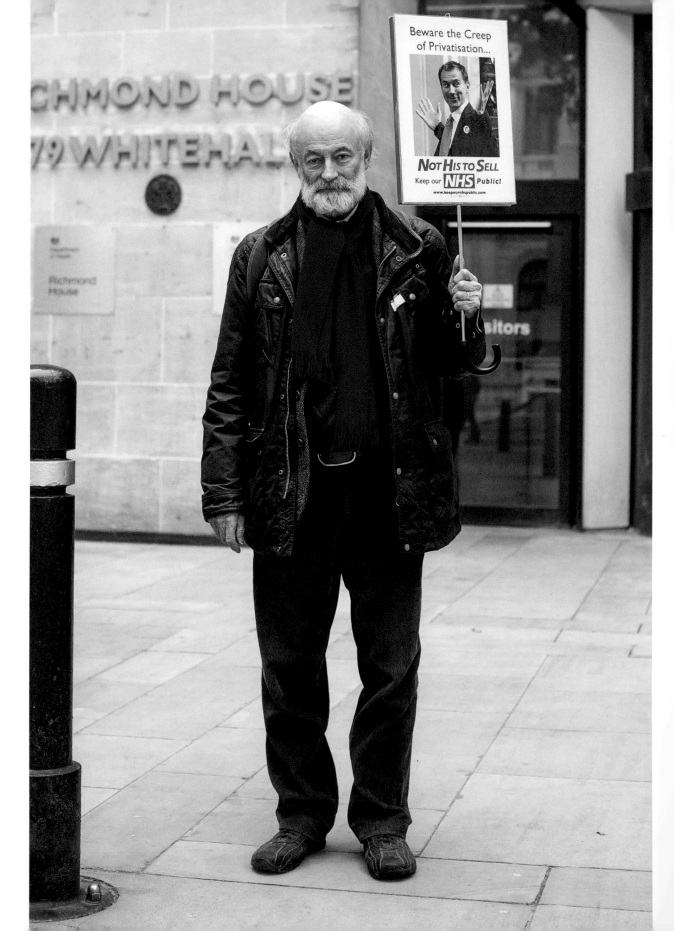

◄ **RAYMOND:** 'The NHS is a profound expression of our decent treatment of each other that is based not on a narrow contract but on a covenant between one human being and another. It was set up at a time, just after the war, when there was a lot of solidarity, and it's now being torn apart by people who understand the price of everything and the value of nothing.'

On the Junior Doctors London Protest, October 2015
WHITEHALL

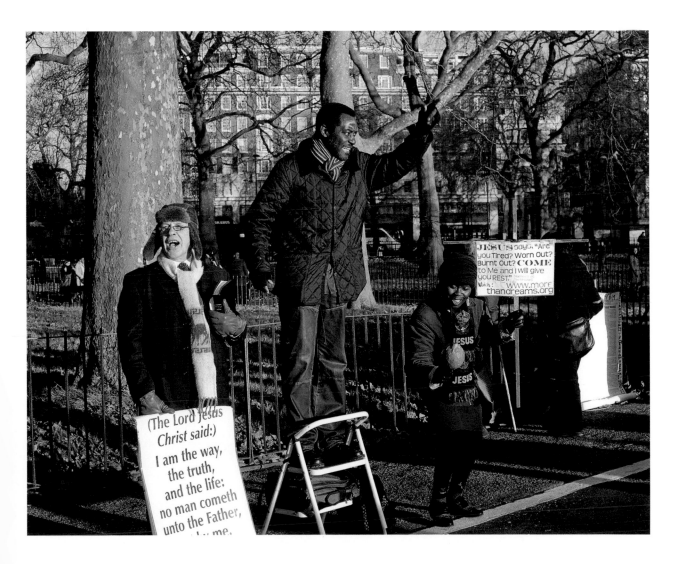

Praising the Lord at Speakers' Corner

HYDE PARK

SEBASTIAN: 'I'm a born dandy. One of my heroes is Quentin Crisp, who had lavender hair for the entire last half of his life. I reckon I was homophobic for a couple of years, just because of the novelty and because I didn't understand it. But then I met a couple of gay friends and they were clearly fine, so I got over that fairly fast. I just dismantled my homophobia and tossed it away.

'I'm also a transhumanist and believe in the abolition of non-voluntary death. I'd like to have the option to live forever. We're a tool-using species; we've always improved ourselves. I feel the narrative of religion is the descent from the vanished golden age, the world crumbling under the weight of sin, and the narrative of science is the ascending staircase, always building to greater glories upon the shoulders of giants who have gone before.'

LONDON BRIDGE

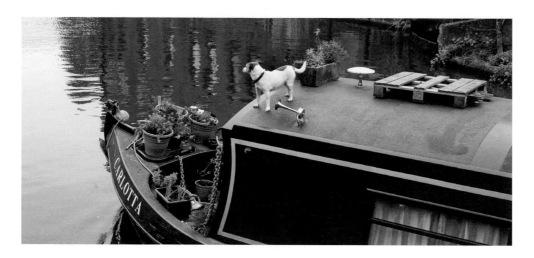

Barge pilots

CAMDEN

➤ THE RAINBOW LOOM GANG – MUSTAFA, HASSENIN, BEN & ALI: 'We've been making these rubber bracelets and necklaces for three days. It did get quite boring, but then it got exciting again when we came out here to sell them on the street and got chatting to lots of people. We're doing really well.'

What are you going to use the money for? Sweets?

'No, all of us are healthy. We don't eat sweets or drink sodas. We're going to give the money to charity – we just haven't decided which one yet.'

ACTON TOWN

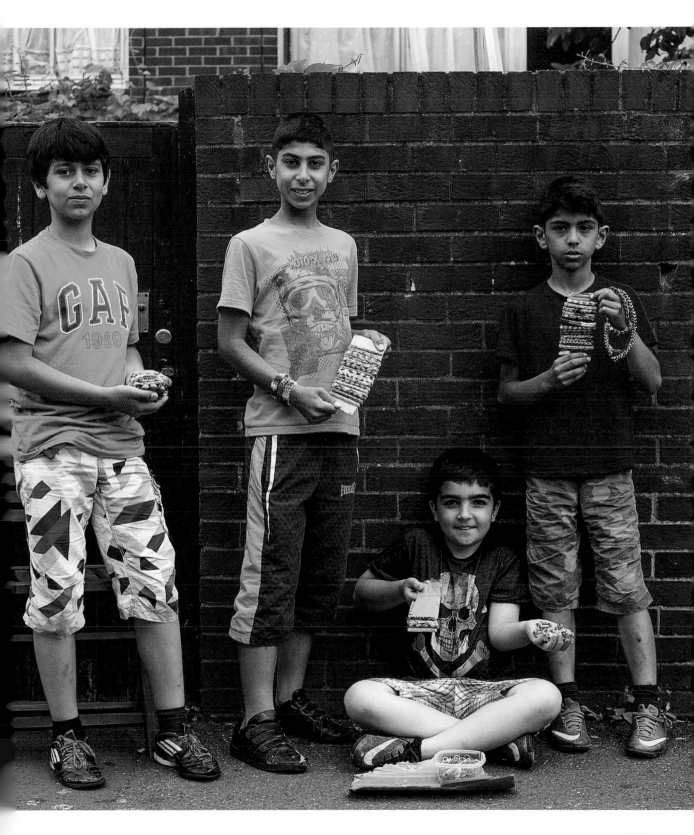

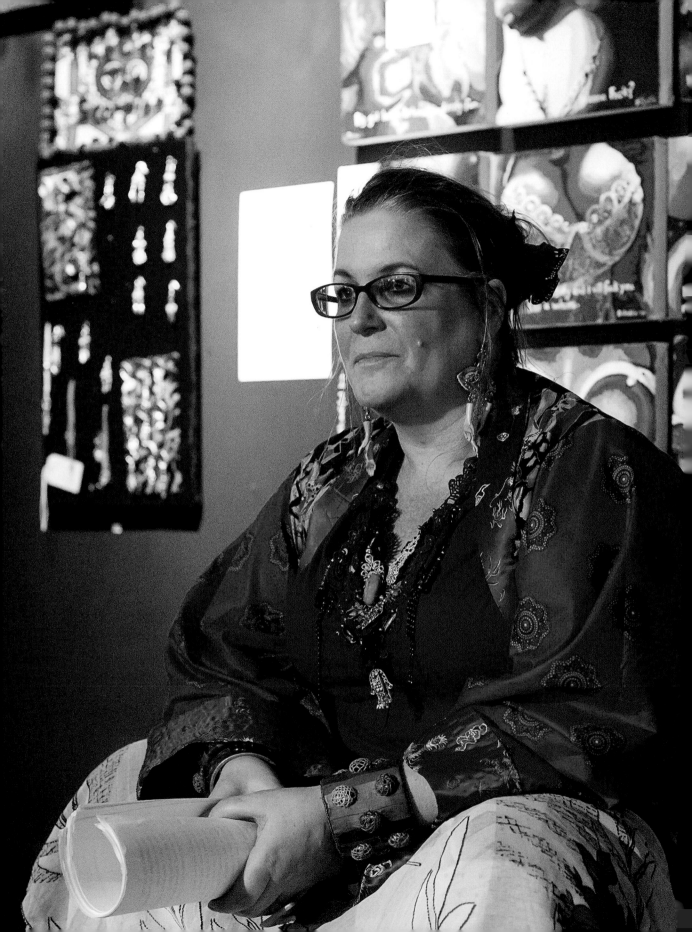

DIANE: 'You know what it is about the menopause? It kind of IS a crazy time, but your hormones are actually levelling out and, once they've levelled out, you get a mental clarity that you've never had before, which is extraordinary. So you're not actually going crazy – you're going sane!

'You also get access to rage, because you break down that conditioning that says women cannot be angry. This is why women are so depressed, generally, because we get taught that we can't express anger, so we internalize it. But once you start raging, once you start stamping your foot, then you can lift up and push through it.

'Meanwhile, men are told they're not allowed to express their emotions, which is just as bad. They're allowed to express their rage, but they're not allowed to express the kindness and gentleness and vulnerability and nurturing and empathy that we're all capable of as human beings.

Speaking at the closing night of her 'The World of Diane Goldie'
exhibition in the Vaults Gallery, Leake Street, November 2015
LAMBETH

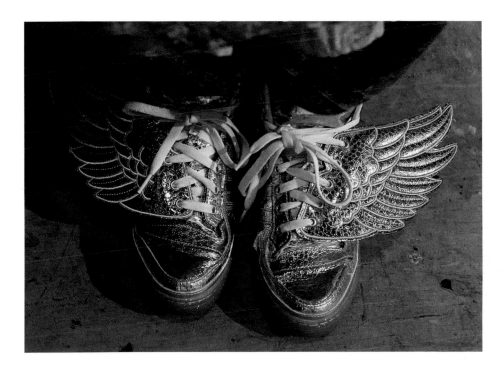

D: 'No matter what ensemble I'm wearing, these shoes always get the attention. Sadly, they're heavy (being men's) and inflexible, and they've never actually lifted me off the ground, but hey, they're beautiful.'

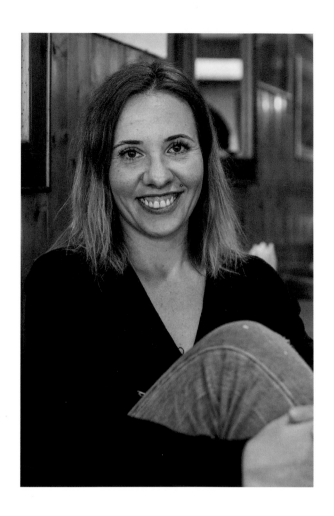

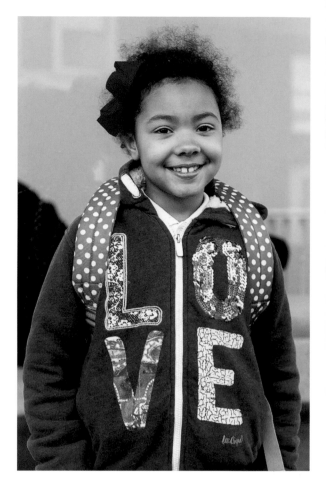

▲ DOMINIKA & LARA

D: 'It's really empowering to have got to a place where I finally feel that, as a single mother, I can be enough for my child.'

D: 'She's seven going on seventeen, and thinks she knows everything!'

L: 'I don't know what 595 thousand 284 billion divided by 9 is though!'

CHURCHFIELD ROAD

> **NEIL:** 'I grew up in Burnley, in Lancashire, which was full of big smoking chimneys, because it was a traditional Northern mill town. Looking out of our back door across the valley, everything you could see was just grey, grey, grey. Then they introduced smokeless fuel, in around 1964 or 1965, and it was as if the valley turned from monochrome to technicolour in about a week-and-a-half. All this gloom just lifted. It was transforming.

'I was a social worker for thirty-five years and overall I enjoyed it. It was never dull; no day was ever the same. I met a lot of interesting people and I've been in some very bizarre situations. Empathy is definitely one of the qualities you need, but you also need to be able to take the knocks. Once you've seen a few bruises on babies, you can start to get sucked into the sadness and it can mess with your life, so you have to learn to come home and leave it behind, which is not always easy to do. But it was good to feel you were doing something useful and making a difference to individual people's lives.'

AVENUE GARDENS

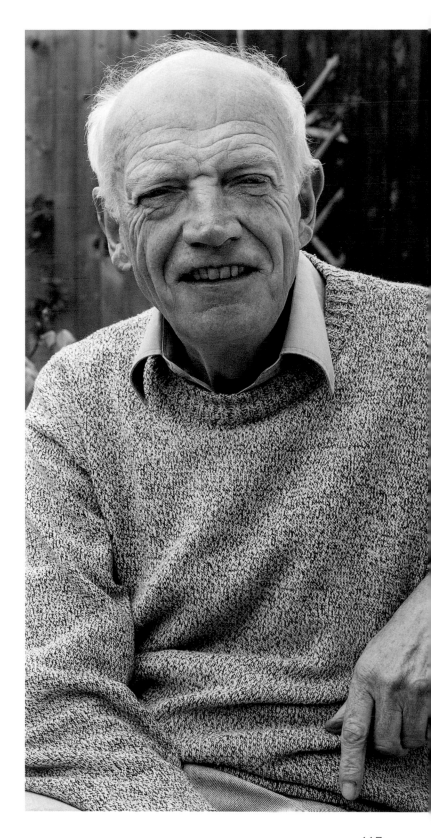

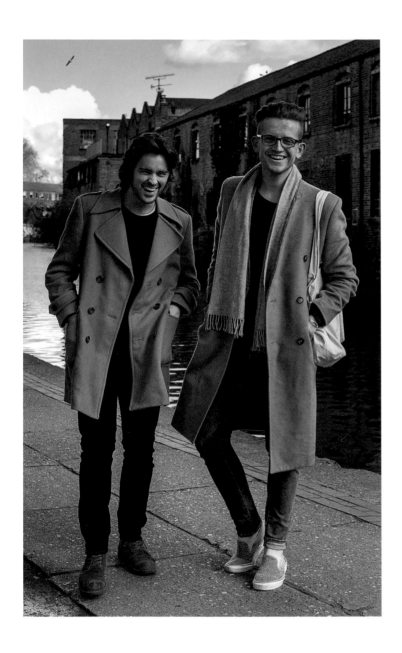

▲ GEORGE & SIDNEY

G: 'We're both actually drag queens. It's like putting on a mask and suddenly you have this confidence. There's loads of reasons for homophobia, but being scared of your own sexuality is one of the main ones, definitely.'

S: 'Everyone has problems, everyone's a minority in some way aren't they? It'll get better – it's going the right way.'

REGENT'S CANAL, CAMDEN

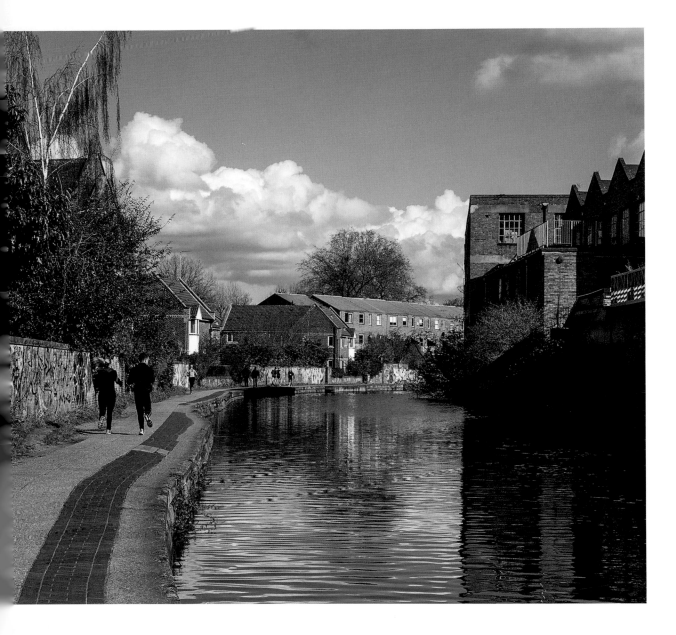

Regent's Canal

CAMDEN

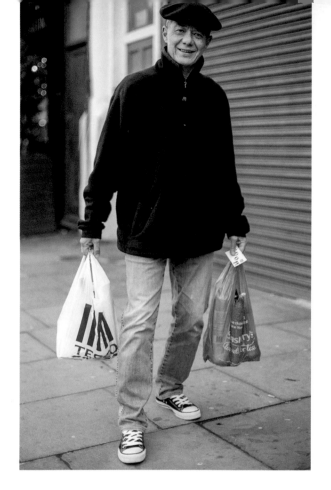
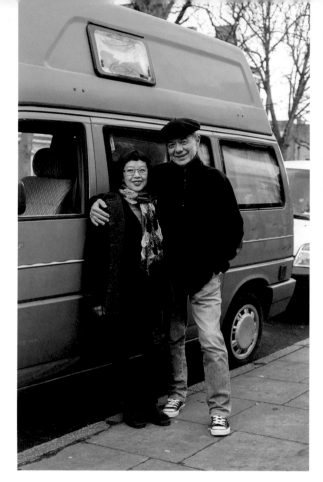

⌃ BILL & CHRIS

B: 'My wife's waiting in that green campervan over there. We're both retired now so we'll normally use the van to go walking every couple of weeks, get away from the hustle bustle of the world. We love places like Dartmoor and the Lake District. No people, just sheep, green, mountains, trees, and when she wants to stop and paint the view, I'll happily read. It makes you realize that there's still lots of bits of the world left where there's peace, happiness, beauty, and it's all free of charge. All you need is a backpack and some sandwiches and a nice bottle of wine!

'We've been together forty years and I think the thing I love most is that we always forgive each other after arguments.'

C: 'And we argue a lot – even though he's a good guy, he's got a good heart, and we've always felt very comfortable with each other. We'd rather not argue, but we're human beings. It's good to talk and express your opinion. I think we agree on the majorly important things – being good to each other, being good to other people, being compassionate, knowing how lucky we are and so giving to others whenever and wherever we can.'

CROUCH HILL

Please hold – your call is very important to us

KNIGHTSBRIDGE

▲ LOLA: 'This is my best friend, Pupa, my baby. She talks to me a lot.'

CANNING TOWN

➤ POLLY: 'Having Roz relaxes me, she's just such a calm, friendly person – I mean dog! When no one else is working for me, no one's saying the right things, she's there.'

ACTON PARK

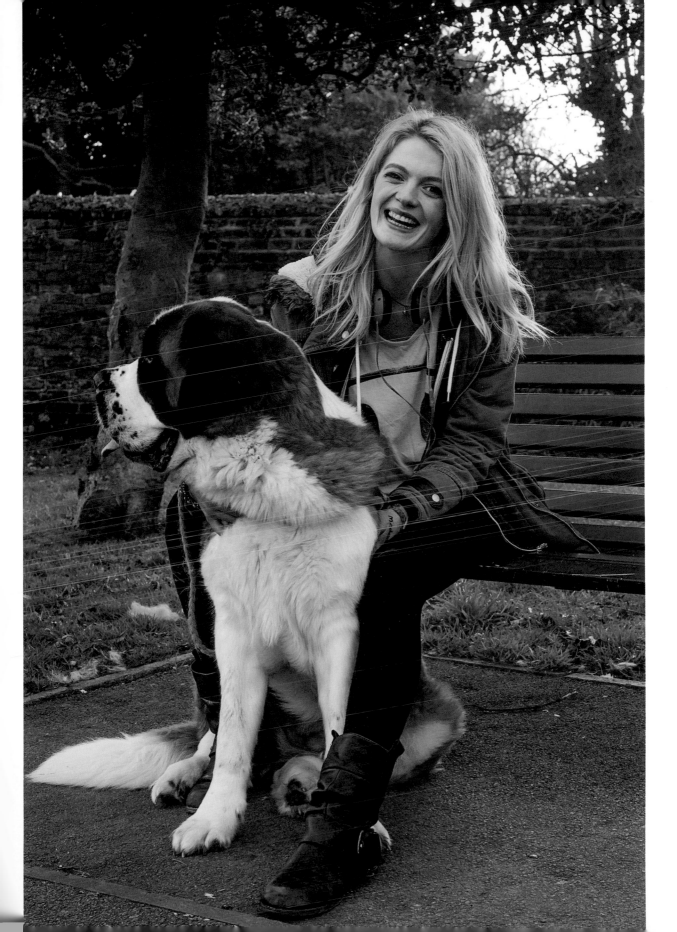

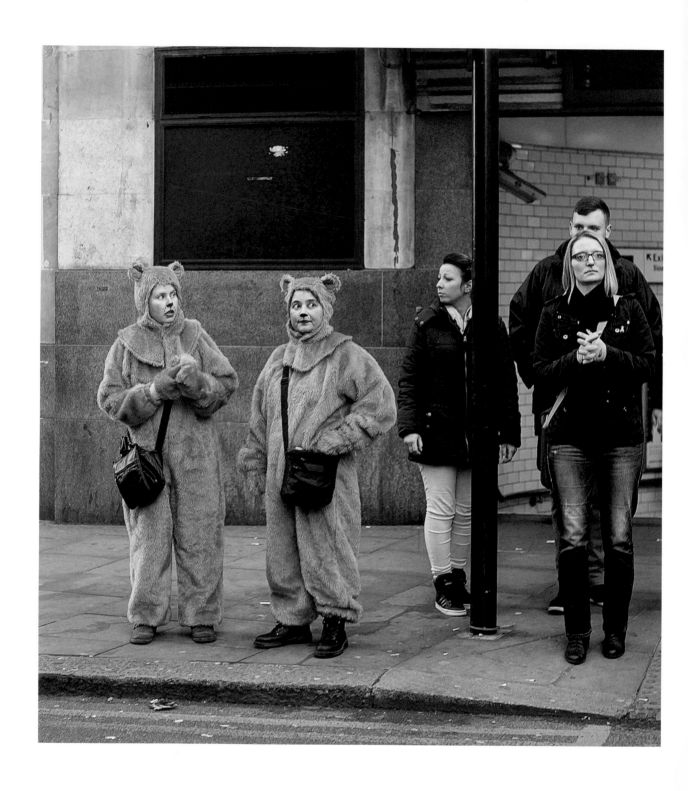

Scared bears

KNIGHTSBRIDGE

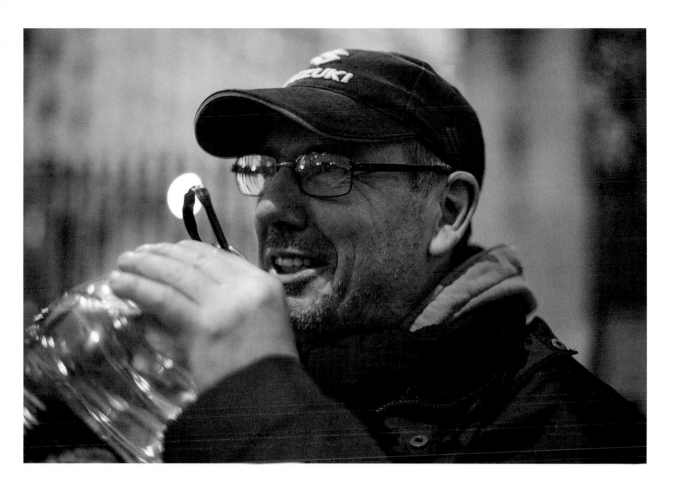

GAYZER: 'I renamed myself Gayzer Frackman by deed poll – thirteen quid! – and I've been camping here on a one-man hunger strike protest against fracking for ten days. I'm just packing up now. Weirdly, I've had no hunger pangs. I have drunk lots of water – somebody just dropped another three litres off last night – and I am taking, in the morning, omega oil and a vitamin pill because that helps your brain.

'I didn't know anything about fracking before they cracked my house. It's in Lytham, near Blackpool, about five miles from where they were drilling. I've left it there, with all its cracks, as a testimony. Thank God for the earthquakes because that woke the whole country up! I went onto the Internet and found out the information and from then on I was like "Stop it. Period." They think because they're in power they've got the power. They haven't. We've got the power!'

WHITEHALL

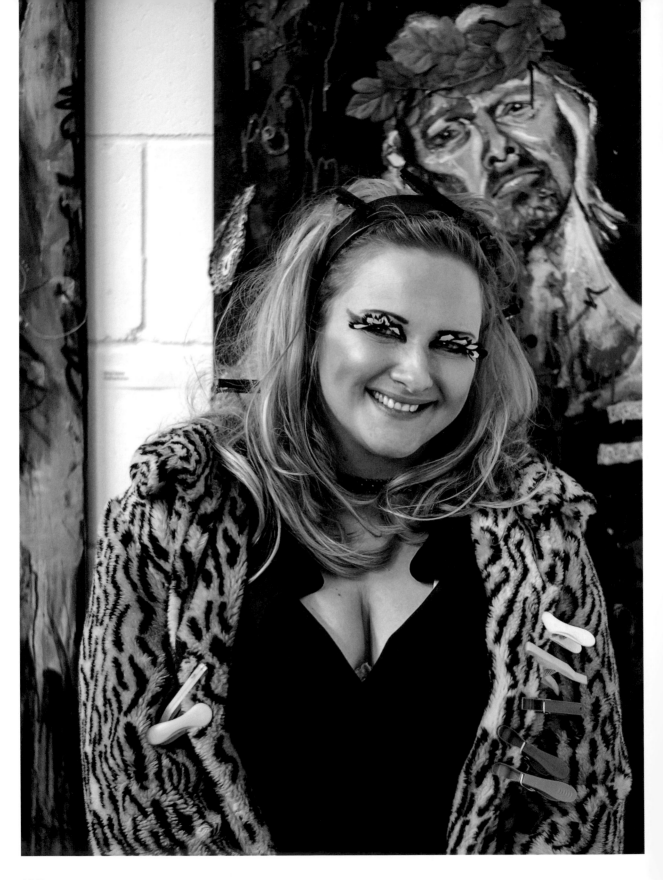

▼ **DANIELLE:** 'Hmmm...'

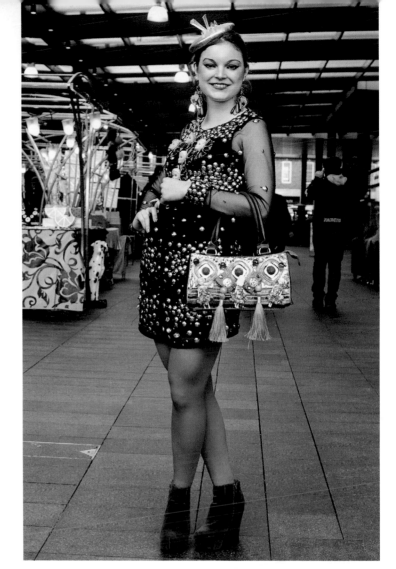

◄ **DEBORAH:** 'I have four children from four different fathers, so I've had to pick myself up from four collapsed relationships, four heartbreaks, and I still bear visible scars from the severe domestic abuse. But I realized that instead of putting all my energy into men, I need to learn to love myself. And now I'm working on doing something extraordinary, so that the house we're renting – which we call "Norman" – can become my children's forever home.'

▲ **ANNE SOPHIE:** 'It's normal in Paris for boys to comment and whistle at girls but I never get that. I can wear the most extreme outfits but, because I'm confident and over-the-top, boys don't ridicule me. They find me strong and intimidating.

'People underestimate the power of costume. It can provoke very strong reactions, which I quite like to encourage. They might find it weird but, often, they can't help admiring it, thinking, "My God, she's got guts to do that!" I've always been creative. I got my MA in art from Central Saint Martins, and now I wear my art. It's become a way of life for me.'

ELVIRA: 'Both these knitted pictures I've done are of my son Ithiel. He was 6 foot 3 and, like my other three sons – I have a daughter as well – he loved playing basketball. But, just a week before a letter came from an American college giving him a place, he went to sleep one afternoon and didn't wake up. They said it was "Sudden Arrhythmic Death Syndrome". I could never have imagined the shock and pain, and I wore his clothes for quite a while.

'People enjoyed him. He lived his life to the fullest and he's a happy soul. Now, his strength keeps me going. I just know I'm being helped. Science, quantum physics, teaches us that we are energy and that energy cannot be created and energy cannot be destroyed, it just changes. So, although he's not here in the physical any more, he is surely here. There's no doubt whatsoever in my heart because I know and because I feel him.'

CLAPHAM NORTH

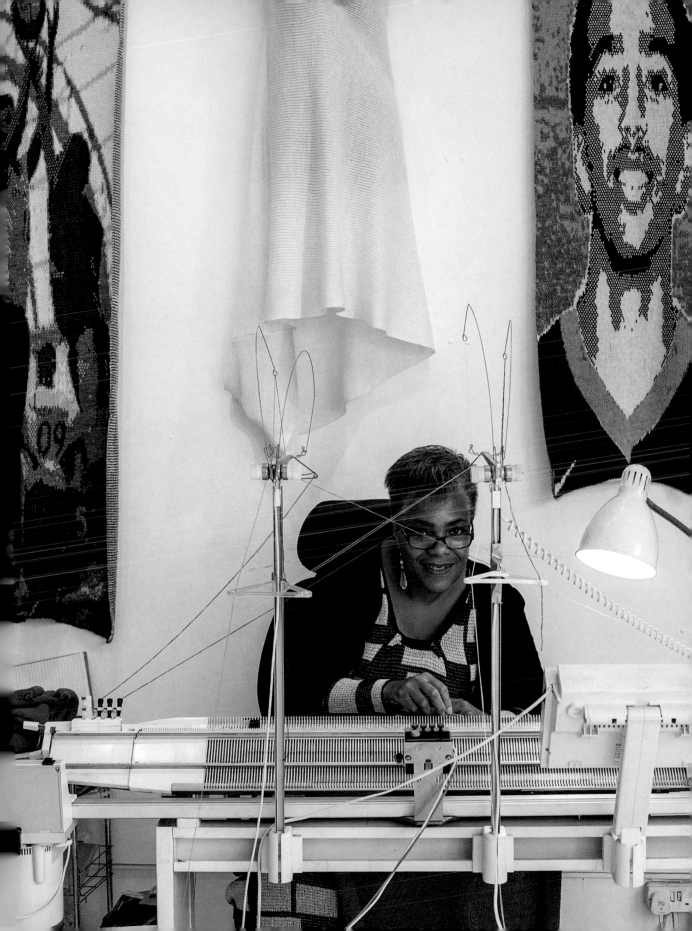

GEMMA: 'I was born in Iran, grew up in Zimbabwe, and used to be an air hostess. All the jetlag, eye bags and insomnia led me to dabble in yoga for a few years, but it was only when I finally broke free from a violent relationship that I really "found" it. That was a hard time in my life. I felt like the rubble remains of a smashed terracotta pot, and that everything "me" had been snuffed out. I knew I needed to heal and the only way I knew how to do that was through yoga. It took about a year, little by little and breath by breath, to glue the pot back together. Now it's a bit scarred, but more robust and somehow more real too.'

CRYSTAL PALACE

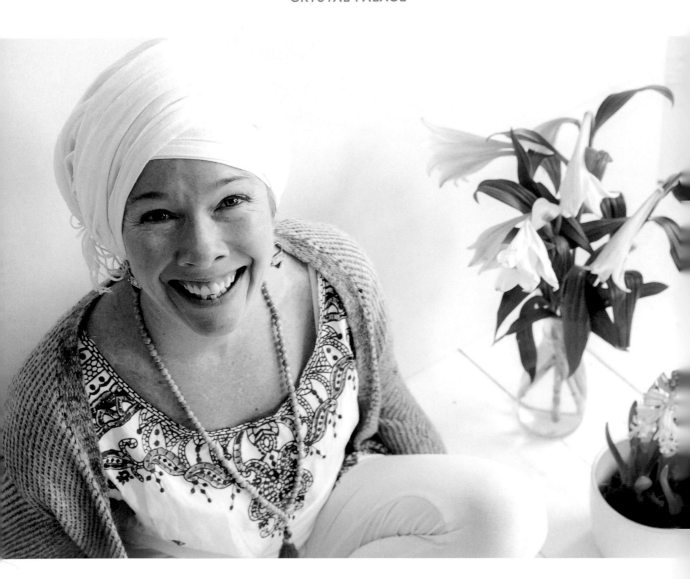

▼ **MIA-JANE:** 'This series of my work is about being a feminist alongside being a submissive woman. Everyone always assumes that if you're a submissive woman then the power role is one-sided, that you must just bow down to men, that it's all about their wishes and rights. But it's not as simple as that; the power is constantly switching. It's amazing to see how many strong women you can find behind submissive roles.'

FITZROVIA

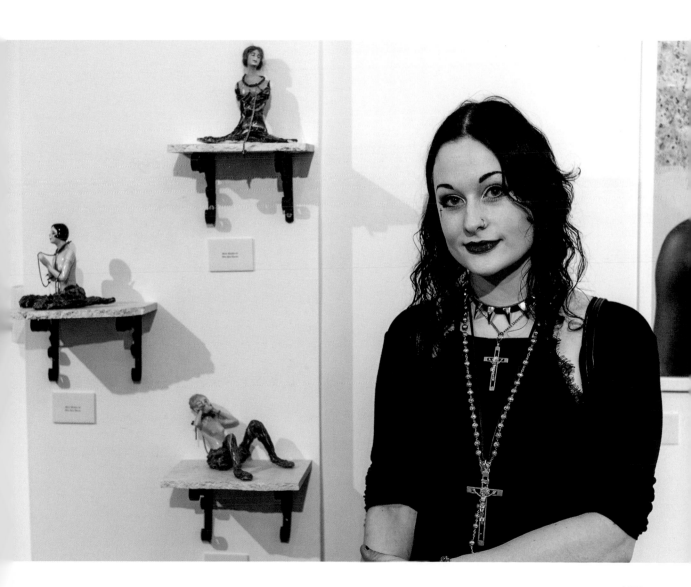

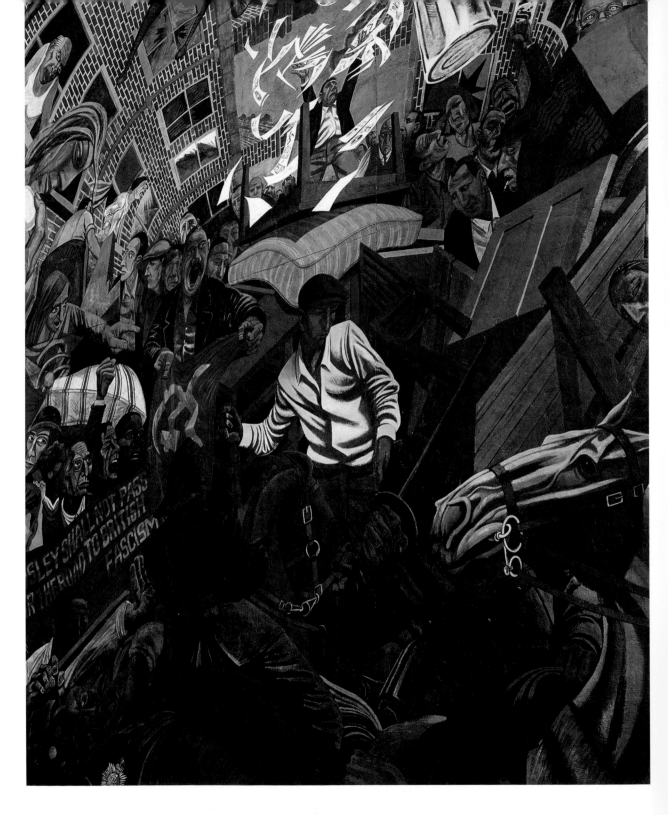

The Battle of Cable Street mural

SHADWELL

Reservoir Romfords

ROMFORD

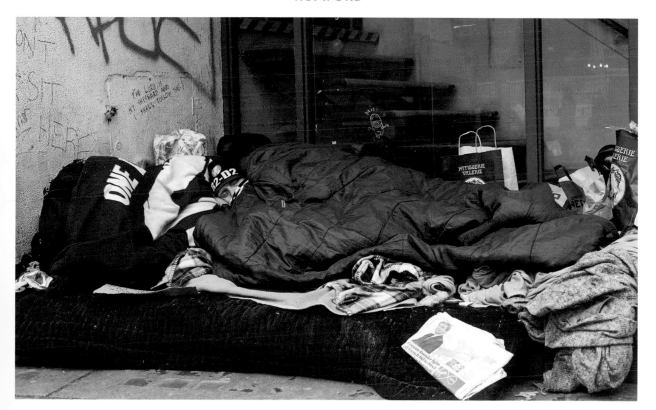

The lie-in

CHARING CROSS ROAD

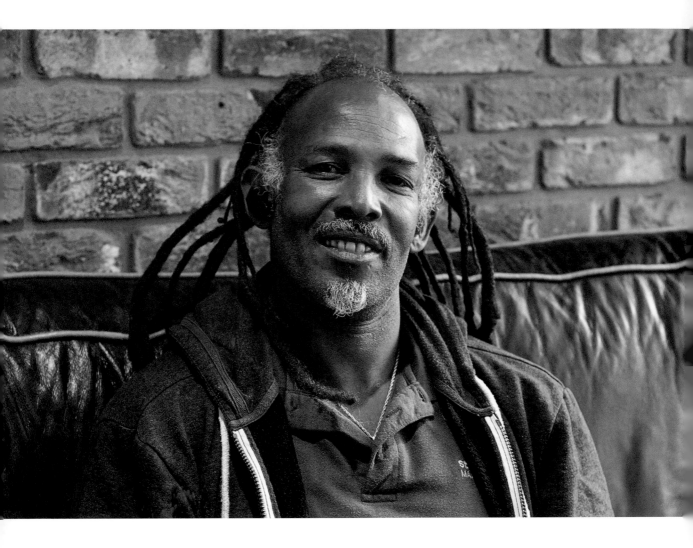

ROY: 'What humanity don't seem to understand is that the resources of the earth belong to everybody, not just to the greedy few. I have to say, as a species, I think we're doomed. The laws of the man, I don't care about them, because they're breaking a lot of the laws of life. There is no human alive today who has more rights than I do. We're all equal, and we're all connected by that one energy source which all of human knowledge and science have not been able to identify or break down.

'Luckily, I take pleasure in every single moment of my life. Just living is a kind of meditation to me. I'm a school caretaker and it gives me enough money to get by – you don't need too much. My son is growing up – he's eleven and he's over the road playing table tennis right now. I'm trying to keep him safe, I'm right here, until he becomes an adult. When he turns eighteen or nineteen, if he wants to go off and explore the world, I think if I've given him enough tools to do so, I've accomplished my job as a parent, a human. Just as long as he carries on in his life and respects that First Law of Life, which is "Anything you do to another person can and will be done to you!"'

FULHAM PALACE ROAD

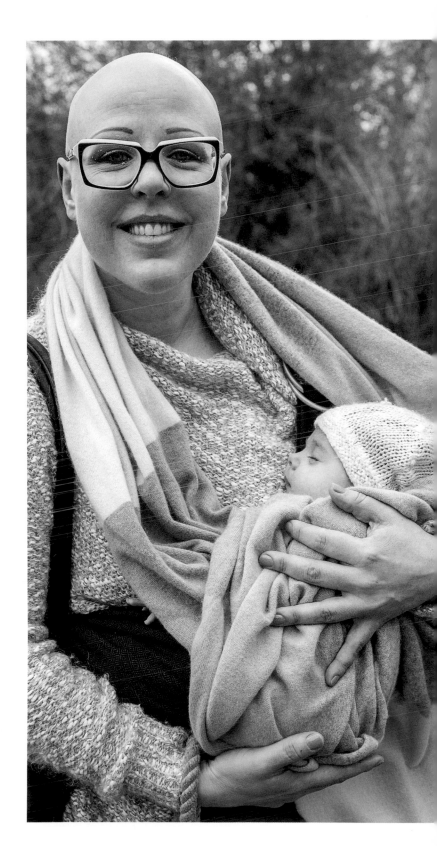

➤ NELL & TALA

N: 'I might be rocking it like it's a style choice, but I've actually got alopecia. Four years ago I was in a work situation with my record label and I was very unhappy and stressed out, and my hair just fell out in two weeks. I had long, blonde hair. You can imagine, as a woman, how much of your identity is wrapped up in your hair. So I wore wigs for a while and then I decided that you're given what you're given in life, and it's much better to be who you are. It's actually very comfortable; I don't have to worry about doing my hair in the morning, and I don't have any "bad hair days" these days!'

HAMPSTEAD HEATH

WILL: 'We see the alienation and privatization of public space all around us. Just as in the seventeenth and eighteenth centuries we saw the enclosures of common land throughout Britain, now we're seeing a second wave of enclosures. The first was allied to the Industrial Revolution. This second represents the last gasp of the finance capitalist revolution, which is destroying us psychically.

'We're already so tightly ratcheted up by the demands of time and money, being whipped along, with no time to sing, recite poetry, lie down, make love, cuddle your dog, do what the hell you want. We need to drift around this city, not be driven through it, and this is exactly the way to go about resisting – people spotting spaces that they wish to be free in, and encouraging other people to come and exercise that freedom as well.'

Will Self speaking during the Space Probe Alpha
action at The Scoop, February 2016
MORE LONDON, SOUTH BANK

RHYS: 'For me, the issue here is about respect. Including on-going training, we already work pretty much 24/7. At this rate, nobody's going to want to train to be a doctor here. They're going to go to places like Australia, America or Canada where they're supported, they have good contracts, and people value what they do.'

At the Junior Doctors London
Protest, October 2015
PARLIAMENT SQUARE

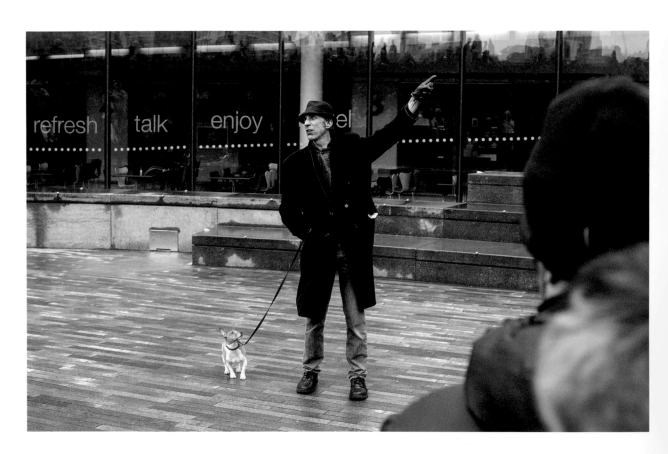

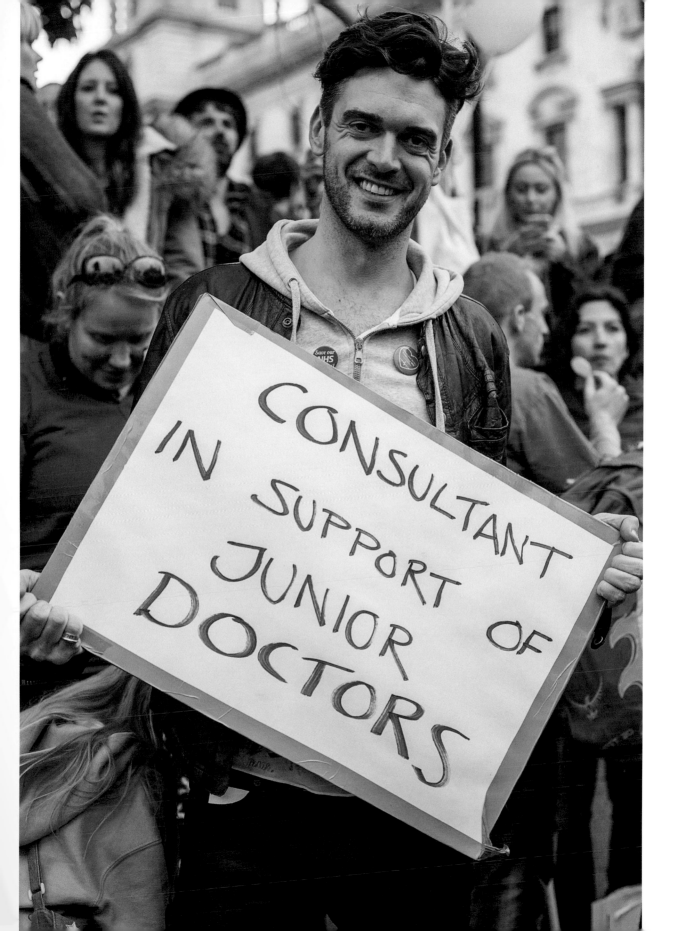

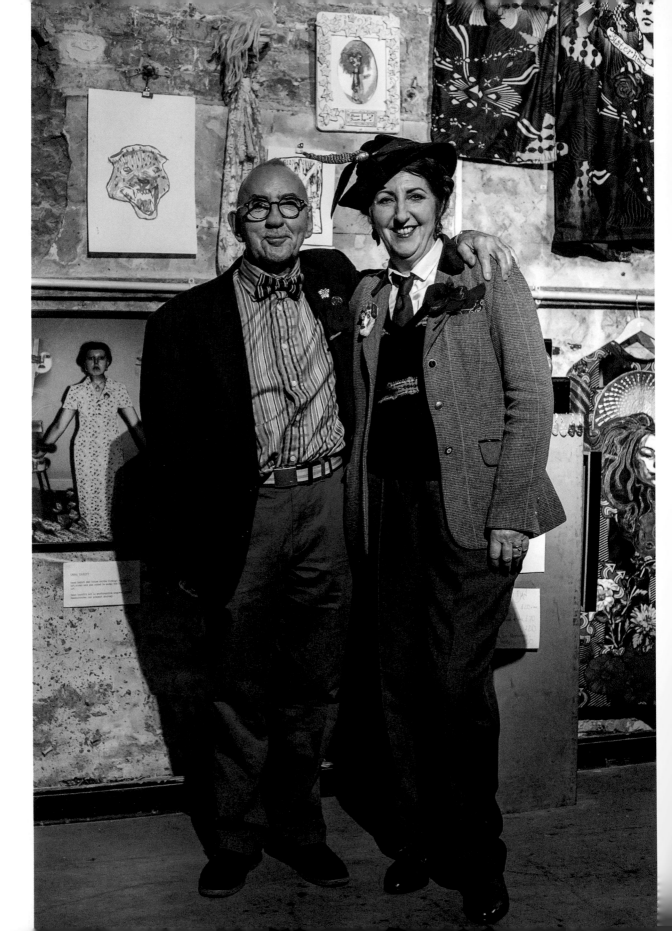

◄ KATHY & DEREK

K: 'My husband is profoundly deaf. He lost his hearing twenty-five years ago after he fell two storeys from a building site he was working on. They found him in a pile of scaffolding with lots of broken bones and a smashed skull. At first they thought he had brain damage because he wouldn't speak, then they found out he'd completely lost his hearing. I was eight months pregnant at the time and we had no help at all, so it was very hard. Then, six months after that, he had a heart attack and had to go for a quadruple bypass, and some years later I had breast cancer too.

'But we've survived all that, we're still here, and I think maybe we had to go through all those things to realize how much we have got. So now I embrace every single day and I'm just ecstatically happy.'

LEAKE STREET, LAMBETH

▼ **NARA:** 'What's inspired me the most? Having crap jobs, basically, that I didn't enjoy or want to do, and just going, "I'm not going to do this any more. I'm good at singing, I'm going to sing!"

'The job that really made me go "Right, that's it!" was working in a call centre in Australia. It was just so horrible. I was so bad at it, I'm the worst salesperson ever. I'd go, "Can you give some money to charity?" and they'd be like "No", and I would go "OK". I was just rubbish. Then one day they kept saying, "Count this, count it again, count it again." They asked me about five times, and I said, "You know what? Count it yourself!" and – I shouted it out – "I'm leaving to become a singer!"'

LEICESTER SQUARE

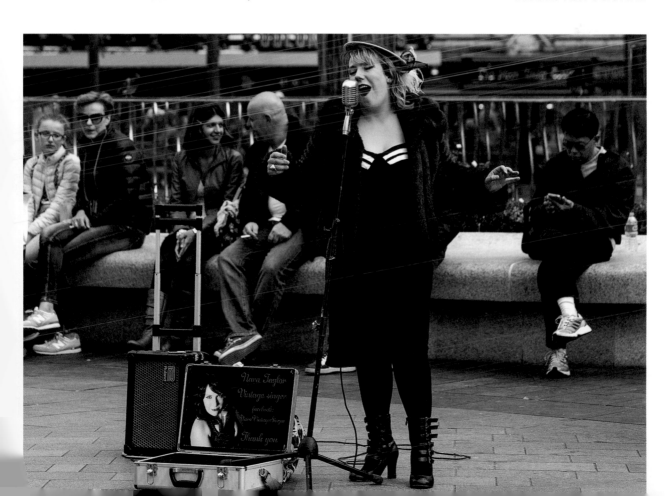

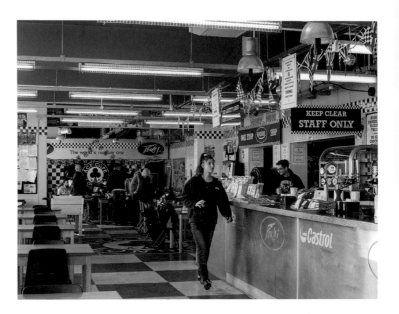

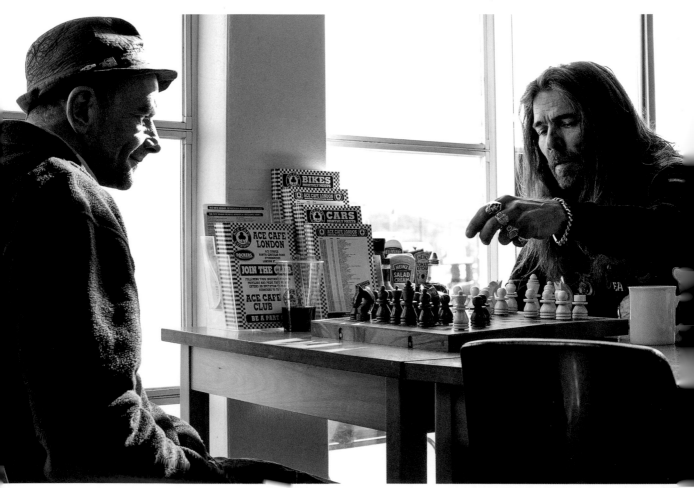

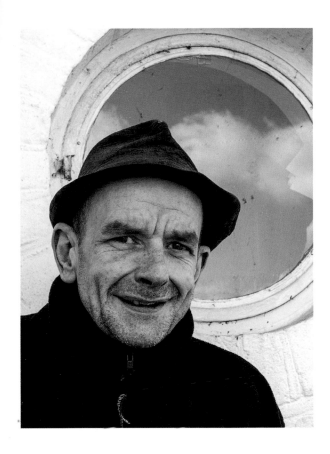

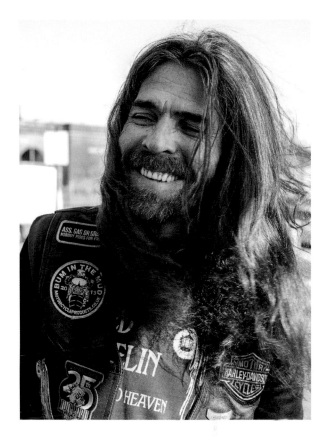

TONY & PHILIPPE

▲ T: 'We like playing chess so much that I called my car "Black and White", and I painted this board on the bonnet so that we can play it outside and smoke at the same time. We've been playing it together for about five years now, and we'll be at it for the rest of the afternoon.

'I'm an old-school trimmer – retrimming the leather seats of classic cars from the 1930s, forties and fifties. I've always liked cars. Me uncle was a trimmer from the 1970s, so when I left Autoglass I thought "Why don't I do that?" Recession was hitting, so rather than let the other people that weren't too good lose their jobs, I left so that they could stay on, knowing that I could always go and do something else.'

▲ P: 'We're not that good at chess but we like it. It doesn't matter the outcome. Good experience when you win, bad experience when you lose, but either way you learn something every time. It's like life, isn't it? You've got patterns, as you do on a chessboard, and if you recognize them out there, then you know what your next move is. I also try to see my life in black and white because the greys are all the compromises, the doubts, the "I'm going to try and do this" instead of just doing it. Black and white makes things so much easier.

'I'm a motorcycle instructor and motorcycle riding is all about balance, without it you'll fall off all the time. So, although you've got to be a bit crazy to ride a bike, I think we're a very well-balanced bunch too.'

ACE CAFE, STONEBRIDGE

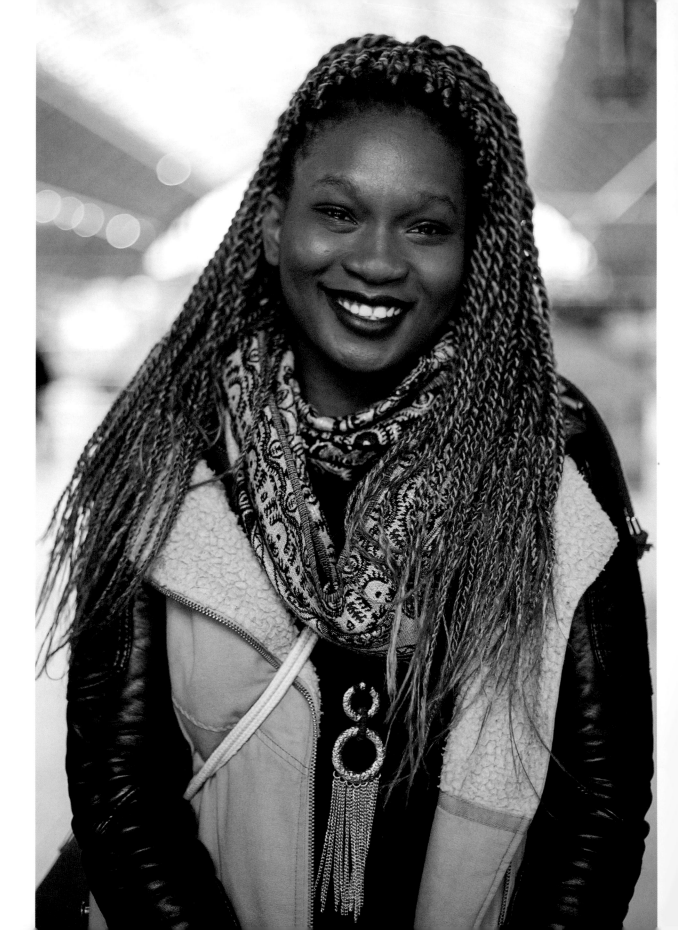

➤ HUMRAYA: 'I never keep dogs, but I saw him in distress so I had to help him. It was so bitterly sad. He was just laying there, shivering with fear, so I went and got this cover from my house to keep him warm. I've called the RSPCA. They're going to come and get him, and they said they'll get the dog warden to call me too, so I can find out what's going to happen to him next.'

EDMONTON

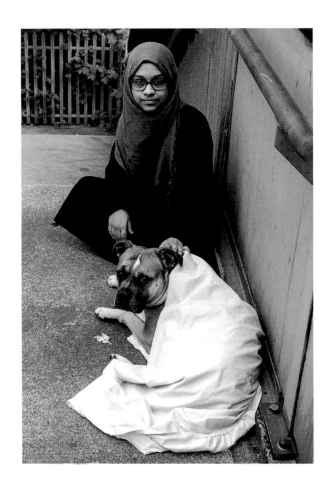

◄ GRACE: 'I'm studying biotechnology in Vienna and I would like to combine it with agriculture to start some small crop-growing initiatives in Africa. I'm from Congo, so I'd like to go back there and help them. I do struggle with understanding why the world is the way it is. I really wish people would wake up, see the beauty of the world all around them and care more, realize that they could do things with a different consciousness and stop destroying themselves. It makes me really sad.'

ST PANCRAS INTERNATIONAL STATION

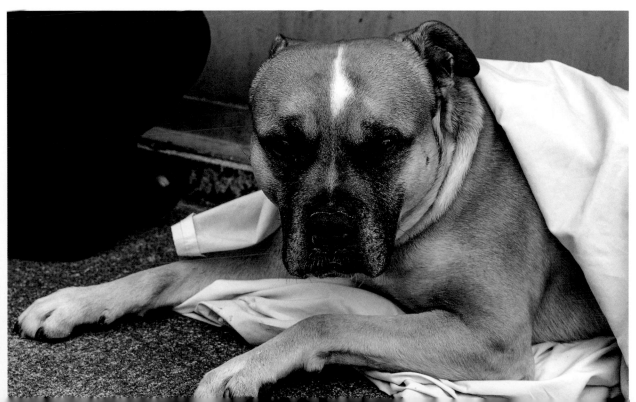

MICK: 'My mother had fourteen children but she didn't have time to take care of us – she was too busy trying to find a husband, so my grandparents brought me up. Then, one day, while I was working as a drayman for Truman's Brewery, my grandmother died of a heart attack, right in front of me, and I went into shock. I disappeared for four days, just wandering about who knows where. Eventually the police found me and took me to Hackney Hospital, but then I cut my wrists. I wanted to die because my grandmother was dead.

'The woman in the next bed was Reggie Kray's wife Frances. It was a mixed ward. She was a lovely girl, but I think being married to one of the Krays had made her a little crazy.

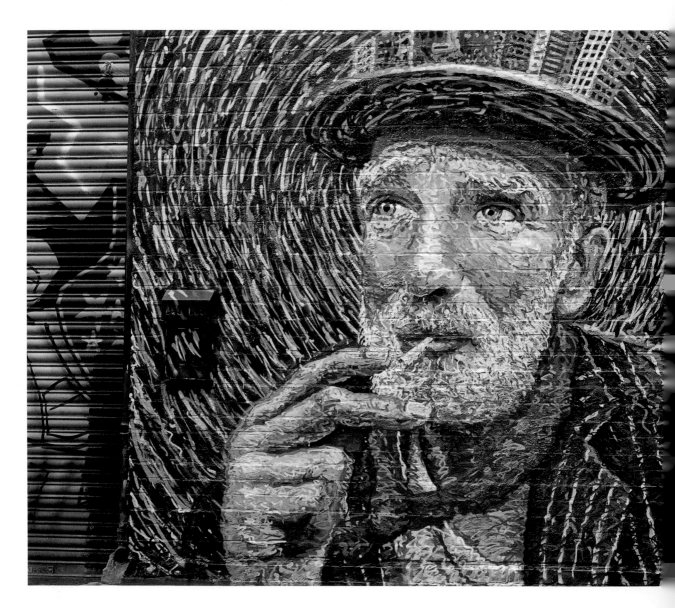

She would often tell me, "Think twice before you do anything!" We were together for sixteen weeks. She needed some company and I took care of her and dressed up smart for her, but I was born and brought up in the East End so I knew I needed to stay out of her husband's way. Then she went home and, almost immediately, she died of an overdose. I couldn't believe it. But you know what? That second shock made me better – it snapped me back to reality. I loved her, and her death somehow cured me of the loss of my grandmother. Now, whenever I hear "Strangers in the Night", it always reminds me of me and her.'

Jimmy C.'s mural of Mick on the left and the real deal on the right
OFF BRICK LANE

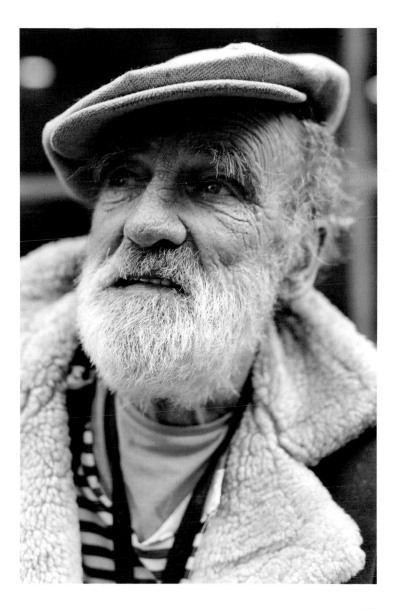

PAT: 'I've come here from Latvia because tomorrow will be concert of Gogol Bordello. It's a very famous group, Gypsy punk, and one part of me is Gypsy. My friend, he make surprise for me and bought these tickets. It was my dream to come to this land, particularly at Christmas time when everybody tells me London is very beautiful. Oh and – I just love pandas!'

ACTON TOWN

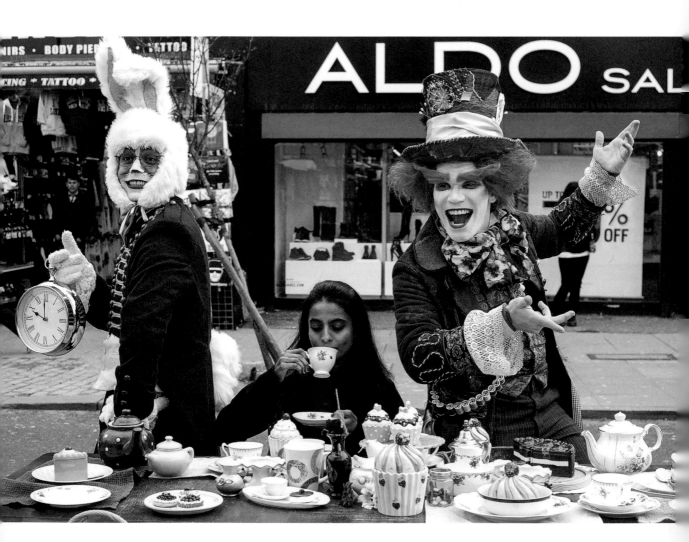

Down the rabbit hole in Camden

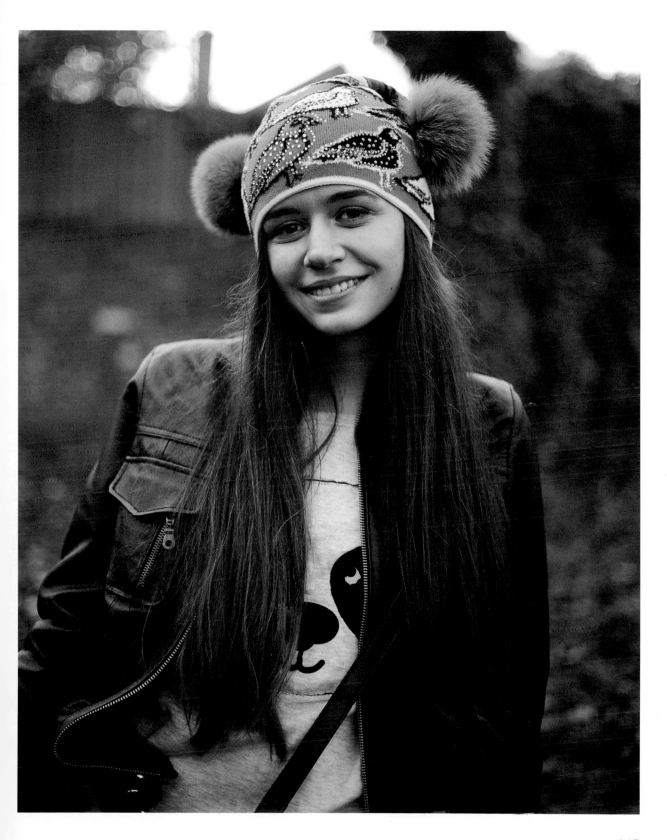

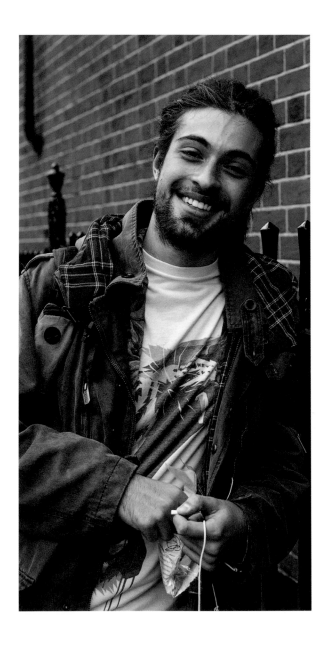

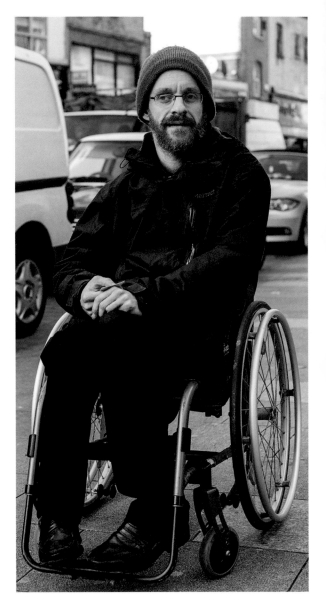

▲ **TAURUS:** 'I'm always looking to connect with people – I can even get a whole Tube train talking! There's nothing wrong with making yourself look like an idiot – it's just having the energetic reserves to continually fuel and finance other people's fun. You've got to keep talking and you've got to keep looking.'

KENSINGTON CHURCH STREET

▲ **ANDREW:** 'I think people often have quite low expectations of someone with a disability, so I'm proud of the fact that I've already achieved quite a lot and proved that can be wrong. I got my degree, I have two jobs, I live alone and go out with my friends, and I do some community radio and volunteering too. My life so far has been happy, mostly. It's not been disastrous.'

DEPTFORD HIGH STREET

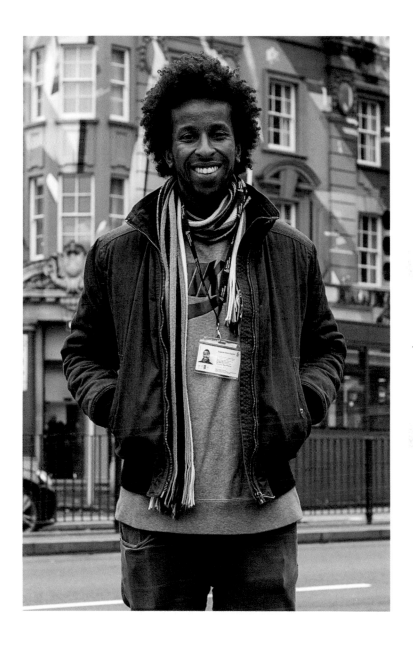

⋀ AAGANE: 'I was working for War Child in Holland, now I'm working for Amnesty International here. I feel gratitude for doing this job, because I'm helping people that I will never meet. They will never know that I'm here on the streets for them, but the fact that they get so much help from Amnesty, being rescued from prison and torture, being reunited with their families and getting back on track, makes me feel absolutely wonderful.'

KING'S CROSS

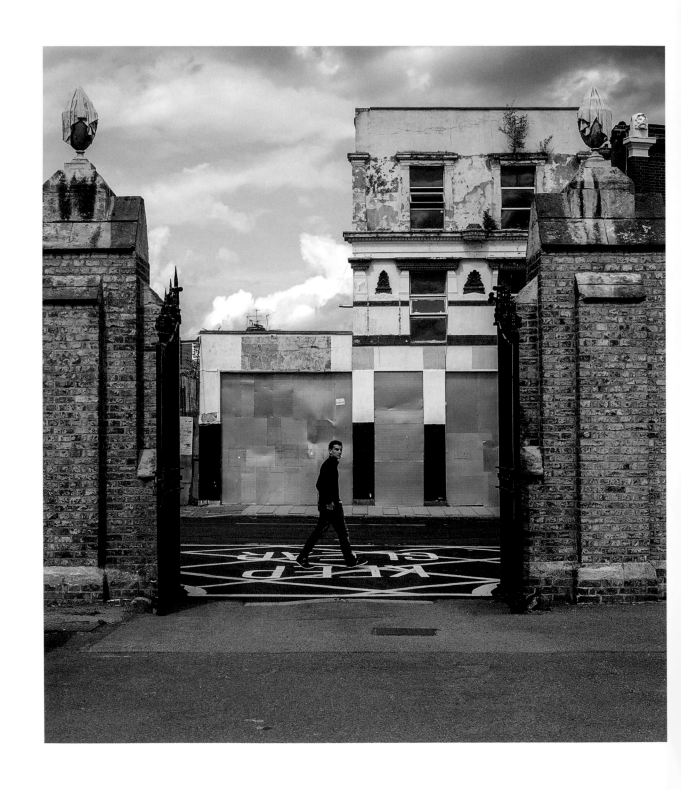

Star of his own movie

QUEEN'S PARK

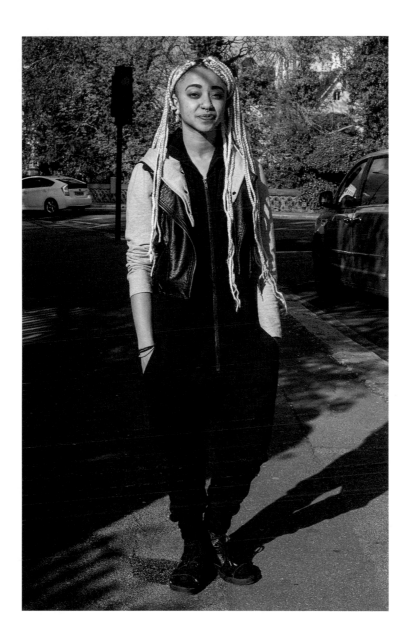

∧ N'Dea: 'My dad and my mum are both Native American with Nigerian, Irish and British blood mixed in. I come from St Louis, Missouri, and because of the way I look I get stopped by police there a lot. Sometimes it's made me really late for work!

'People need to be able to acknowledge the racism and the racial tension, because a lot of people are still in denial about that, but it's saddening and stressing people out everywhere.'

REGENT'S PARK

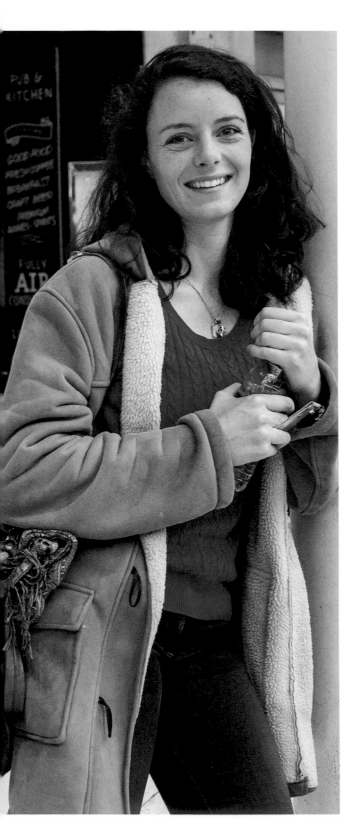

◄ **ELLIE:** 'I quit my admin job last week, and today I started a two-year training course to become a nurse. I've realized that I'm not cut out for the nine to five, sitting at a desk in front of a screen, answering emails. That, and money, just don't drive me. I do care a lot about people – sometimes, I think, more than they care about themselves – which can be a burden. But being a nurse will hopefully allow me to help other people while also helping myself by doing something more fulfilling.'

WATERLOO STATION

➤ **GLEN & MARGARET**
M: 'We've been happily married for sixty-two years (I'm eighty-four and he's eighty-three, so he's my toy boy!), and we belong to the Unitarian Church, which takes everybody – you can be black, white, yellow, green, it doesn't matter what religion or if you've no religion, you can just come and be part of the community. It's all about unity.

'Our son's gay and our granddaughter is married to a Jamaican, so to us it doesn't matter what sexual orientation or what colour you are, we've got no problem with that at all. When our son was about sixteen or seventeen, I said to him: "David, what's wrong, because you're obviously worried about something?" and he said, "I think I'm gay", and I said, "Oh thank God, I thought you were going to say you were seriously ill or something!"'

TOTTENHAM COURT ROAD

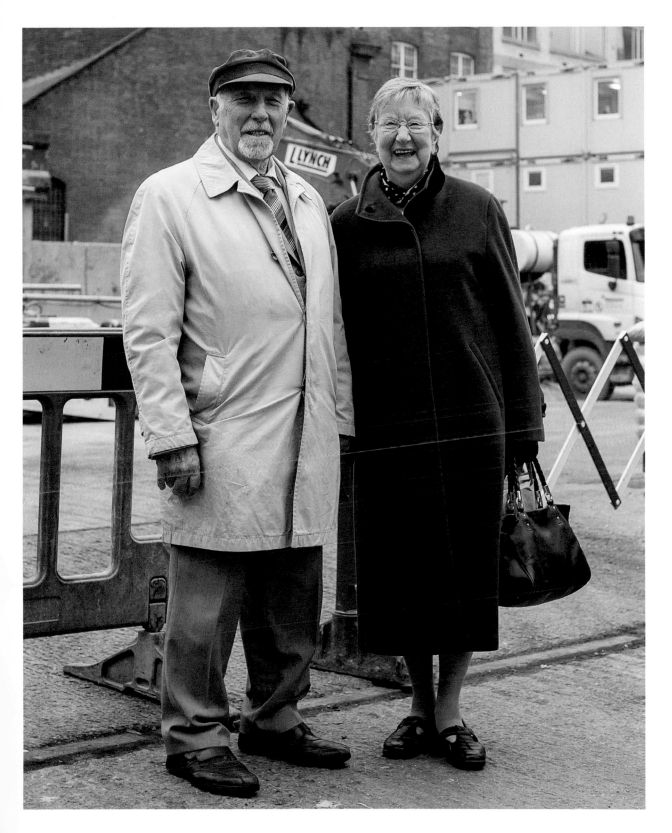

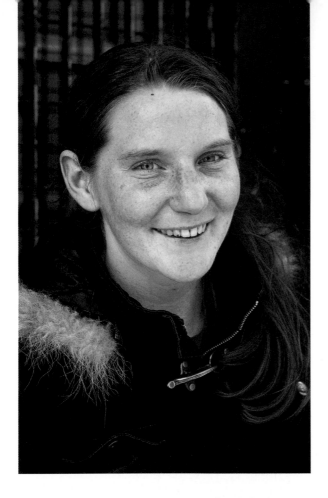

Naiomi's Story

NAIOMI: 'I come up from Devon to get away from my dad – both my parents are heroin addicts – and I've been living rough, on and off, for about three years. Then, two years ago, I had just a little cut on my foot and it developed an infection called pseudomonas, which is antibiotics-resistant, and then that got into my bloodstream and gave me septicemia and osteomyelitis – where it goes into your bone and rots the cartilage. So I've ended up with this massive hole in my foot where you can see the bone and stuff. It's disgusting, and all the nerves are exposed so it's ridiculously painful too.

'Before I ran away, there was this really lovely woman called Jackie who took me on when I was about thirteen or fourteen and basically became like my mum. She was amazing: she did so much for me, and she helped me become a qualified riding instructor too, get my BHS [British Horse Society] exams, before my dad came and threatened and robbed her and she had to let me go.

'That's what I really love doing – teaching people how to ride, working in livery yards, breaking and training horses. I just need to be able to walk properly again. And I've got this weird feeling that there has to be a reason for all this, for being so unlucky, and I'm going to be able to do something about something somewhere along the line. I don't know what yet but I know I will.'

May 2015
CAMDEN ROAD

After Naiomi's first Facebook posts inspired hundreds to want to help, I set up a JustGiving crowdfunder which raised £1,400 and helped her get off the streets and into the council flat you see here.

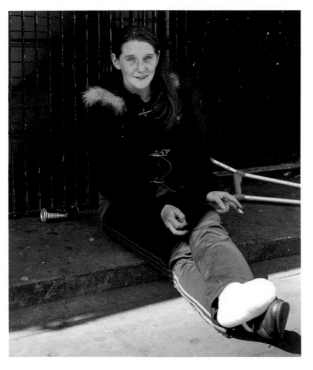

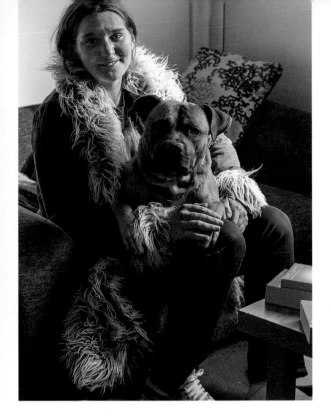

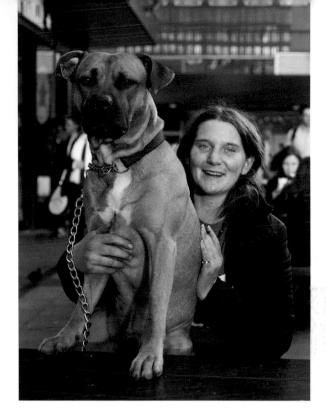

'I'm so happy to be here, in my own flat, I can't even tell you! The crowdfunding money all those amazing people gave me allowed me to pay for a hostel long enough to be classified as a resident, which then means the council have to help you.

'The neighbours down the end have been really sweet and given me loads of stuff – that table, the fridge, the rug, cutlery, clothes, really useful bits and pieces, and I've spent my Community Care Grant voucher in Argos and bought loads of furniture too.

'It also really helps you, reading all these kind words from all these lovely people, offering their support and wishing you the best. It makes you think, "Aw, lots of people *do* care, even ones that have never met you." It's really nice. It gives you hope, and it's a very big change from feeling invisible on the street.'

July 2015
HOLLOWAY

'I've had my dad staying with me for the past six weeks because my mum died – it was over-prescription of anti-depressants and anti-psychotics which killed her – her body just shut down. Before I went back down to Devon, after I found out my mum had died, I hated my dad more than anything in the world. Then I saw the state of him. He'd taken an overdose and he was in bits, and I realized that he's still a human being, even after everything he's done to me, and he still deserves some kindness. If I hadn't taken responsibility for him, they'd have sectioned him and that really would have been the end of him.

'Hopefully he'll be well enough to go back down to Devon soon – I've already invited him back for Christmas – then I can concentrate on getting my foot properly healed, it's doing really well, and applying to loads of stables to see if they'll give me some work. I've already made a big list.'

October 2015
EUSTON SQUARE

⌃ TRACEY & LIAM

T: 'You know, London is a lonely place and the thing that made me connect with it was finding people who did this traditional Irish and Scottish music. When I first moved down here from Glasgow, I didn't play music properly in public for a few years, and then I met Liam at a session in South London and that was it.

'We've been playing together for about twelve years now. He's the best singer in London for traditional music, I think, and he's also helped hone my rhythm because I have a habit of speeding up a lot! Now we're really good friends and, because neither of us have any family in London, we're like extended family to each other too. When we do gigs together, sometimes we don't need to say which songs we're going to do next, we'll just do it telepathically.'

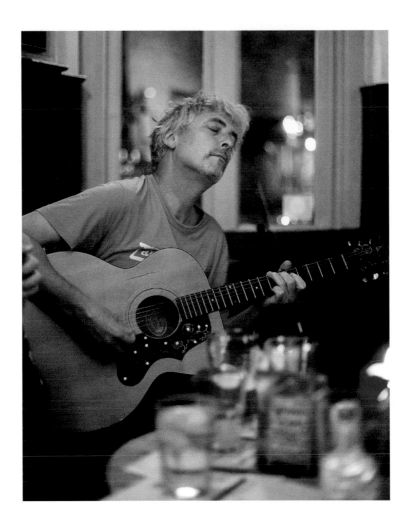

L: 'I can cry while I'm singing. I try to disguise it sometimes because it can be very emotional, but I try to live the song, rather than just sing it, you know? I came from a musical family in Dublin and my earliest memory of music was when I was five years old, listening to the radio with my mother, and hearing Motown. It was like electricity, like being plugged in for the first time. It was like this drug!'

WANDSWORTH TOWN

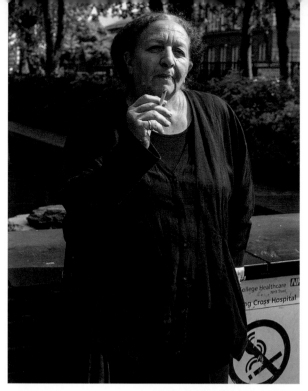

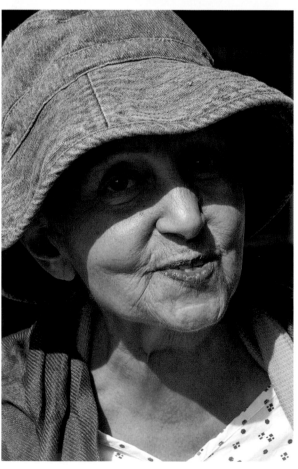

MONA & FATIEH

◄ M: 'I was part of the May 1968 uprisings in Paris, which was exciting! But after that I felt there were things that were happening in my home region, and that I should go back and be part of that. So I moved to Lebanon because there was a very dynamic arts culture there, and everybody would leave you alone to do what you wanted to do. When I was young, we were moving away from all this religious sectarian stuff in the Middle East; everything was becoming so much more liberal. It's terrible that it's now going the other way.'

◄ F: 'I've already had cancer, mainly lung but also breast, for the last seven to eight years now. When they found the tumour in my brain I thought, "I will go through this and I will try to survive it. This is just another experience, one which brings you face-to-face with life and death, which you can learn from." I think this is very important, always to think that you can do it.'

► M: 'We're sisters. She's the baby of the family, five years younger than me, and we've always been close, though we've not always been in the same country. I came over from Lebanon to be with her when she was first diagnosed with the brain tumour, because that's a very scary thing and I didn't want her to be alone.

'Her operation was three days ago. She was supposed to be out in an hour or so, but she didn't re-emerge until eleven that night, and all the time I was thinking, "She might be confused, she might be brain damaged, she might be dead..." Then I heard the squeaking of a trolley and Fatieh was wheeled out and she was laughing!'

CHARING CROSS HOSPITAL, HAMMERSMITH

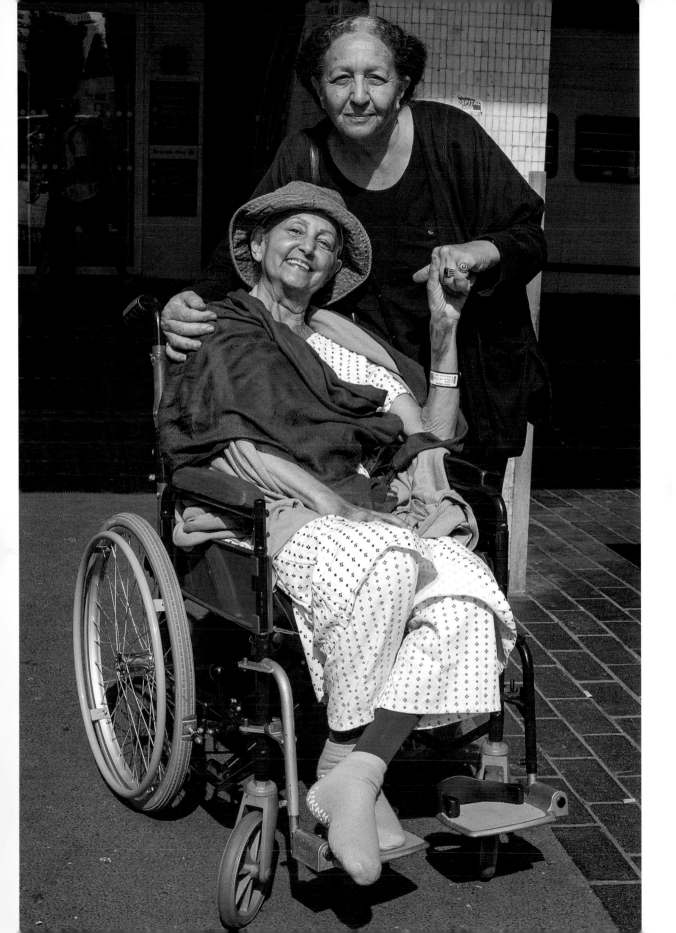

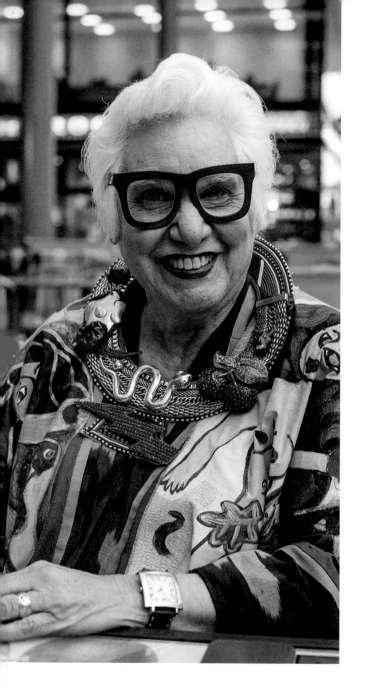

SUE: 'I met my husband, Steve, when I was fifteen and he was sixteen, and we got married when I was twenty-one or twenty-two, so we've been married for about 120 years! We had one child, because I love children and I wanted to do it once. But I had an insanely bad mother so I was very nervous, and we didn't have Shawm until I was in my early thirties – after we'd been nagged to pieces by our families for over ten years! Then they nagged us to have more!

'My husband and I haven't lived together for the last ten years and it works really well. While Shawm was growing up, we lived together like a normal couple, but we're both extremely obsessed with our work. He's a scientist – human biochemistry – whereas my passion is wearable art, and I've just been commissioned to write a book about it. The coat I am wearing is one of Diane Goldie's early pieces and it's a treasured garment. The collar I made myself to go with the whole Adam-and-Eve thing. So Steve and I are both still working full-time, even though he's seventy-six and I'm seventy-five. He lives in Cambridge, I live in London, and we spend our weekends together. Then three times a year we'll go and stay in my little apartment in New York for a couple of weeks.'

SPITALFIELDS MARKET

Sue and I quickly became friends and she invited me round to see her extraordinary home, filled to bursting with her own and others' technicolour art.

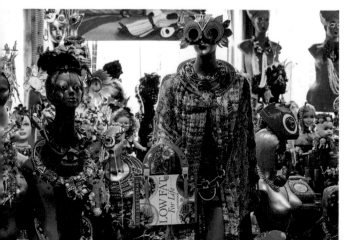

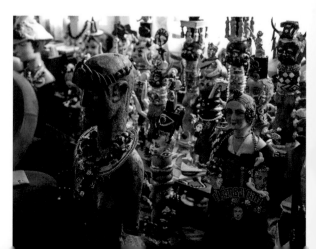

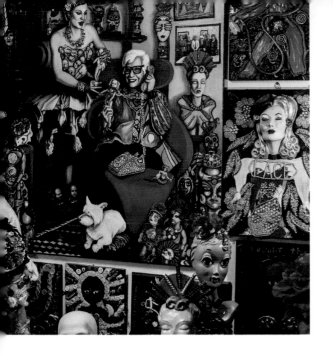

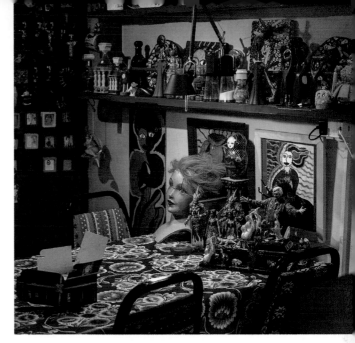

'I was always told that I was absolutely crap at art, since I was a little kid in primary school, but I always knew I loved colour and I loved art, especially outsider art, the so-called "primitive art". My houses were always very bright. I collected all kinds of stuff, but I knew I couldn't do it myself. Then I had my mermaid-on-a-scrap-of-paper moment that I told Brandon from the Humans of New York project about. I'd never done anything like that before in my entire life. I knew I couldn't draw. I couldn't even doodle. But after that I became completely obsessed with drawing. I just stopped cooking, stopped writing cookbooks, stopped a perfectly good career, just to make stuff. My agent thought I'd completely lost my mind, which I probably had.

'Is it art? Is it good? Is it bad? It doesn't matter. I don't care what you think of it or what anybody thinks of it. It just is. I'm my own best audience, I love my work. If other people love it too, that's a bonus, but they don't have to. It comes from the guts – it's never become about commerce or what I think I'm supposed to do – and it's still the centre of my life.'

Sue Kreitzman's gallery home
MILE END

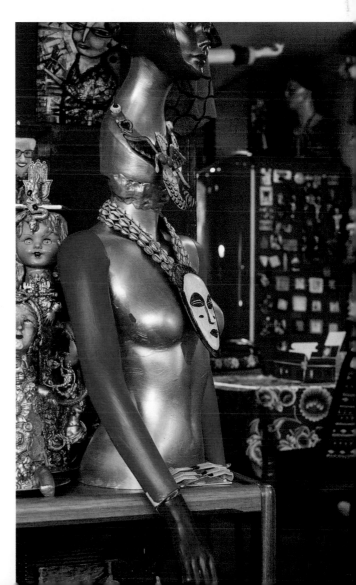

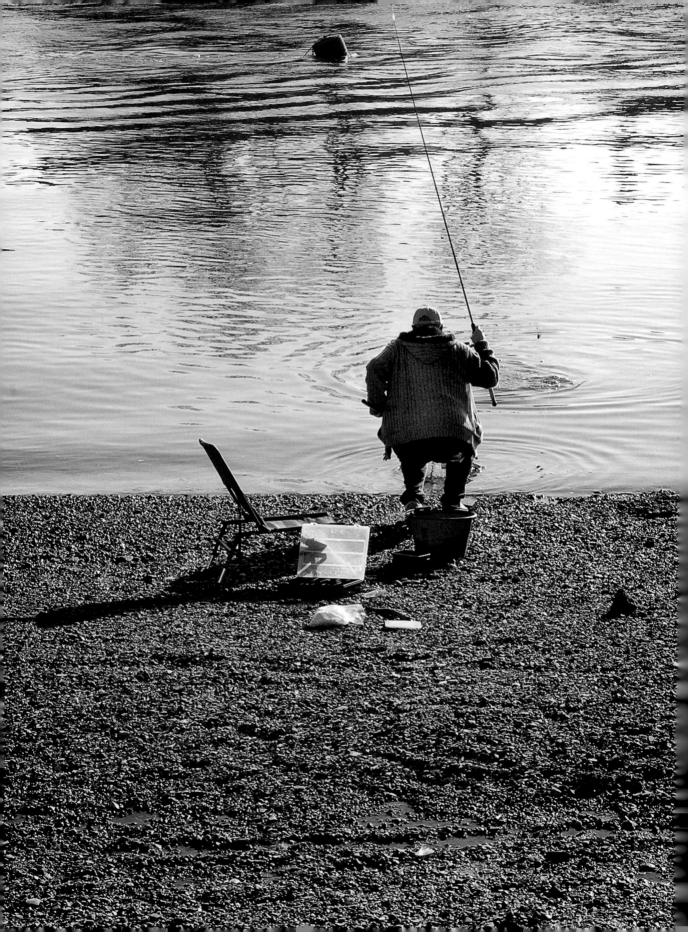

This chap had been sitting patiently in his picnic chair for ages, watched by a whole crowd who were drinking by the river in front of the Bell & Crown pub. When he finally got a bite and leapt to his line, we all clapped and cheered.

STRAND-ON-THE-GREEN

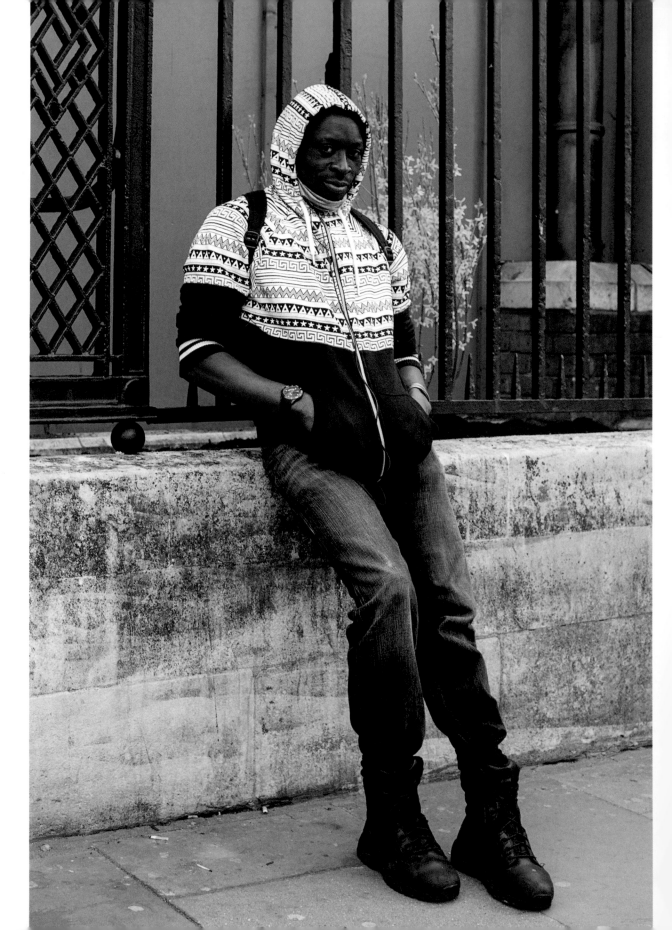

JACOB: 'Basically, I'm known as a bit of a psycho, yeah? I've been a bad boy from a young age. I wanted to be a boxer but I'm asthmatic so my family, my mum, said, "No way, that's not for you." So I thought, "I'll turn bad, do what I want", and I got into a bit of crime, then the Class A drugs and the alcohol, which led to more crime. I was addicted for twenty-one years.

'Now I'm a good boy and I've been five years clean, which makes me feel good. Proud. I stopped. Self-will. I've proved I can do anything I put my mind to. I may still have a little beef at a time, that's why I walk the railings of London Bridge – to get my braveness out of me.'

DENMARK HILL

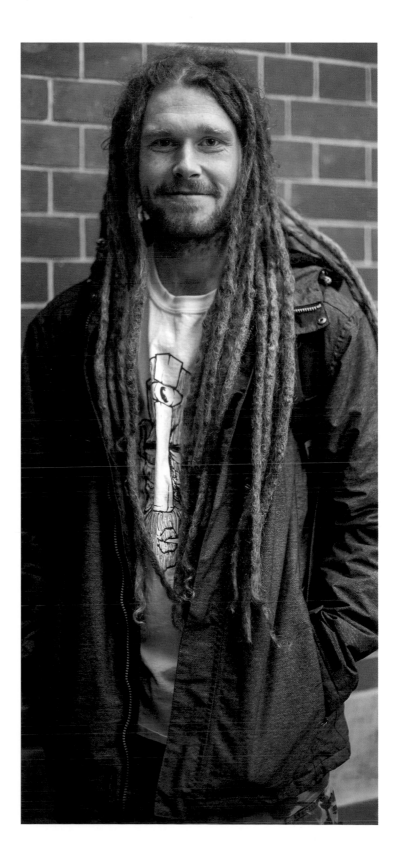

DAVE: 'I work in arts mental health – using music and arts and dance to help people feel better. We're all naturally a bit crazy – it's a spectrum, isn't it? – and the people I help are all struggling in their own ways. Things have got on top of them, so we help them restore some balance just by having fun, being creative, making music, all in a safe space. That's medicine.'

ST PANCRAS STATION

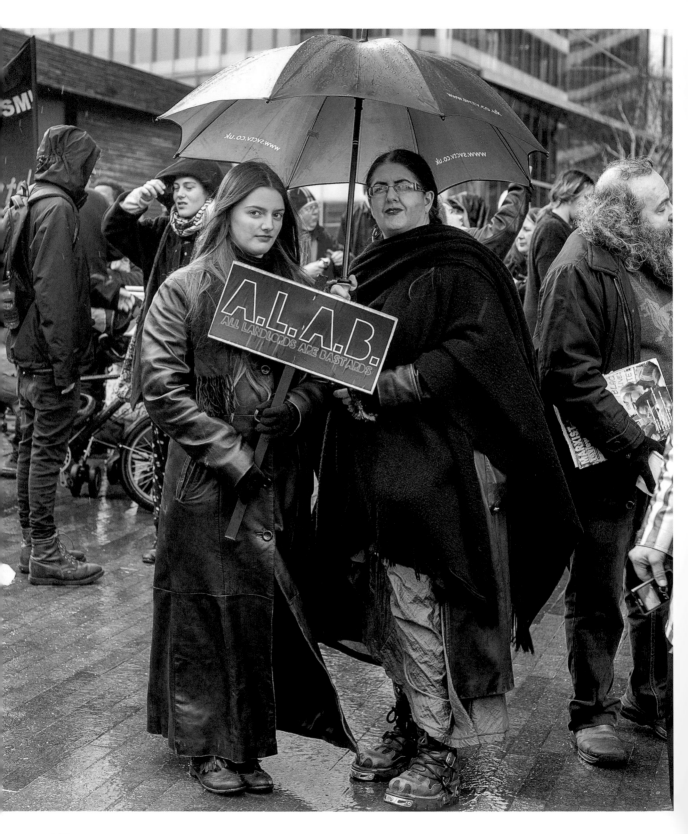

◄ RUTH & RUBY

Ruth: 'The A.L.A.B. placard is a bit unfortunate. I suspect Ruby picked it up because it was "Ruby-sized" and pithy. I actually don't think all landlords are bastards, just many of them. I think I probably came out the womb non-conformist, it's in my blood because I've got a French Huguenot background. I hate injustice so I'll rail and fight against it. People say to me, "I wonder how it happened that there was a rise of fascism and why did people go along with it?" And I say, "Well, open your eyes and see how people are being kicked and brutalized right now, and you're doing nothing, you're just living your lives, looking after your family." When they say, "Why isn't someone doing something about this?", my response is "Well, why aren't you?"

'If enough of us do this, we will effect change. If you look at unionization, suffrage, civil rights – all of those came about through collective action, grass roots movements by ordinary people. Governing power never surrenders control spontaneously and willingly – it must be wrested from them. The alternative is to surrender (in the words of activist writer Mary Scully) to this "barbaric phase of capitalism". So I, for one, will be a dissenter and a resister to my last dying breath, for the causes of true liberty, compassion, justice and human rights.'

➤ **ANTHONY:** 'Today's been very inspirational – very political but with a very positive feeling too. I've had nothing but warm hugs in this cold weather, and you know we have to sustain ourselves emotionally as well as politically? Anger's important, because we're all angry about the state we're in, but having a positive emotion is one of the things that's going to sustain us to defeat these people who are wrecking everything.'

At the March for Homes, December 2015
CITY HALL

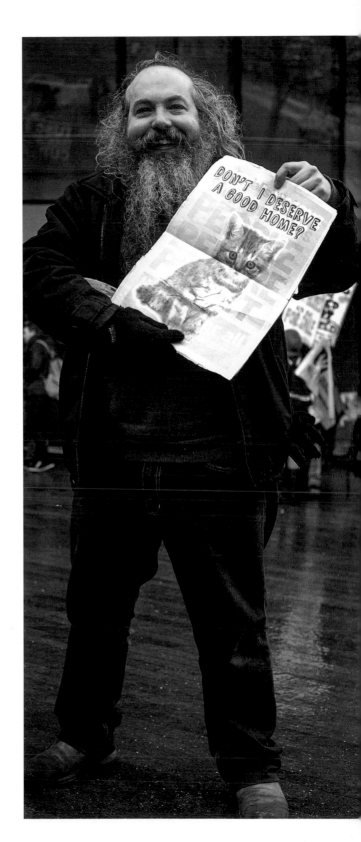

163

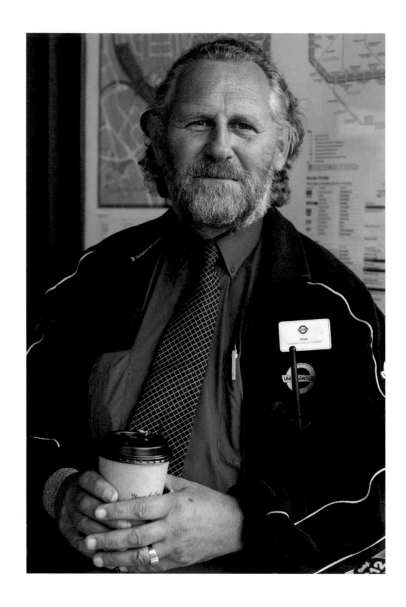

⌃ MARK: 'Having a humane outlook and helping people out is what I like most, whether it's something as simple as giving someone directions or helping out a tourist with poor English. I've bought people coffees, or given them a couple of quid if they were desperate and had no other way of getting home. It's a nice way to spend your time, and then getting paid too – that's the bonus!'

ACTON TOWN STATION

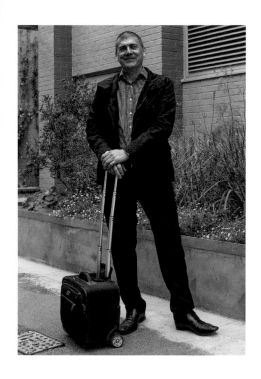

COLIN: 'I used to work seven days a week, twelve hours a day plus, for years and years and years. I've had the money, the fast cars and the big houses, but none of those things really bring you happiness, and I suddenly thought one day, "God, there's got to be more to life than this!" And there is!

'I've not long finished training as a clinical hypnotherapist; I'm now a Level 2 Reiki practitioner, and I've been volunteering at this hospice for youngsters with life-limiting conditions. I'd like to start doing some soul midwifery soon, where you help to comfort and calm people who are dying, help them on their journey. I think I'd be quite good at that.'

BOROUGH

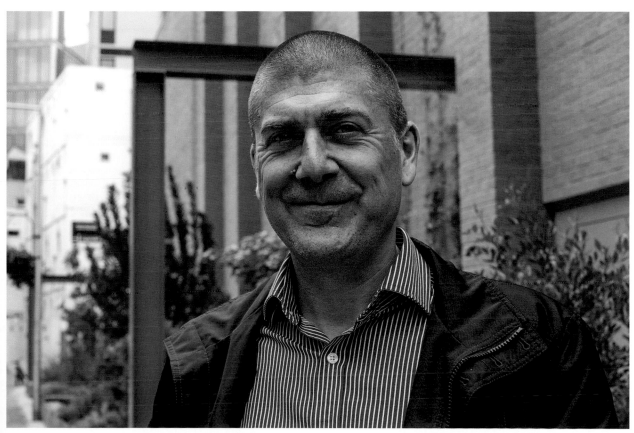

▼ **HENNAH:** 'I was born with spina bifida, which means I can't use or feel my legs at all. But when I was sixteen I played drums in a punk and death-metal band. Now I really want to start a band called Unnecessary Burden because so many people still see disability as weird and a tragedy. But it's just nature. For me, it's normal. I don't see it as a burden.'

CAMDEN

▼ **ELSA:** I've been working to help get Shaker Aamer released from Guantanamo for several years – he's been cleared for release since 2007, but he's still there. We've been demonstrating, writing, calling Obama in the White House. We need the British government to take action, not just to make statements. I am involved with several campaigns – Palestine, Guantanamo, Colombia, Julian Assange and whistle-blowers. There is so much injustice! We need peace based on justice for all, my darling.'

Protesting as part of the
Save Shaker Aamer campaign, December 2014
PARLIAMENT SQUARE

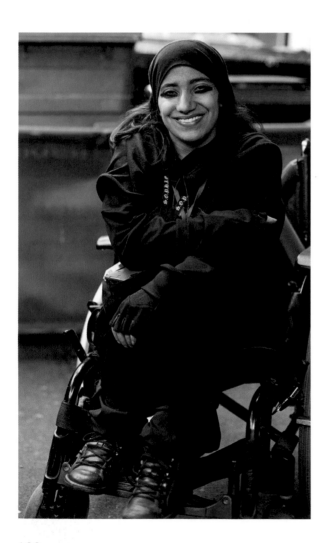

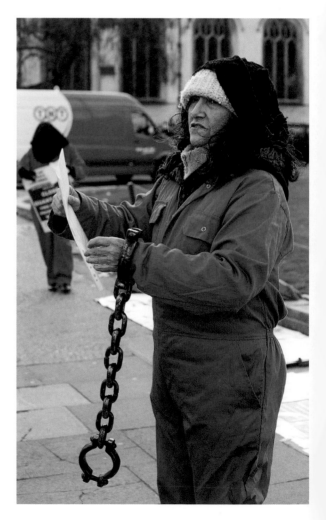

The chalk words say: 'No politics, no religion, no hate, just flags. Peace and Love. If you don't see your flag, don't be offended, please ask and we'll draw it'.

TRAFALGAR SQUARE

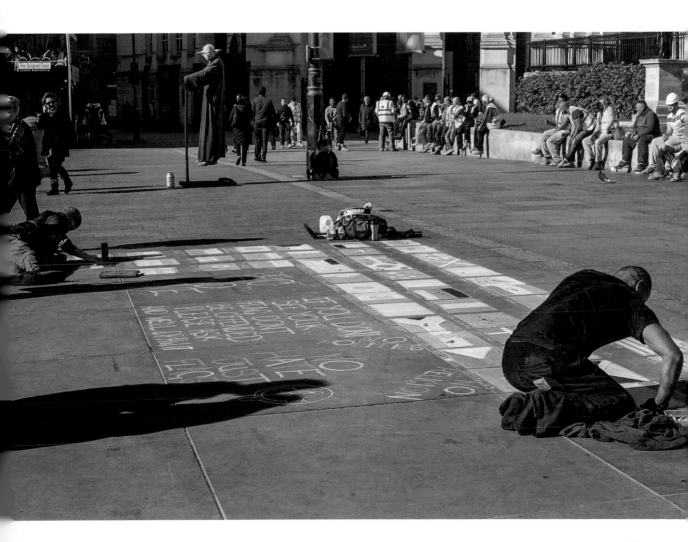

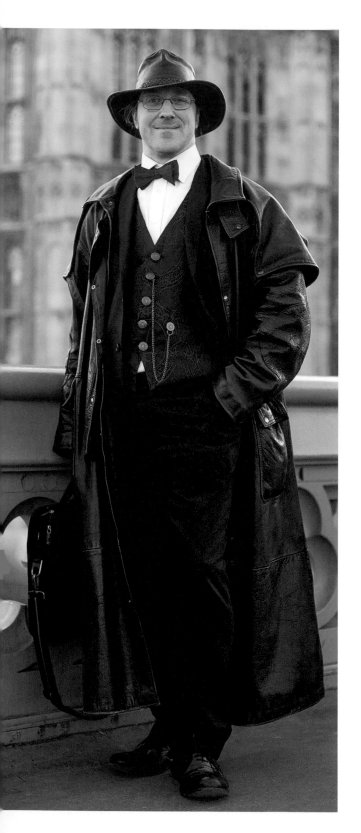

◄ **MALK:** 'Back when I was working in the IT industry and suited-and-booted was the way to go, I used to dress down as much as I could – I would go to the office wearing a T-shirt with ripped sleeves, held together with safety pins, and a cricket hat, walking round the office barefoot. Then, when dressing down became the norm, I thought, "Well, screw it, I'm going to dress up!" So I started dressing like Oscar Wilde.'

WESTMINSTER BRIDGE

➤ **LESLIE:** 'I run a stall here, I DJ, I do bits and pieces. I'm a proper old-school Londoner – I know how to survive.

'I used to be a very aggressive person, very angry. As soon as the police stopped me I'd start going "Rarara!" I was just playing into their hands, and I knew that. Now I realize, "Leslie, you're too passionate about what you believe in, you hate bullies, so the best thing you can do is just switch off." Because I will get arrested, I will end up getting into trouble, becoming an "Anti-System Person", because I don't have the power, the finances, the political backup to support my beliefs. Most people, as I say, are just too happy playing with their iPhones. I take my hat off to all those people who *are* standing up and using their voice. Me, I have no right to talk as long as I do nothing. I can only say that I really do hope it changes.'

With a spontaneous prop-adding friend
PORTOBELLO MARKET

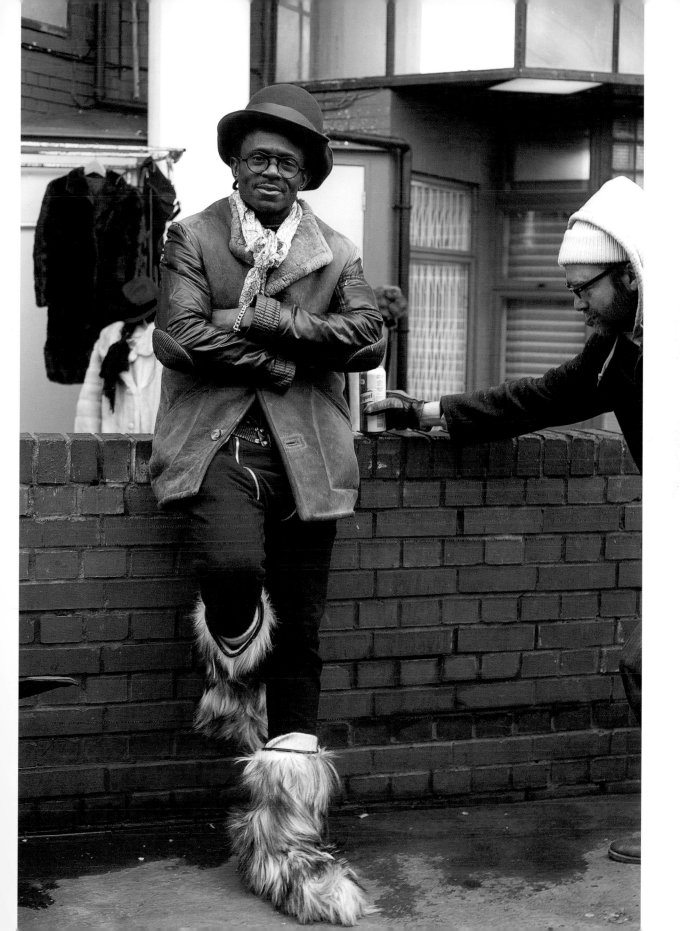

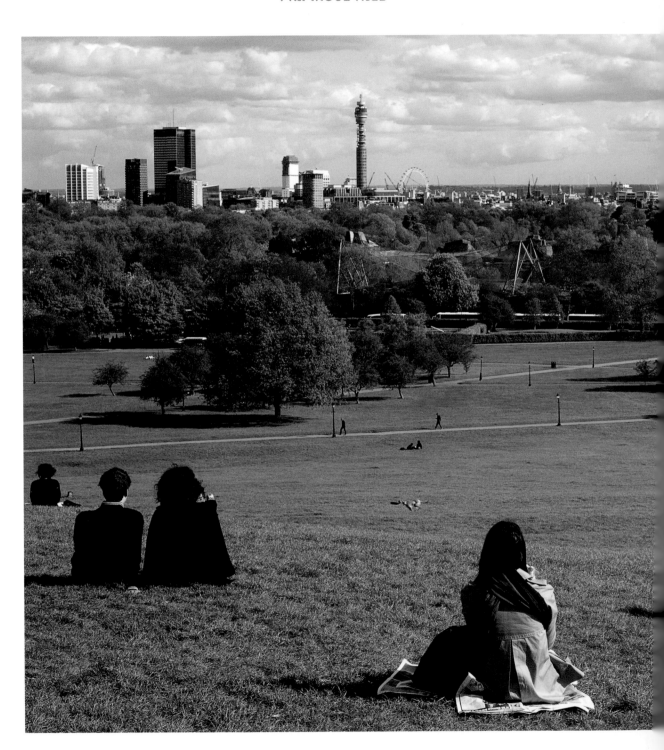

CATHY: 'I only started riding two years ago when I was sixty-one, and I'm still very much a learner, but this is a fantastic stables and riding school. A whole bunch of different people come here, all shapes and sizes, all levels of riding ability, and we go riding on the Common. It's bliss.'

WIMBLEDON VILLAGE

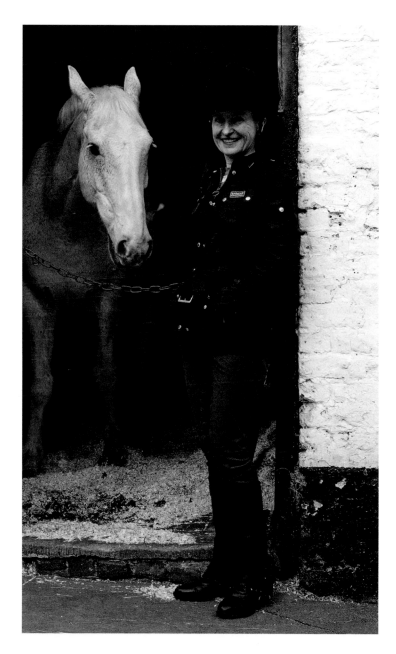

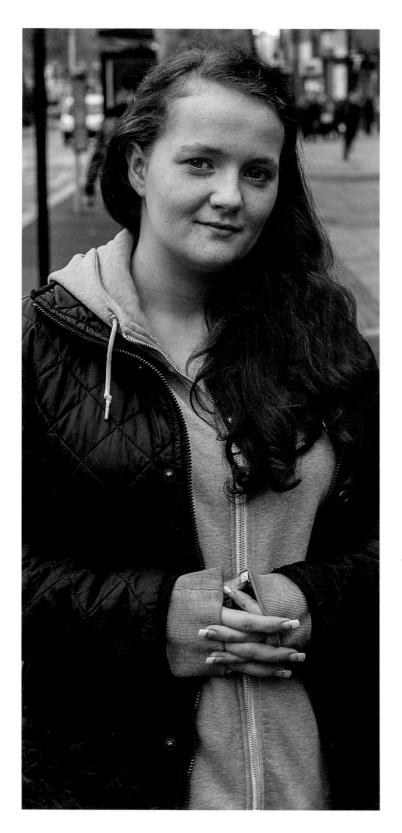

◄ **SAM:** 'I'm one of the original Focus E15 Mothers and I wasn't political at all before I was evicted. Now, I class myself as a made activist. Twenty-nine of us got issued with eviction notices, but we weren't given any explanation why. So we acted upon it. We decided to come together to see what we could do about it, even though we were up against something so big. And we actually won our court case with no conditions, which was astonishing, and got rehoused.

'Now we've changed our name to "Focus on the Future" to widen the spread and the awareness. Because we know it's not just happening to mothers like us – it's happening to the elderly, people surviving on pensions and all the low-waged people, not just to people on benefits.

'It's changed me immensely, and my confidence has grown a hell of a lot. I was never outspoken before, but just doing the street stall, getting to know people, talking to them, talking about the stuff that's happened to you and hearing about the stuff that's happened to them, that in itself builds confidence – in yourself and in other people too.'

STRATFORD BROADWAY

➤ **BETTY:** 'The Focus E15 Mothers were a massive inspiration. When I read about them I thought, "Do you know what? If they can do it, then I can do it too!" I'm a single mother with two kids and, about a year ago, I started up a campaign to stop the evictions of tenants of the Guinness Trust in Brixton. Now we've spent a whole year campaigning, lobbying, blockading, protesting, marching, occupying, and I've got the bug. I'm like "Woah, I can do this, really!" It's made me a lot more confident, much more practical and able to fix things in my home all by myself, and it's made me realize how the system works as well.

'For an ordinary person like myself, the system is like a maze. I won't lie, the stress levels are huge and it does affect your health, but the campaign has been a success in that they are now rehousing people – which they had no legal obligation to do, just a moral one. The saddest thing is, most of them are not being rehoused on the estate or even in Brixton, so they have pretty much destroyed the community there.

'But it forced me to come out of my comfort zone, and that's not easy at this age, in my forties. I've learnt a huge amount, and I've met loads of amazing people who are dedicated to helping others for no financial reward. So it's been really rewarding, really good, and it's actually made me a better person.'

BRIXTON

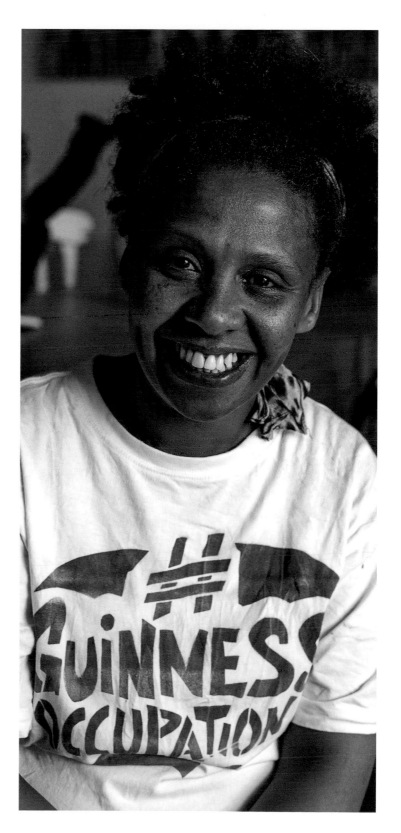

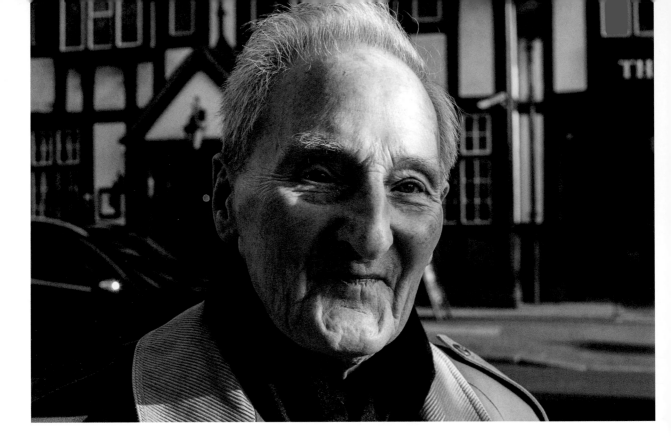

ARTHUR: 'In 1942, after I'd turned eighteen, my number came up and I was conscripted, so I saw quite a bit of war. I have two abiding memories from that time. The smell of death – it's not a nice smell, sweet and clinging. It gets into your hair, and you never forget it. And the first time I saw a dead soldier. He was a German lying on his back, and I looked at him and I thought, "Well, he's one of us. He could just as easily be the chap next door, a lad in my class at school. He could have been me." It made me think, "This is bloody silly! What's it all about?" From that moment onwards, although I was involved in the kiling spree which happens when you're a gunner, it was just about having the discipline to see the war through and trying to survive.'

CHEAM VILLAGE,
SUTTON

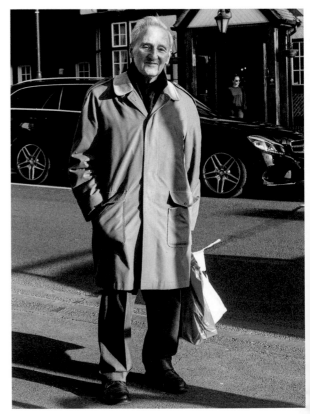

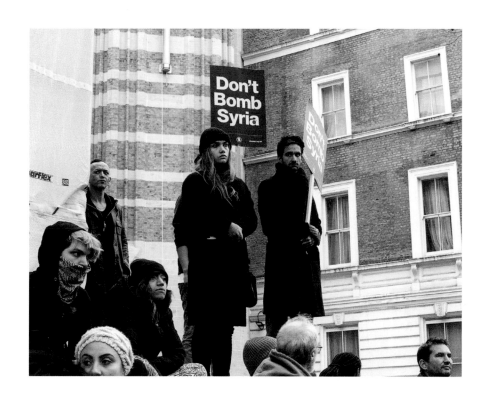

Don't Bomb Syria: London demo, November 2015

WHITEHALL

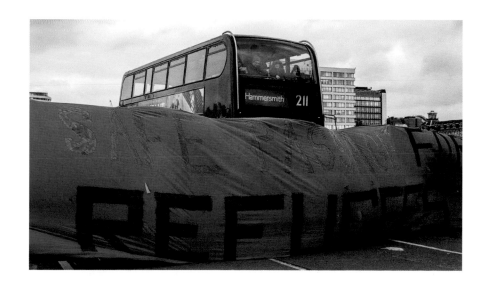

Emergency Demo for Refugees, March 2016

WESTMINSTER BRIDGE

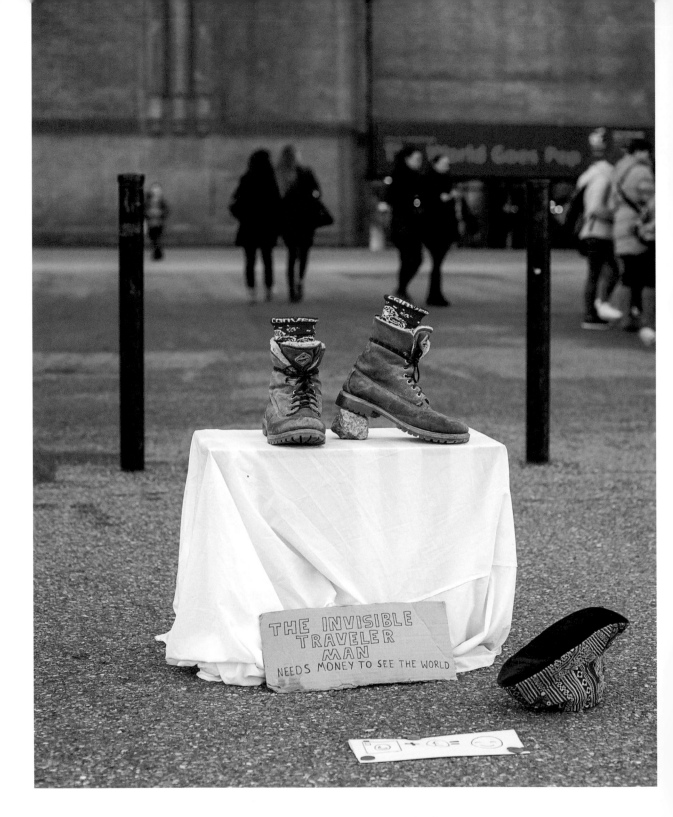

Nice try, in front of Tate Modern

SOUTH BANK

Beamed up
SPITALFIELDS

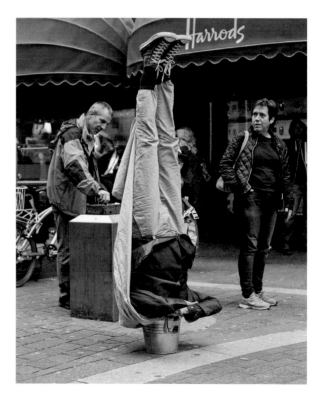

Superhero crash-landing
KNIGHTSBRIDGE

SONIA: 'I ended up working in mental healthcare for thirty years and I loved it so much, I felt this was where I should be. I've always been very good at loving myself, and that's made me very good at loving other people. I helped my patients feel safe and taught them strategies to deal with stressful situations, and they in turn taught me how to really be myself and that there is always hope. I think people are wonderful; it's so good to feel their warmth, and that's given me a very happy life.'

EALING BROADWAY

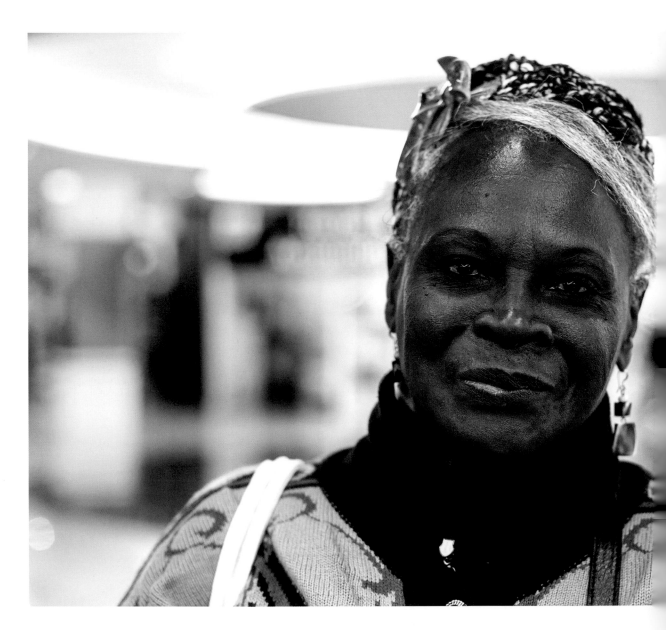

STANLEY: 'People in India, not many exceed sixty, sixty-five. At that age, you're really an old person. That's why I look at myself now and think, "What have I done to deserve still being here?" I'm eighty-six and I'm still ticking over, still walking about. Every morning when I wake up I say, "Thank God, I've got another day!"'

COCKFOSTERS

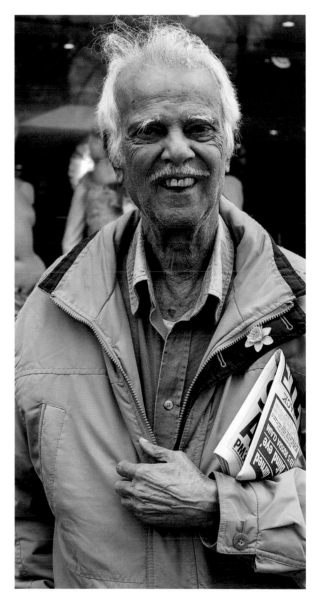

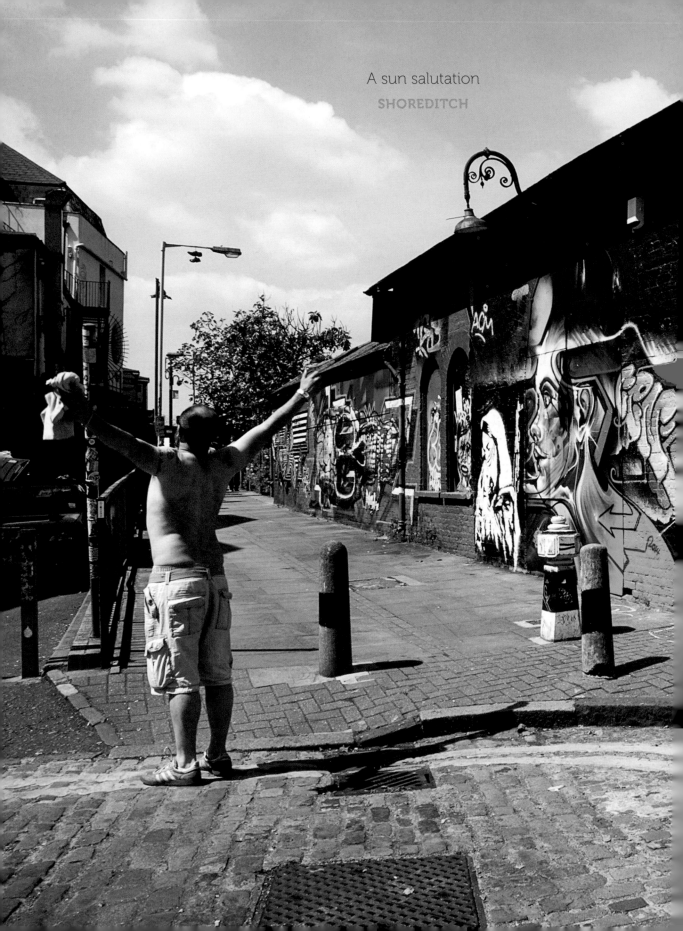

A sun salutation

SHOREDITCH

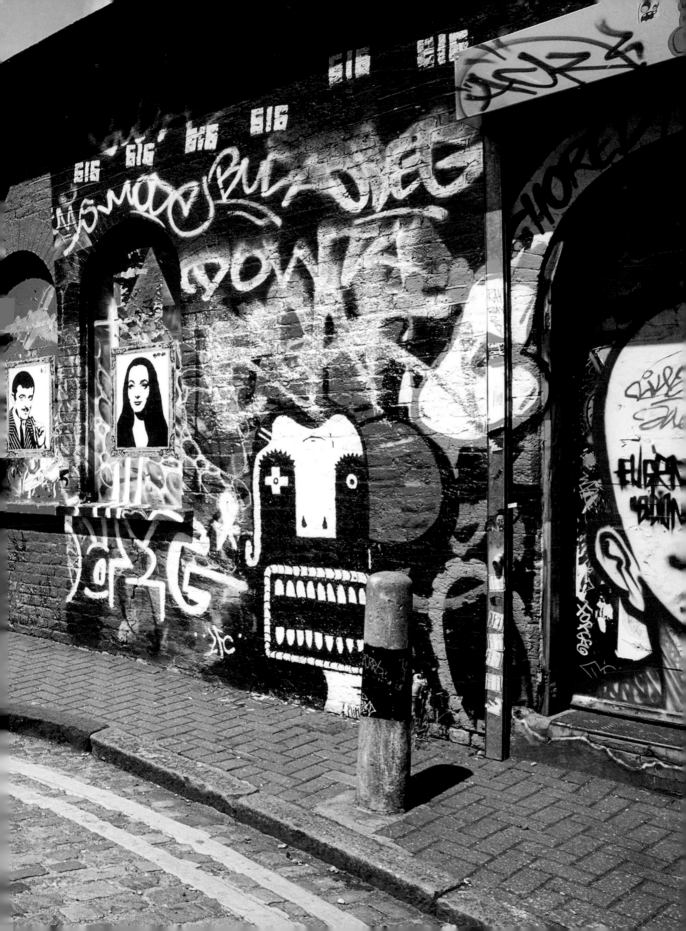

◄ **DONALD:** 'I came here from Harlem because I have a three-year contract with a top modelling agency in London. Then I decided to work at a care home for the elderly and disabled and study for my Care Diploma while I'm here too. Not because I need the money but just to do something different, and because I have a grandmother who's getting old, so I've been thinking about how she'll need to be looked after in a few years' time. She's a beautiful person, inside and out, and she was always there for me when I used to get in trouble as a little kid. Was I her favourite? Of course. I'm everybody's favourite once they get to know me!'

BARNET

➤ **DEZ:** 'This is the first march I've been on for a long while. Normally, I can't be bothered to go on marches. I used to do it when I was much younger. But what's happened recently in Gaza is too upsetting. To see so many children, women and old people being bombed and massacred made me think "I really need to get off my pipe and slippers here!"'

After the march against bombings in Gaza, August 2014
OFF OXFORD STREET

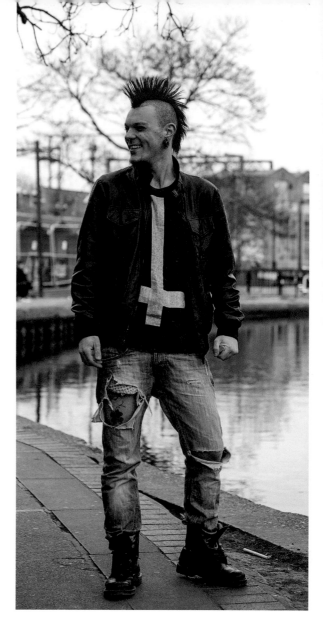

▲ **VINCENZO:** 'Always enjoy everything. Do everything to the maximum – but be careful to know your limits!'

CAMDEN LOCK

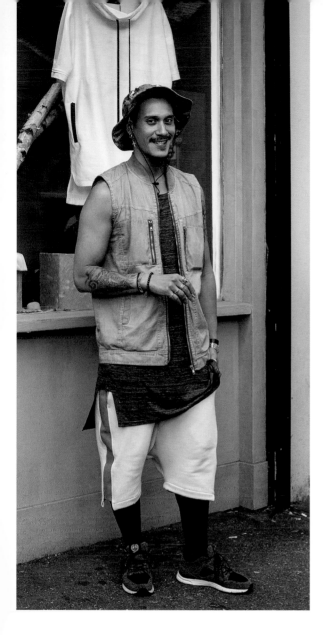

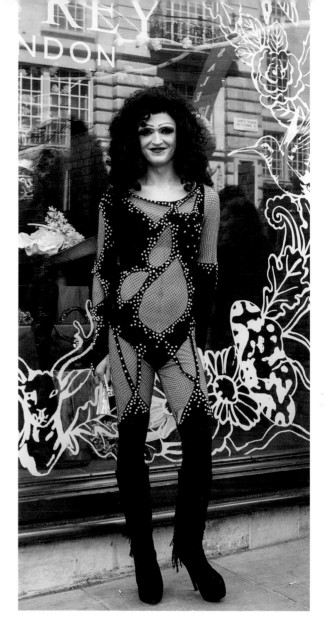

⌃ NICK: 'I've been with my girlfriend for eight years. We're both from Paris but we met in Ibiza, and we have a son now, he's one year old. We came to London a few years ago on holiday and fell in love with London. Parisian people are very angry all the time and not very open-minded. Here, you can be yourself and do what you want, wear what you like.'

CHALK FARM ROAD

⌃ REECE: 'My twin brother is gay as well and he likes to dress up too, although he's not quite as passionate about it as me, and we've got two other brothers who are straight. I'm lucky. My family's really accepting. Yes, you do get some grief but you take the good with the bad. I think the world's getting better at accepting all sorts of people for who they are. We just need a little more peace and love and we'll get there.'

Pride, June 2015
LOWER REGENT STREET

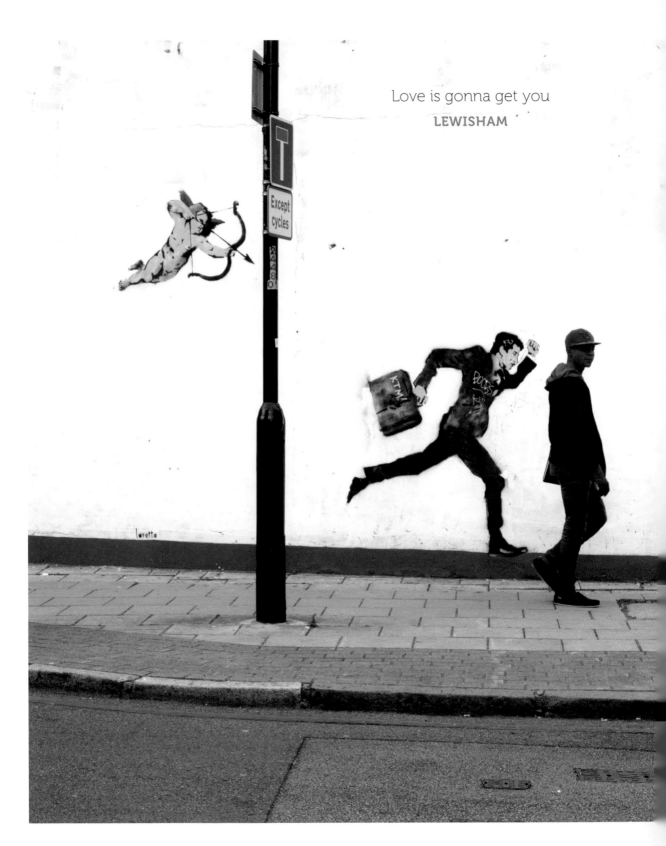

Love is gonna get you
LEWISHAM

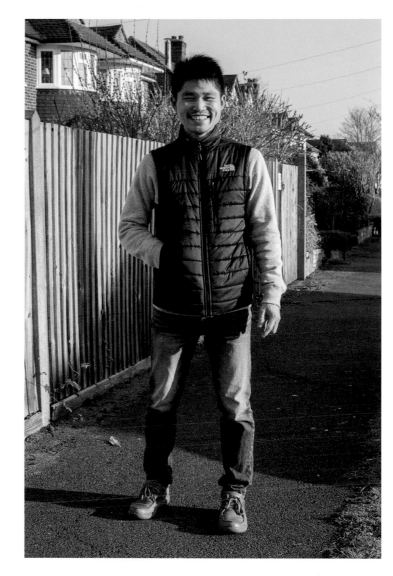

∧ JUNCHEN: 'I left my girlfriend behind in China when I came here seven years ago. It's a long time to be apart and I've hated not being able to help her if she has a problem, take care of her if she's sick, comfort her, hug her. But she's coming here next month for a holiday and I'm going to propose! If she doesn't accept me at first, I'll keep asking until she does! I've earned enough now to go back and start my own business, which means I can start a family too. I just don't think I can be away from her any more. She lives in my heart, I can feel her. She's the only one for me.'

SUTTON

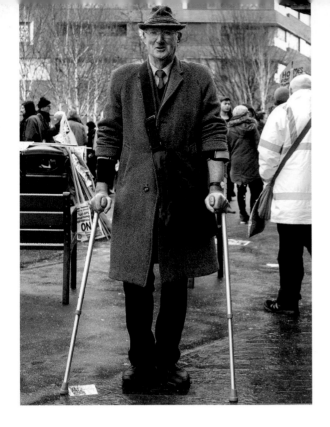

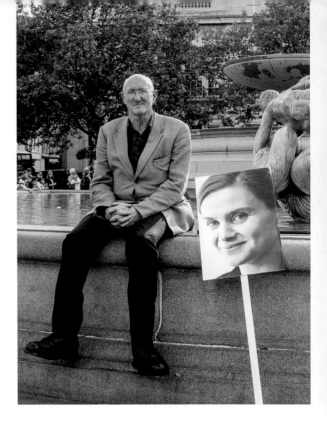

⋀ JIM: 'I worked as an inspector on the Underground for nearly forty-five years, and when I was locking up stations at night I was always having to ask people who were hiding there – some of them elderly – to go out into the cold, bitter night, knowing I was going home to a warm bed. So I went and found out the addresses of hostels and shelters where they could stay, made it my business to help them out in any small way I could, and I got to know most of them in the end. Since I've retired, I've kept doing it.'

At the March for Homes, December 2015
CITY HALL

'Whenever I'm going through a hard time, thinking of this poem by Oliver Goldsmith always helps me pull myself together and get on with it. It goes:

'Hope, like the gleaming taper's light,
Adorns and cheers our way;
And still, as darker grows the night,
Emits a brighter ray.

'So that popped into my head today. It's like the Chinese saying that "it's better to light a light than to curse the darkness." This was lighting a light today.'

Jim, met again by chance at the More in Common gathering to commemorate Jo Cox, June 2016
TRAFALGAR SQUARE

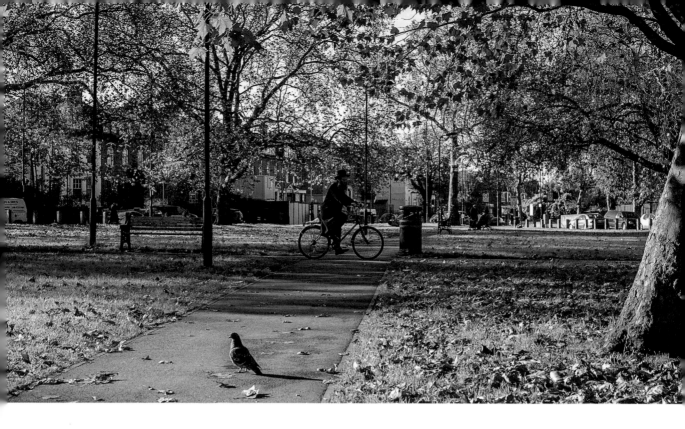

CLAPTON

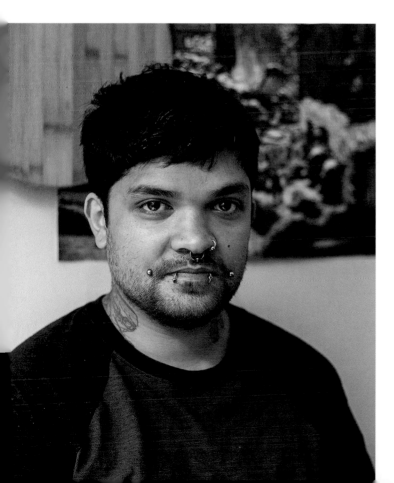

◄ **JAY:** 'I was diagnosed as bipolar when I was seventeen. It's a chemical imbalance, but it's also genetic. I could become so volatile that it was really difficult for other people to be around me, but it also boosted my creativity, I was drawing all the time. I've so far chosen to section myself three times (when I was being so manic I thought I might keel over with a heart attack), but I don't want to become one of those people who's always in and out of hospital. I feel so defeated after.'

BOROUGH

◀ **GARY:** 'I founded and lead the Victoria Cross Trust. It's a military charity that commemorates, honours and looks after the graves of British heroes. We got a donation once, an ordinary little envelope that contained £5, from a twelve-year-old boy who said, "I've seen what you do. I only get £5 a week pocket money, but I'd like you to have it." Knowing that there are twelve-year-old lads out there who are now getting educated about these guys, and what they did, their value to us as a community, that's been my proudest moment, I think.'

VICTORIA MEMORIAL BY BUCKINGHAM PALACE

The difference a ten-minute chat can make.

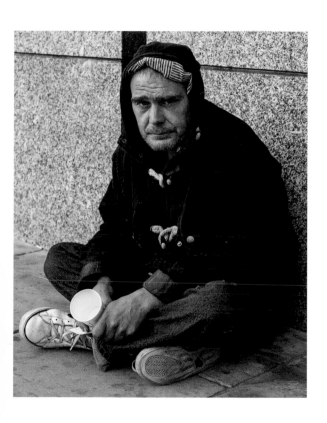 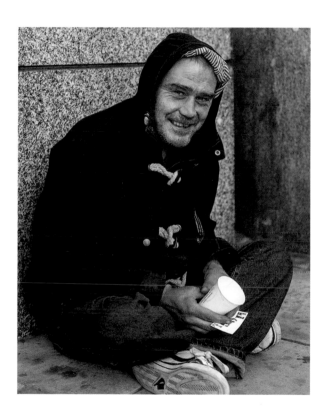

▲ **JIM:** 'I've got hope. You've got to have hope, haven't you? If you haven't got hope, you've got nothing.'

LONDON BRIDGE

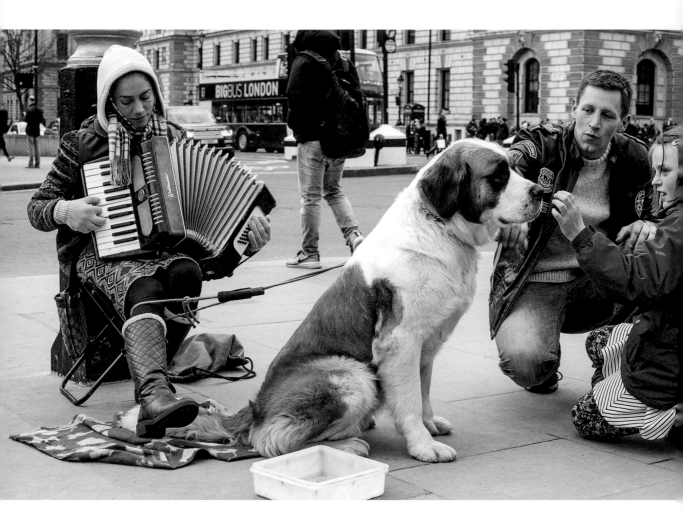

⌃ STELLA & BELLA

S: 'Is very hard. I came here a month ago. I thought I could find work but is not good, there is no work, I have too little English. I have three-year-old baby, I have to buy Pampers, we're sleeping in a car. I play accordion to survive.

'My husband look after her while I do this. Then when I go back he go out to make money. We want to go back to Romania but is long way away. We need to find enough money, £500, to go home.'

WESTMINSTER

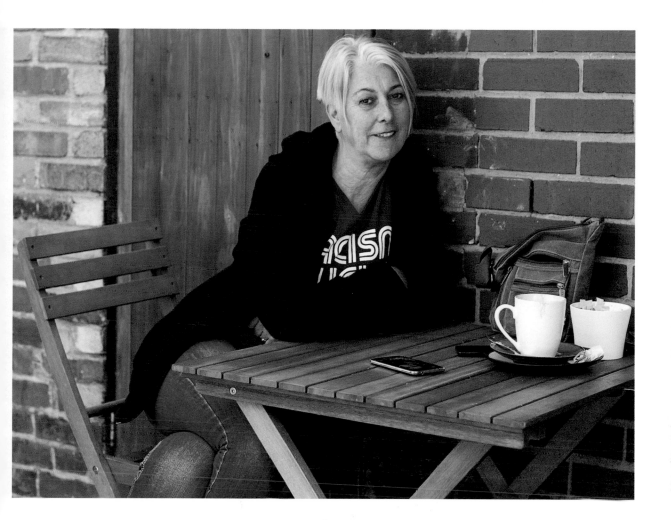

JANIE: 'I went to the "Jungle" in Calais six weeks ago, and when I came back I sat and cried for about three days. My mum called it "spectator stress", which is a bit like survivor guilt – you can get it when you're looking at horrific things that you can't change. There aren't nearly enough toilets, so when it rains there are landslides full of sewage that wash all the tents and other temporary structures away. Loads of the lads are wounded too, with gashes and burns and broken limbs from trying to break through barriers, or falling off vehicles they've tried to hide under. And they only get one meal a day, in the evening, unless the food has run out by the time they get to the front of the queue, in which case they don't eat.

'But I've just set up a crowdfunding page to buy fire bricks, fire boards, pizza stones, flour and salt. So I'll be going back to deliver those and give workshops on how to build simple brick ovens and make pizzas and flatbreads. I'm going to make a practice one this week outside my flat, but I'll have to watch some videos on how to do it first!'

Janie is now one of the coordinators for the Refugee Community Kitchen, which is feeding roughly 2,500 refugees in Calais and Dunkirk
HAMPSTEAD HEATH

193

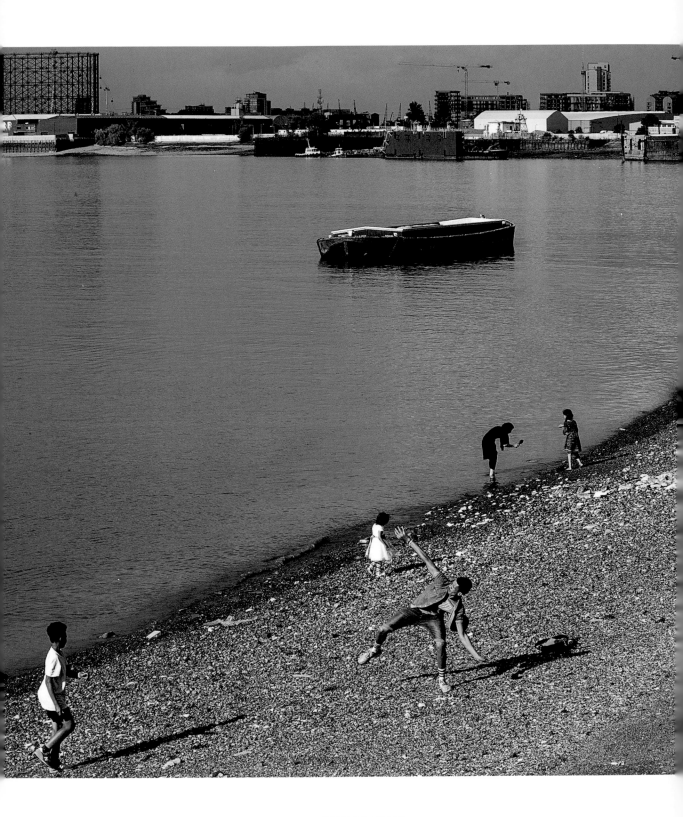

GREENWICH

▾ **AGNE:** 'I came from Lithuania two months ago because I fell in love with a man who lives here, then we broke up the day before my twenty-first birthday. But, you know, life goes on. And when I meet the right person, I will appreciate them more. Without night, there is no day. Now, step by step, I'm falling in love with London. I have a new man and it's this city!'

GREENWICH

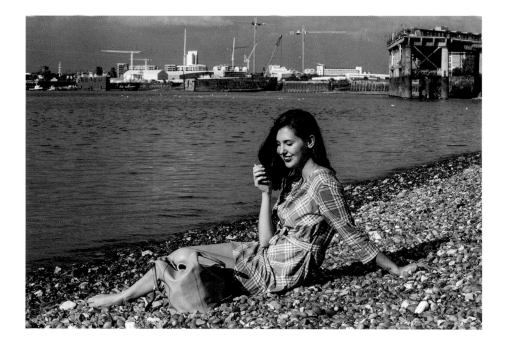

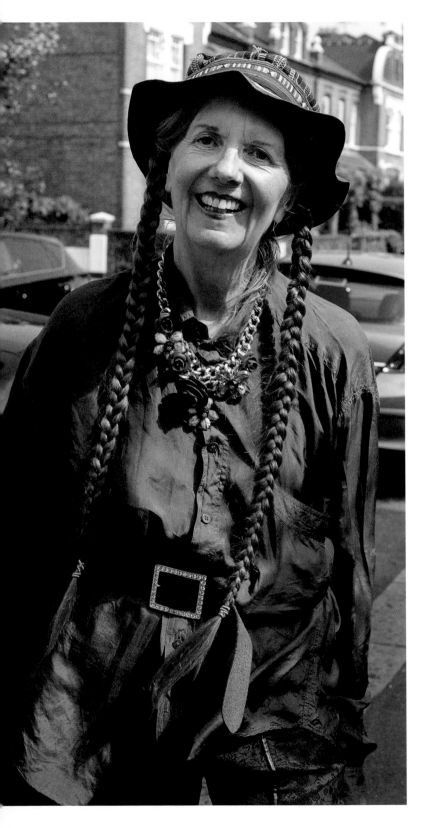

TUPPY: 'It all started back in the eighties when I was selling my book *The Sex Maniac's Diary* and one of my distributors, Nigel, was losing his sight. He was quite swanky, and when it had completely gone his girlfriend and most of his friends deserted him. So I said, "Right, I'm here for you, I'm going to look after you!" Because losing my sight is my worst nightmare, I was determined to stick by him. So I took him to parties, we had a laugh, and I introduced him to women and that's how he managed to find new girlfriends. Then we thought "Let's start a club for people who are disabled and who want to find partners." We called it "Outsiders".

'You know, when you start these things you think, "Oh, this will never last!" and here we are, thirty-six years on and it's still a great success. It's all ages and all disabilities, dating and friendship. It's brilliant. The peer support our members give each other is remarkable. I love it to bits.'

CROUCH END

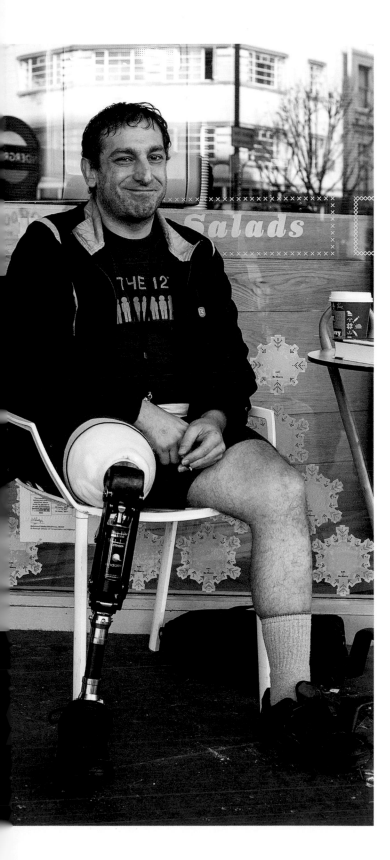

◄ KIRY: 'Ride a bike, not a moped. If I'd hit that barrier on a motorbike, it would have hit the metal rather than cutting through my leg. But, at the end of the day, it's only a leg. I've still got the rest of my life to live and they make really good prosthetics these days. The leg works brilliantly. It's the KX06, the state-of-the-art, hydraulic one they give to squaddies who've been blown up in wars, which means you can ride a bike, or even run It's the stump that's having a really hard time adjusting to it. Every step is painful For now, I guess I'll just have to keep pushing through the pain barrier because I refuse to end up in a wheelchair. I'm determined to get back to being as active as I can.'

NOTTING HILL

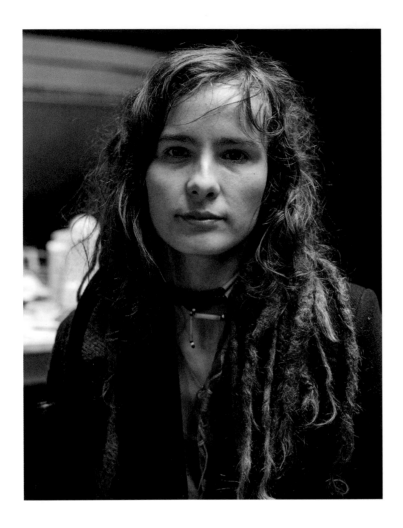

⋏ PETRA: 'Time is getting short, with global warming and the rubbishing of the planet, but I believe if we can make a real change here in London, it will give a great example to other countries in Europe. It's all about inspiring creative resistance.

'For Christmas, we're planning to make an Act of Compassion – giving free dinners and gifts to everyone who comes along, by collecting donations, thrown-away books and clothes, and some of the 8,000 tonnes of good food that's dumped in London every day. It will be the opposite of Black Friday! We want to encourage people to give to and support each other, to unite and share.'

Occupying the closed Sequoia pub
WHETSTONE HIGH ROAD

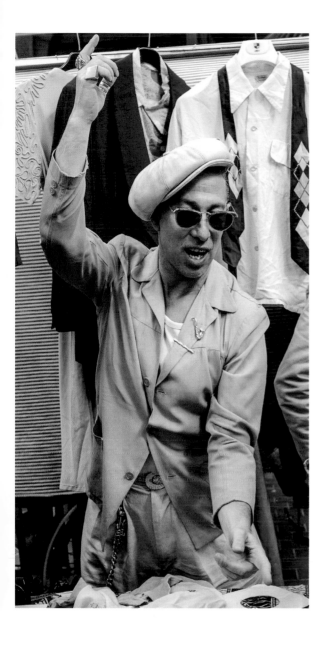

NATTY: 'I grew up mainly in Thamesmead, which is a massive, three-mile-square, grey council housing estate. My parents were both teachers. My dad was musical, my mum was an artist, and they were both righteous – they'd do the right thing and they wouldn't accept racism at all. There was quite a lot of violence at school and I'd also get quite a bit of abuse from the skinheads who'd call me "Paki-lover" or "Nigger-lover" or (because they were Nazis and they knew I was Jewish) "Gas-dodger". Sometimes they'd beat me up. But my parents had taught me how to be a decent human being by living it, and I'd discovered that expressing myself through art and music, and sculpting my own style, were what made me feel really alive inside, so it was worth the alienation and pain.'

SPITALFIELDS MARKET

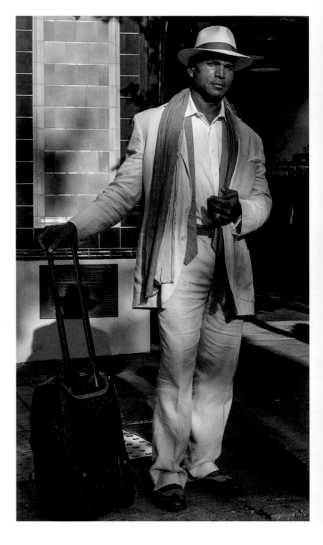

∧ **SUBH:** 'Last week I was looking a bit laid-back, so this week I thought I'd raise the bar and be a bit more glamorous and stylish. It's not for any reason – I'm not going out anywhere or meeting up with anyone. I just thought, "Why wait for a reason to dress up, I'm going to do it anyway." It's good to just do what you want to do and not have to wait for a reason, otherwise you can end up waiting for your life to happen to you.'

CAMDEN ROAD STATION

∧ **BRIAN:** 'I always look this fabulous. You put something on, and you become that, and you go out and you face those insecurities and you make something beautiful happen. And in that way, I think fashion is very, very, very serious, at the same time as being deeply, deeply superficial.'

SEVEN DIALS,
COVENT GARDEN

REGENT'S PARK LAKE

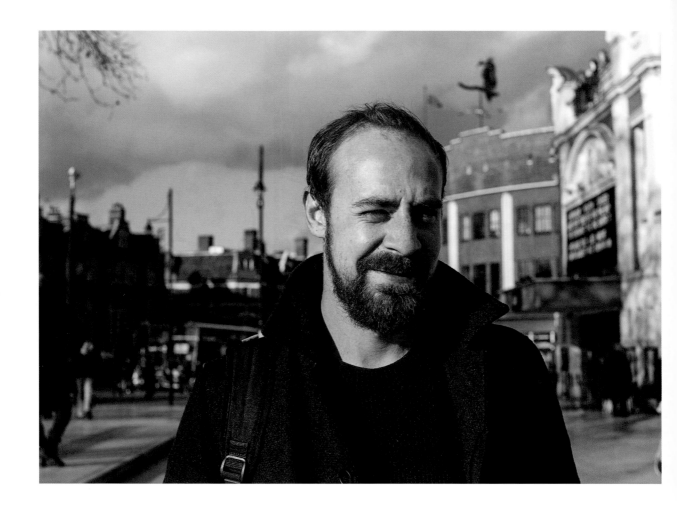

ᐱ ALEX: 'I do think education's still stuck on Victorian lines. That worked in the industrial age when they needed workers to go into the factories, but we don't need that any more. We're a service economy and entrepreneurship is what drives Britain forward, that creativity. That's why we're so powerful – little island that we are. So, I suppose my rebelliousness at school has served me well. Now I'm my own boss and I'm excited to be at the forefront of the Airbnb movement that's looking at a different way of doing things – a sharing economy.'

➤ MARINA: 'Romania is very, very beautiful country but it is very poor country; there are no jobs, no chance to get experience, so all the young people are going. I came here, I didn't have experience, but they like me, they take me, they give me a chance.'

BRIXTON

BARKING

202

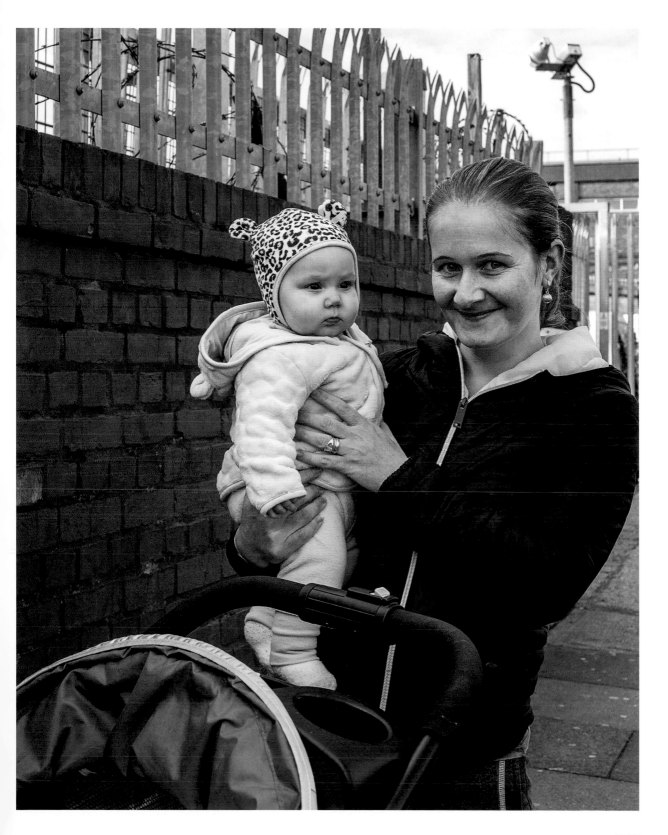

➤ **MONICA:** 'I do love to dance! I'm actually a travel agent, but I'm also a fairy.'

BRIXTON

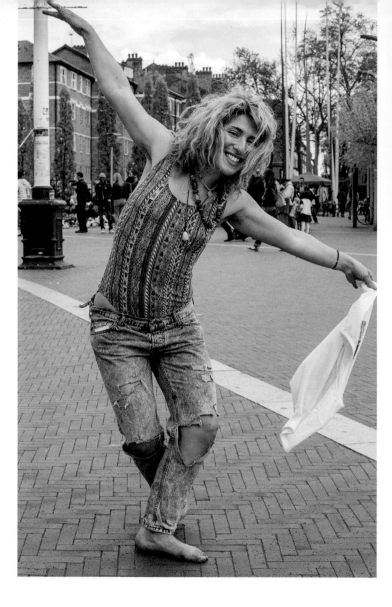

➤ **JENNY:** 'I love doing fairy stuff with Monica. You know how the Tube in London is the most closed-off place? If you go on dressed as a fairy, people can't help but smile and interact with you. Our magical power is bringing people happiness and joy, and helping to break down their barriers too.'

BRIXTON

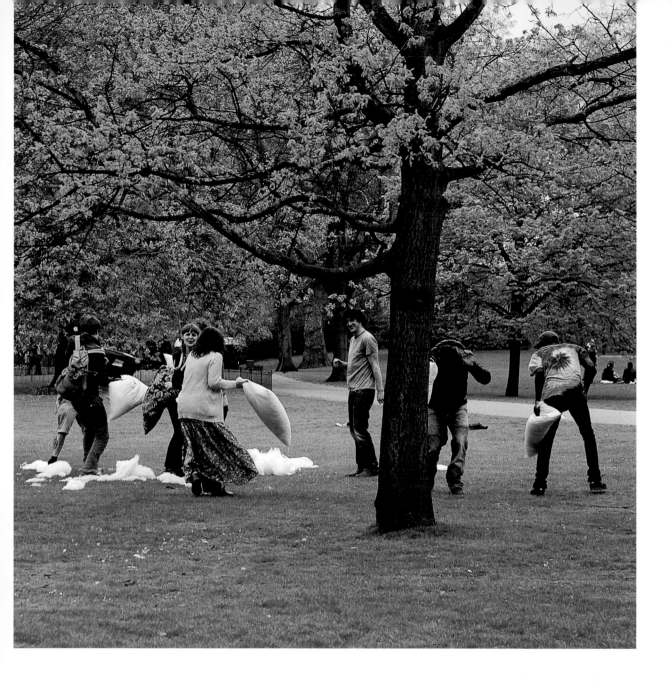

A spontaneous skirmish on International Pillow
Fight Day, spotted a little way from the main
event in Trafalgar Square, April 2015

ST JAMES'S PARK

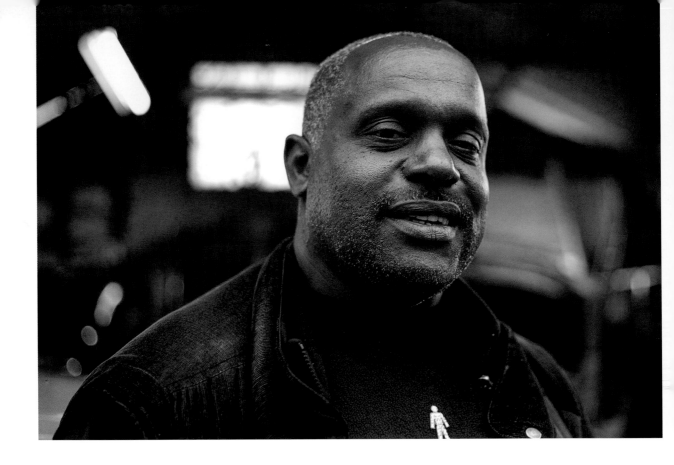

ERROL: 'I was one of the lucky ones. My wife was complaining about my snoring so I went to the doctor, and while I was waiting for my appointment I picked up a leaflet from Prostate Cancer UK. So I asked the receptionist for an appointment for the test and she said, "You don't need one, it only takes ten minutes." Little did I know that those ten minutes were going to change my life.

'Nothing prepares you for that word "cancer". When someone tells you you've got it, it does knock the stuffing out of you. I went and sat in my car and I cried and thought, "This can't be." My wife came and sat with me, and she let me cry, and then she said, "Well, what are you going to do? You've never quit on anything." So I decided I needed to stop crying and go back in and face the problem. I had the operation, had my prostate removed, then some chemo and radiotherapy treatments after and, fortunately for me, I'm now cured.

'Prostate cancer is a major issue, it's a silent killer, affecting 10,000 men a year in the UK. One in eight men will be diagnosed; one in four are Afro-Caribbean. But eight out of ten men are not even aware of what the prostate does, never mind the problems that it can cause, and it's much more of a taboo for men to talk about their body health than it is for women.

'I consider myself very lucky, so I started offering my customers a 20 per cent discount on the cost of their car repairs if they'd go and get their prostate checked, telling them that it's as important to MOT their bodies as their cars. Over the past two years, thirty of my customers have been diagnosed and twenty-eight have survived, and we've so far raised £22,500 for Prostate Cancer UK. So now I try to talk to at least a hundred people a day about this issue, I'm that passionate about it, trying to save one life a day.'

HOXTON

> **MARTIN:** 'I think it's one of the greatest things we've ever done in this country, create a free National Health Service. We were so respected for it – before we started selling it. So I'm here to fight for the NHS basically. Doing this here has been amazing – every time someone beeps it makes me want to stay for another hour.'

PARLIAMENT SQUARE

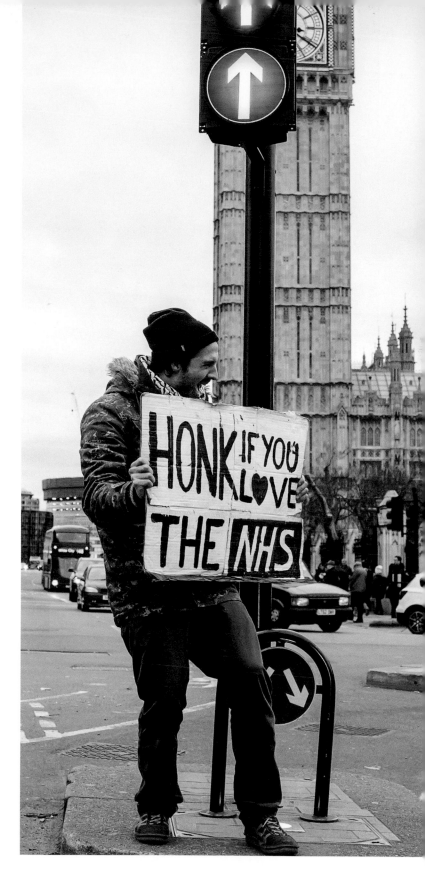

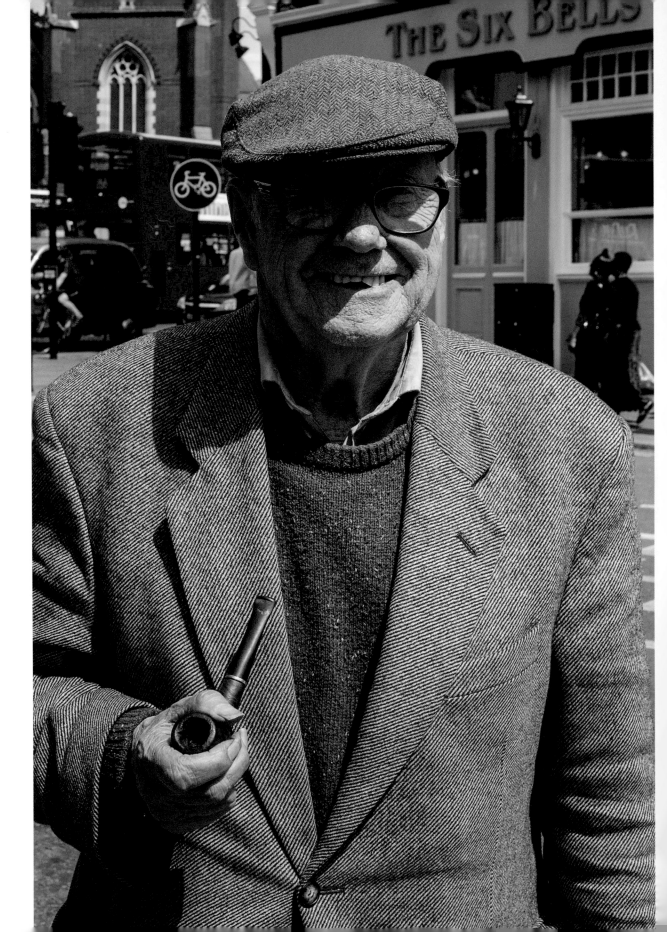

◄ **BRIAN:** 'I'm nearly seventy-five. By 1965 I'd lost all my family, and I live alone, but I make sure I get out most days, so every day is different. I'm good at talking to strangers. You have to be really, don't you?'

ACTON TOWN

➤ **BOB:** 'It can take me between four and eight months to find and collect all the right ones together, and then get just the right combination on a hat. I've got about 3,000 of these pins. It's my way of expressing myself, I suppose. I also found putting lots of them on my fishing cap reflected the sun and kept my head cool, so then all my fishing mates started doing it too.'

UXBRIDGE ROAD

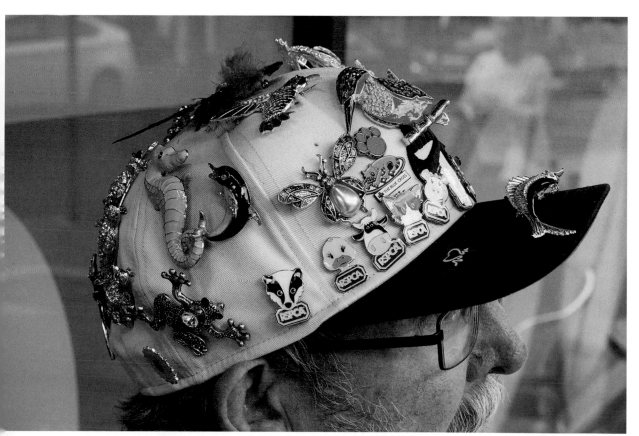

Ritzy Brixton

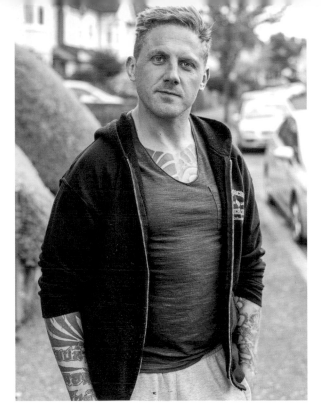

GREG: 'My family have worked at Columbia Road Flower Market for over 100 years, but I always wanted to be a professional wrestler instead. I had no idea how to make that happen, but after I was almost run down in New York by a skidding ice truck, I decided I just had to do it, not risk lying on my deathbed with regrets. Anything's possible if you've got that drive and vision, if you want it enough and you don't give up. But you really have to structure it and ask yourself, "What are the small, minute steps I need to take to get there?"

'Now I'm a professional wrestler and a stuntman, a fight choreographer, actor-producer and a director too. I've just made my first feature film, *London Rampage*, about a fight that decides the new leader on a rough council estate in the East End. I made it on a very low budget. Everyone told me it was impossible to make a feature for that little, but I just flew back from the Cannes Film Festival and now it's being sold for distribution.'

WANSTEAD

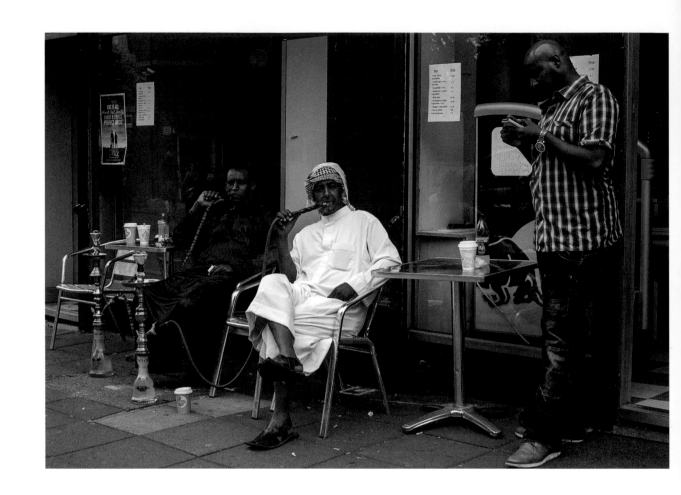

^ MUSTAFA: 'I don't always dress like this but today we are celebrating Eid. One month of fasting – twenty-one hours every day of no eating, no drinking, no smoking – has just finished, so everyone is very happy. Did you know Eid is also the day when you must forgive, for the happiness of the family and to remember God?'

CROWN STREET

➤ QALID: 'I'm going to be on Facebook? Cool. I'm going to show this to my teacher!'

CROWN STREET

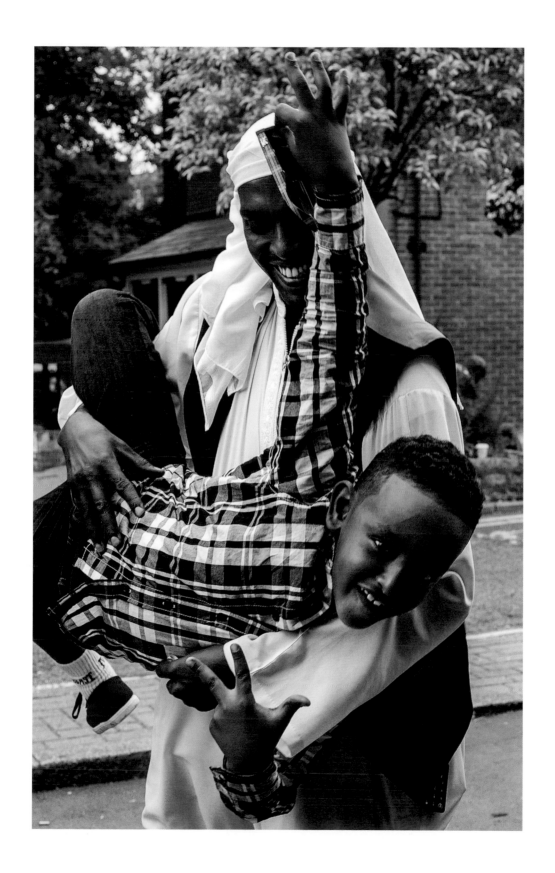

The Little Greenhouse transformed into a shadow lantern as part of the Festival of Light

DALSTON EASTERN CURVE GARDEN

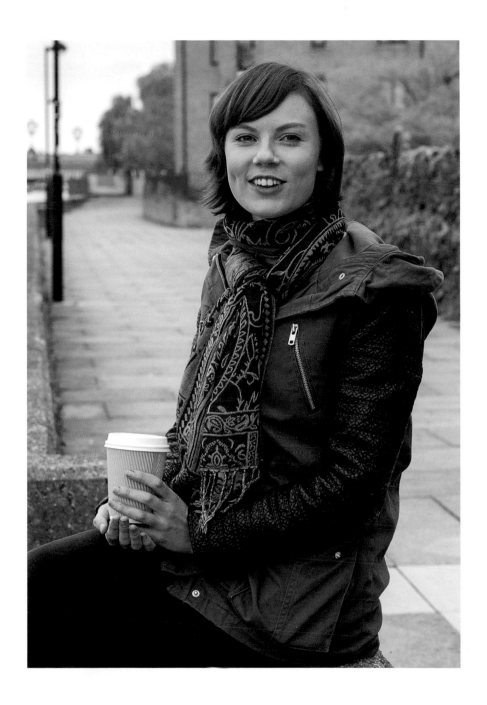

▲ **HOLLY:** 'Painting, for me, is the ultimate freedom. I'm quite a physical painter – I use a lot of paint! I really chuck it at the canvas, which is fun, and sometimes I'll dance to music while I'm doing it too, to get into the flow. It does mean it's a very messy studio with paint everywhere – it's all over the walls, the ceiling and the floor!'

PUTNEY BRIDGE

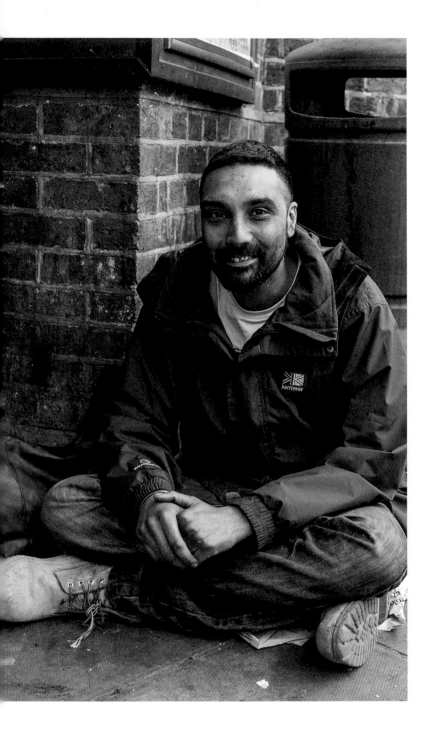

Jay's Story

JAY: 'I'm a British Indian, born and bred here, and I've been in this predicament for just over a year. My family don't know I'm homeless. I keep in touch with them and find out how they're doing, but they've all got their own lives and I don't want to burden them or stress them out. I'm thirty-two years of age now, so I think I'm old enough to fend for myself. I've had some good jobs – airport security, MoD work, archiving and research on Royal Navy WWII files. It's surprising that someone who's capable of these kinds of things could end up in this situation. Life can take some funny, funny turns.

'But, you know, I've learnt a lot along this journey. I've met some amazing, amazing people at this spot, the best of every nationality. People who've brought me home-cooked food or paid for a week's worth of coffee and toast at the local café, who've given me expensive jackets or blankets or missed me when I wasn't here because I got a couple of weeks' work. All the friends I've made, and the love that you feel from them, the concern, I'll cherish that forever. Even when my life gets sorted out, there'll always be a space for them in my heart.'

April 2015
ACTON TOWN

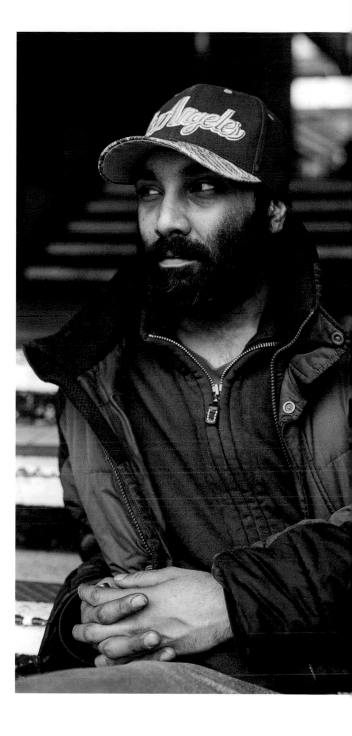

I didn't see him at the station all summer and autumn, and just hoped he was doing OK. When he reappeared in his usual spot, I found he'd been in a basic shared rental for six months then the landlord had decided to redecorate and he'd become homeless again.

'I'm grateful that I haven't developed any problem with drink or drugs. I'll have the odd sociable drink, but any more than that is not in my best interest. It's also money that I'd rather spend on other things – like socks! I'm forever running short of those because I haven't got the facilities to be washing them all the time.

'I've just been filmed as part of this BBC Three documentary on homelessness. They paired me up with Julia Bradbury for two days and two nights. The hardest thing about being homeless is being alone, so it was really nice to have company, have someone stay where you're staying and eat where you're eating. I enjoyed taking her under my wing and feeling that I was looking after someone else for a change too. Then the BBC organized an interview and trial training session for me with Change Please and she actually started crying!

'It's a new venture, backed by *The Big Issue*, and it's a great opportunity for me. They sell coffees out of these little vans and my barista training session with them went really well – the guy who was teaching me was really impressed by how quickly I learnt to use the machines – so I think I might get the job!'

December 2015
ACTON TOWN

CONTINUED ▷

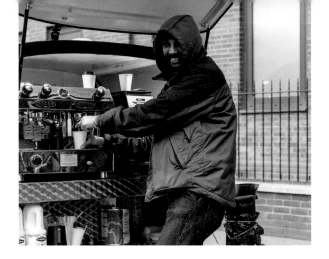

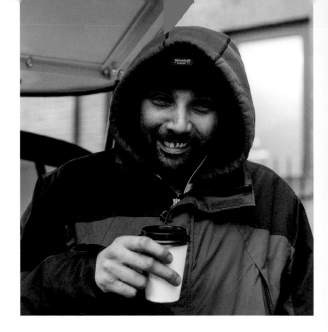

'I'm happy – I got the job, I'm working right now! This is a new phase in my life, so I'm just trying to make sure I get my arse here when I'm supposed to – at 7 a.m. I'm not overly a morning person, and it's hard to get early nights when you're sleeping outside or in untoward places – you basically have to wait until things settle down so you're inconspicuous. So I've been going to sleep anytime from 11 to 1.30, then I'm up again at 5.30 to be leaving for 6. Some days I've had to jump the train, just to get myself down here. Other days my boss has given me a bit of money to put on my Oyster card.

'I just want to say a really big thank you to all the people who've read my posts on your Facebook page and left a comment. It means a lot that people have a supportive reaction and that they make the effort to put it up where everyone else can read it. So thank you very much! They're quite inspiring. They give you the strength to carry on, the energy to keep going, because they're so positive.'

I could print them out for you so that you can reread them whenever you like?

'That would be really nice. Then I can maybe reflect on them when I'm feeling a bit low, feel a bit of extra warmth.'

Then came a vicious cold snap and, having read on the page how Julia Bradbury had paid for Jay to stay in a B&B over Christmas, a bunch of Humans of London fans stepped up to pay for him to have more warm nights indoors.

'Tonight will be my fourth night in the B&B, I've got two more and then Sunday's booked too! What can I say? It's just been amazing. When I'm brushing my teeth and looking in the mirror, I keep smiling to myself. I feel so lucky! I've been so comfortable that I actually haven't wanted to get out of my warm bed to go for training, but I've got up because I don't want to let people down. People have got faith in me. People who've never even met me face-to-face are prepared to spend their hard-earned money on me, so I'm not going to let them down, or let their money go to waste. I appreciate it so much because they've given it out of the goodness of their hearts, without my ever asking, which makes it so much more personal and precious. You never know, one day they might come past my little stall and I'll get to make them a coffee and thank them in person!'

January 2016
LONDON BRIDGE

January 2016
LONDON BRIDGE

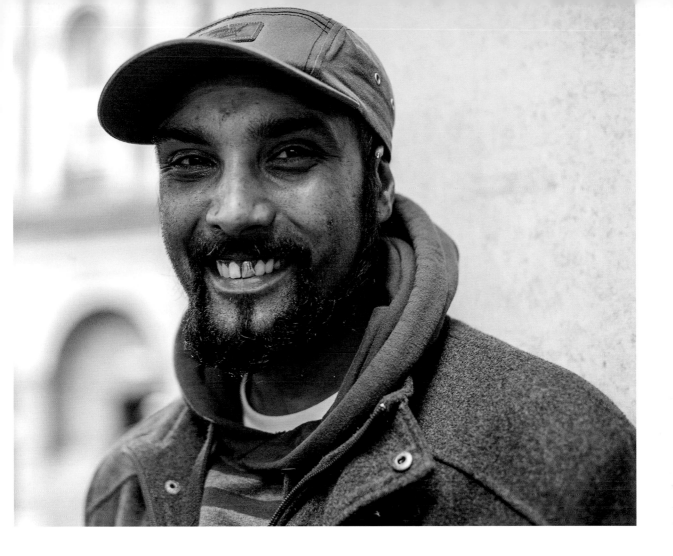

'I've got a roof over my head now – I've been staying in a hostel just up the road in Kennington. It's a brand-new build so it's in really good nick, really clean, up-to-date, very modern. £25 a night – that's a third of my daily wage, basically, which isn't too bad really.

'I've been working as a Change Please barista for five months now, going on six. In a sense, I'm my own boss. I take responsibility for what's going on here – it's on my head to deal with the customers as I think appropriate, get my spot, make sure everything is as it should be, take care of health and safety issues. Don't forget that I've got wires running off the van that connect to a power point and there's water here, so you could quite easily get electrocuted for pissing around.

'I'm enjoying working here – meeting all sorts of people from all over the world. It's so colourful and diverse, it's got a nice vibe. So I'm not thinking ahead at the moment – I'm just glad that I've got a job and a really decent boss with a big heart. I feel privileged that he's asked me to do certain things for him – like go down to Brighton and do The Great Escape Festival, give speeches in front of a board of investors and at social enterprise breakfast clubs. Obviously, I did that BBC documentary, and I've recently been in an advertisement for Change Please, which had over a million hits worldwide in a matter of weeks. So now I'm famous too, hahaha!'

June 2016
BOROUGH MARKET

219

ABOUT THE AUTHOR

© David Oliver

CATHY: 'I've long been accident-prone (though luckily good at bouncing, too) and, in the summer of my second year at Exeter University, after a too-hectic weekend of editing the student newspaper, I managed to tumble eighty feet down an unstable Devon cliff onto the rocks below. I'd been looking for an empty beach, had found one, and hadn't let the lack of a cliff path stop me. After landing head first and smashing my skull, I then staggered around on the beach for two days before I was finally found and airlifted off to intensive care. Once there, I'm told all I would say, over and over, was "I'm *not* going to die!"

'I was very lucky to survive, and that the CAT scan came out fine, although I did have such serious concussion that for almost a year after it felt as if I had brain damage – all the leads seemed plugged into the wrong holes. But having come that close to death, especially so young, proved a revelation. It also sparked an intense interest in the whole topic of "survival" and the extraordinary power of the human spirit to overcome extreme odds.

'With two artist parents, but unable to draw well myself, I'd enjoyed photography from an early age, but it wasn't until I helped set up a student darkroom that I really fell in love with its magic. So, when I graduated (only a year late) and moved up to London, I began work as a freelance photographer, writer and editor, and I've been doing that ever since. My two favourite commissions actually prefigured HOGL. One was recording Southwark's rainbow of carnivals, festivals and workshops as the council's official event photographer, and the other was celebrating the wonderful human diversity of Brixton through its community project "Brixton Has Many Faces".

'In 2003, I left London, moved down to Brighton, and just loved it. Not only for its special light and vibrant subcultures but also its smaller size – it's often described as a 'Little London by Sea'. I felt part of a community,

loved bumping into friendly faces in the street and firing up creative connections, and regularly being offered work and exhibitions didn't hurt at all too. But my beloved partner Simon needed to be up in London, was often driving long hours for work, and eventually confessed that the added London–Brighton commute was making him feel his life was "bleeding away in the car". So, in 2007, love trumped location and London reeled me back in.

'Now, I'm so grateful to HOGL for giving me a licence to connect with any and all Londoners, whenever they interest me and wherever I find them, and allowing me to bring others closer together here too. Thanks to that, London finally feels like home.'

The 'Brixton Has Many Faces' project was a community response to the latest in a long line of sensationalist newspaper articles claiming Brixton was a haven for gun-toting drug dealers. It involved photographing 127 humans found in Brixton over five days and three nights, and produced this poster, which I still have proudly taped to my wall.

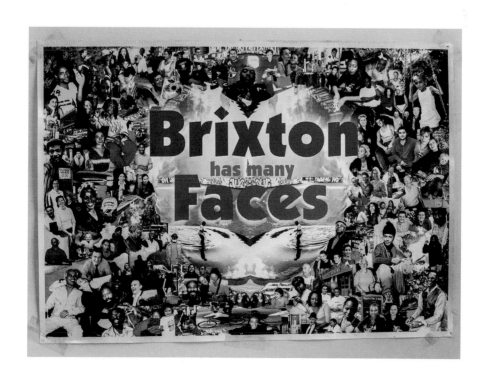

CONTRIBUTORS

▲ **RICHARD:** 'In 2014 I had a heart attack and had to have open-heart surgery, and it really did shock me – how mortal I was! Luckily, it coincided with retiring from thirty-eight years of teaching. So, since then, I've really been embracing life, doing yoga and pilates, sketching and doing life-drawing classes, cycling and making full use of my Freedom Pass to explore London. I also got more involved in the art and music scenes, and now I skip around meeting and photographing lots of fascinating people for Humans of London too.

'Having retired, I was walking round London, a bit bored and a bit lonely, because everybody I knew was working, so I would end up talking to strangers anyway. But HOGLing meant I actually had a licence to go up to somebody and say "You look interesting, could you tell me something of your story?" I feel so privileged to be able to do that. I've really enjoyed it, and I've also met so many fantastic people through it, lots of whom have since become good friends. I also just love making people's day, because it so often does, and that's a superb feeling. I'm definitely in it for the long haul, and I'm really looking forward to more people joining us and building a bigger team.

'I also like to show the subcultures of London, get people past their "Oh, that's a bit weird" reaction and challenge preconceptions. I love that I'm now doing my little bit to help people celebrate our differences.'

Richard Kaby HOGLed Russella (p39), Emma & Emily (p49), Estelle (p79), Deborah (p122), Anne Sophie (p123), Gemma (p126), Mia-Jane (p127), Natty (p199), Greg (p211) and Tuppy (p196).

⌃ TRISHA: 'I've known Richard for over twenty-five years; we met while I was doing my City and Guilds in photography, and he suggested I start HOGLing because he knew that I'd always liked doing street portrait photography, though it had never occurred to me to record or write down anyone's words. I'm actually severely dyslexic – though I wasn't diagnosed till I was twenty-eight. Before that I was so ashamed that I couldn't read or write that I used to try and hide it from people, which made close relationships impossible. When I finally owned this core truth about myself I felt so much lighter, and I was able to get some proper help too. I'm still not fluent at reading or writing – I'm much better with visuals so I make a lot of art, but now I can do it if I need to.

'I do find HOGLing challenging – to approach people and then expect them to give something of themselves to you, out of the blue. Let's be honest – why should they? If I think about it too much I can paralyse myself, get too self-conscious, and it doesn't really work. I find just following my gut, taking a deep breath and jumping in is better.

'But having been a hairdresser for so many years has definitely taught me to talk to people. Sometimes the chit-chat is very light and airy; sometimes people will share really deep, sad stuff with you. I'm going to stick with HOGLing, and try and set aside time to do more, because I really love finding the unexpected in people, taking a beautiful photograph of them and hearing their stories.'

Trisha O'Neill HOGLed Garry (p83), Hymn (p92), Humraya (p139) and Mick (p141).

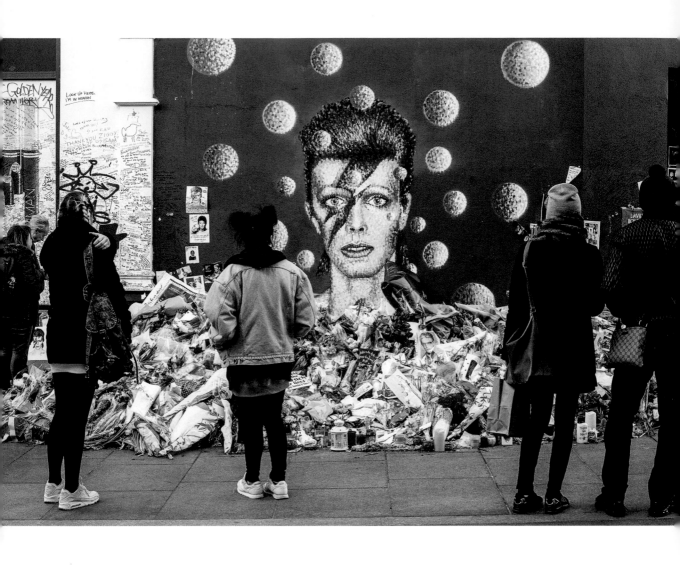

The Bowie mural in Brixton by Jimmy C. became a magnet
for mourners after David's death in February 2016.

BRIXTON